Public Space – Private Life
A Decade at Slane Castle

Public Space – Private Life

A Decade at Slane Castle

HENRY MOUNT CHARLES

faber and faber

LONDON · BOSTON

First published in 1989
by Faber and Faber Limited
3 Queen Square London WC1N 3AU

Photoset by Wilmaset, Birkenhead, Wirral
Printed in Great Britain

The quotation from *Nineteen Eighty-Four* by George Orwell
is included by kind permission of the estate of the late
Sonia Brownell Orwell and Secker and Warburg Ltd.

British Library Cataloguing in Publication Data
is available.

ISBN 0–571–15497–2

To Mary Browne

Contents

List of Illustrations

1

The Beginning

It was in the summer of 1976 that I returned to Ireland to take over Slane Castle from my father. It was a move I made reluctantly, for in the depth of my heart I knew it was the end of my freedom to plough my own furrow, and that I was casting myself in a stereotyped role, from which I was going to have great difficulty escaping. From being my own master in what seemed a promising career in publishing in London, where I could escape from the feeling of being, at times, a stranger in my own country, I was thrown back, aged twenty-five, as Lord Mount Charles, owner of the Castle. I was an Anglo-Irish anachronism tolerated in a modern Ireland, as long as I adhered to the stereotype. The problem was that in reality I was a young married man with a somewhat different perspective. I had spent three formative years at Harvard University in the United States, and a short, but deeply emotional period working in an Anglican Mission in South Africa. I was returning to an Ireland I loved, but still a country bedevilled by division and much hypocrisy. Despite all of this, there was, I suppose, a choice: I could have said no, but the pull was too strong. I had a deep bond with the country that I had been brought up in, and deeper still, an emotional and spiritual attachment to a place called Slane by the banks of the river Boyne.

It is very difficult to describe the influences that such a place has on one's psyche, for it is so different from normal experience. Slane has an almost mystical quality, much associated in my mind with water. The river winds through the estate, cutting a swathe through the valley below the Castle. At night, the sound of water rushing over the weir has a soothing and calming effect. Sometimes, standing alone in the moonlight with the dark shadows of the trees, and the dancing of the water, you feel close to the origins of life: to reject that would be almost

[1]

philistine. The landscape is wonderful; it has the lush greenness of the pastures of Meath, and the rolling undulation of the Boyne Valley, before the land gets rougher to the north, or more flat and uninteresting towards Dublin.

The Castle itself is magic, the combination of several architectural styles reflecting both the complex temperament and taste of one of my favourite ancestors, William Burton Conyngham, a renowned patron of the arts, academic, politician and progressive landowner. He consulted James Wyatt, Francis Johnston, Gandon and Capability Brown. The building today is much the same in structure as it was at the end of the eighteenth century. It is in every sense an imposing building, sited on a mound overlooking the Boyne, at times almost austere; but inside it has an intimacy, despite its grandeur. The hall is a classic room dominated by four pillars and the delicate plasterwork of Francis Johnston, into which is incorporated the family motto 'Over Fork Over' which dates back to Malcolm escaping from the tyranny of Macbeth (Malcolm was hidden in a hayloft by a member of the family, who forked the hay over him, and thus he escaped detection). As a child the room seemed to have a quiet grandeur and formality, disrupted only by endless games of hide-and-seek, or gymnastics on a huge ottoman sofa. Its atmosphere was teased by the welcome clatter of my father's friends returning from the river, or the Guns coming back after a day's shooting. Every time that door clatters in that way today, the past echoes within me.

Off the hall were two rooms of mystery and wonderment, the ballroom and the drawing room. The ballroom is extraordinary, without question one of the finest Gothic Revival rooms in Ireland, with plasterwork of breathtaking intricacy. In my youth I remember it being painted a sort of strange yellow colour with portraits hanging high on the walls, and faded curtains and statues of women I thought were angels. It was a room of fantasy and contemplation – and marvellous for playing with toys. We had a table-tennis table in the middle, and many happy hours were spent battling away over it with my brother Simon. The room was dominated, as it is today, by a magnificent and dramatic portrait of King George IV by Sir Thomas Lawrence, which overlooked this children's paradise and gave it a sense of history and past glories, perhaps inflicting on us, in retrospect, a false sense of importance. Adjoining this room was the drawing room, forbidden to children except on rare occasions, for it was the sanctuary of that rare and somewhat alien breed of people called grown-ups, who used to dress up

in dinner jackets and long flowing dresses in the evening, and to whom we were summoned to be inspected before going to bed at night, often escaping from their critical eyes with a sense of relief. It was painted pale pink, a colour I have kept to this day, and was full of objects of history and beauty, which we handled while visitors muttered reverently and admonished us with, 'I hope you appreciate all these wonderful things.' When I got older, this sort of phrase uttered once too often made me want to respond with, 'What do you take me for, a bloody philistine?' as I fondly handled the ring that George IV gave to Lady Conyngham, gold with emeralds, representing the shamrock for Ireland, and with the rose and thistle respectively for England and Scotland.

Adjoining this room was the dining room, bedecked with family portraits, among them a wonderful romantic painting of the first Marchioness Conyngham, George IV's mistress, painted in a long flowing dress with her eldest child, Henry, the first Earl of Mount Charles, on her back. There is a wild mountainous landscape in the background, which I presume to be County Donegal. Hanging in the same room was a superbly painted Gilbert Stuart of William Burton Conyngham, and a very stylized court picture of Lady Conyngham by Sir Thomas Lawrence, depicting her as a well-proportioned lady of fifty years of age. Showing people the picture today, I often quote a contemporary diarist who described her as the 'Vice Queen, not a brain in her head only a hand to grab pearls and diamonds with, and an enormous balcony to wear them upon'. This room was flooded with memories. It was where my parents ate. As small children we were catered for separately in the nursery; very much in the spirit of 'being seen but not heard'. It was really only on reaching the age of twelve that we graduated to the dining room to eat with Mummy and Daddy.

Below this world of the grown-ups was the engine-room of the Castle, where the real activity took place. This was the world of kitchens, housekeeper's room, still-room, and storeroom, often filled with goodies like biscuits and bars of Bournville cooking chocolate. It was the world of cooks, butlers, kitchen maids and lady's-maids. It was comfortable and friendly, full of chat and gossip, and it was ruled and dominated throughout my childhood and early adulthood by a remarkable Kerrywoman called Mary Browne, whom I still think of today with great affection. She was a fount of knowledge. She had first come to the Castle at sixteen years of age to work for my great-grandmother, a very eccentric but beautiful lady, who was the daughter of Lord Ventry, and

who also hailed from Kerry. Her family home is now a convent, and on my last visit I was greeted by the nuns, almost as a lost member of the family. Mary Browne's brother was still living in the Gate Lodge. I was a pallbearer at her funeral, and seeing her lowered into the ground was in every sense the end of an era. Mary graduated to housekeeper and she has left her stamp on the place. I can still hear her slow climb up the stone back-stairs in the Castle. Every night, even up to my late teens, she would come into my room and lean over me to make sure I was still breathing, which I suppose to her had a sort of logic, as in my teenage years we did get up to some pretty wild antics. I still recall her horrified face when, one evening, as I returned from a particularly energetic bout of carousing, she leaned out of her window to find me dancing round a tall wrought-iron light beside the front steps, in full-blooded song.

Mary's real kingdom was below stairs. She seemed convinced that it was an essential component of life always to have two or three enormous kettles permanently boiling on the Aga, just in case anybody should suddenly want a cup of tea. Apart from the occupants of the Castle, there was another group who she felt needed sustenance from this source. These were the men of the road, who wore great black coats often tied up with binder twine, who used to turn up for 'a cup of tea and a bite of bread', and Mary always had the kettle boiling to cover such an eventuality. To a child this all seemed part of a special ritual, happily accepted by my parents.

Mary's other astonishing feature was her encyclopaedic knowledge of the family. My father was never particularly clued up on the intricacies of distant family cousins, and we were even deeper in the dark, for as children we saw much more of my mother's side of the family. However, Mary knew them all, how they fitted in and exactly what they had got up to, when they had last visited the Castle, and basically whether they were worth the candle or not. As children we probably learnt more about what was going on from her than almost any other source. She used to take us for endless long walks to exhaust us, and during those hours and sitting with her in the housekeeper's room, we heard of the exploits of previous generations, most particularly of my grandfather, who in his youth was as wild as a March hare, and really only slowed down in old age, and of my great-grandmother, a domineering but endearing eccentric, who held sway in the Castle until 1939. I remember Mary telling me that my great-grandmother would ring the bell on many occasions in the early hours of the morning summoning

[4]

Mary to show her the family miniatures and valuables to make sure they were safe.

Mary presided over a team. First there was nurse, a warm-hearted lady called May MacDermott, whom I still see occasionally; the butler, Joe Smith, who was affectionately called 'Baldy' and still lives in the village of Slane; and Edie Armstrong, who until comparatively recently used to live in a small house hidden behind the yards, with what seemed like a secret garden in front of it. Edie was a wonderful cook, and had worked previously for my mother's family nearby. Her husband had been in the Guards, and as children we were conscious that she was a Protestant. Edie still speaks with a long, slow, distinct drawl and now lives with her son in England. She remains forever in my mind, trawling the woods for sticks. A storm meant a bonanza, as a large stock of firewood was essential for life. She had a highly developed sense of humour and nothing really seemed to faze her. It seemed as if she had seen it all before. All of these personalities were very important to us and so many memories are attached to them. My brothers and I still talk about riding round the corridors of the kitchen floor on bicycles with Mary Browne yelling at us and about brewing endless bottles of ginger beer from a recipe given to us by the keeper's wife, of which at least 40 per cent would explode. Mary Browne used to tell us stories going back into Celtic mythology, the significance of which only dawned upon me years later when I was studying the subject at Harvard. So many events from that period are still with me that I can only give a few illustrations from my recollections.

When Edie retired from doing the cooking because of ill-health, Mary Browne took over responsibility; her talents in this area were a little inconsistent but such was our affection for her that we couldn't really bear to hurt her feelings. As a result we would dream up elaborate ploys to dispose of unconsumed food. One incident in particular sticks in my memory. After an outstandingly indigestible offering, we decided the kindest thing to do was to chuck the remnants of the meal out of the dining-room window into the moat below. Unfortunately at the very instant that our lunch was hurtling towards the basement of the Castle, Mary Browne was out there collecting rainwater for my mother to wash her hair in. I can't quite remember what tissue of lies we dreamt up to talk our way out of that one, but we somehow calmed her down.

Nurse May MacDermott was teased unmercifully, especially at the hint of any romance, and Joe, the butler, tolerated all our childish

pranks. It seems so strange now to think of Joe packing my suitcase for me, before I headed off to America to university, but somehow it did not seem unusual at the time.

Most central of all was Mary Browne's deep attachment to Slane and to the family. She had lived in the Castle most of her life, and she lived to see it pass from my great-grandmother to my father and finally into my hands. She drilled into me a sense of duty, that I had a role to play in keeping the place together. It was a sense of duty that I got from my parents as well, but from Mary it had its own special strength, for it was wrapped in childhood memories, and the sort of sensitivity and resolution that seems to emanate from people from Kerry. In a very real sense, if I had declined to return home I would have been letting down not just my family but also Mary Browne, and a deep sense of equilibrium would have been shattered.

If the pull of the building was strong, and the personalities involved capable of inducing so many happy memories, there was also the age-old 'call of the land': in spring, lambs in the lawn-field where Bruce Springsteen and U2 have played, milk brought into the kitchen in the morning, the first salmon of the season; in summer, long rambles in the woods, kingfishers, salmon spawning in the little river behind the back of the Castle, the smell of freshly cut grass from the lawns, fresh figs and grapes from the greenhouses – so many images that flash in front of me with a warm intensity, some gone, some remaining, but all part of the fascination of the place.

The world outside the Castle had its characters too, some of those also gone; John Lynch, the gardener, whose face was the colour of a beacon, and whose journey home from the pub at night on foot wearing a dark coat filled all with trepidation; Ted Smith, known affectionately as 'the Humper' for reasons not quite clear. People at Slane seemed to collect such names – 'the Minister', 'Pres' and 'the Cowboy'. 'The Cowboy' is still with us, and 'the Minister' and 'Pres' still live in the village of Slane. Such is the sense of continuity that Gus Doggett, the farm manager, Paddy Walsh, the herd, and Mick Scully, have worked at Slane since I can remember. They are as much a part of the place as I am, and must have watched all the changes, sometimes with horror and sometimes with amusement.

Before my return to Slane, my father was living there with my then stepmother, a lady whose erratic behaviour was not exactly conducive to domestic tranquillity. My parents had split up when I was fifteen and

my father had lived for some time in Portugal with my stepmother, while my mother continued to live at the Castle with my two brothers and me. These were years of considerable emotional turbulence and difficulty, not assisted by my having to race through adolescence with a fury and in many circumstances being forced to adopt an adult role before I had really finished my childhood. It may have helped teach me how to take the rough and tumble of life, but sometimes I feel I was cheated of my period of innocence. However, what is relevant is that in the midst of these domestic difficulties Slane assumed an almost spiritual significance. It was something solid and definite to hold on to, and from it I drew inner strength. It gradually dawned on me that I could never be entirely separated from it, and in that sense it made the decision to return all the easier.

My father came back in 1971, my parents having eventually sorted out their arrangements – not easy in a country with such primitive and insensitive legislation for those whose marriages have disintegrated. They were divorced in London on 11 November 1970, which always struck me as somewhat ironic because it was Armistice Day. The intervening years during my father's absence from Slane from approximately 1966 to 1971 had their moments: school-friends staying, teenage parties, wild forays around the countryside; the carefree exuberance of the mid to late sixties, the music of The Rolling Stones, The Who and The Animals blazing around the Castle; waiting at table at my mother's dinner parties, attending my mother's dinner parties; hunting, talking late into the night, teenage romance and teenage despair, all against the backdrop of Slane. Memories still shared with friends, many of whom still visit the Castle today. But not everything was so tranquil and carefree. As the sixties drew to a close, it became increasingly clear that storm clouds were gathering in the North, and that the continuing intransigence of the Unionists was going to lead to disaster. These were highly charged times, and trouble erupted in the Castle in the most dramatic manner. The trouble started with the fishery. Prior to the Boyne Arterial Drainage Scheme, a deeply destructive and enormously expensive undertaking embarked upon by the government, with the stated aim of generating employment and assisting in the development of the agricultural base in the Boyne catchment area, the salmon fishing on the Slane water was some of the most sought-after in the country. After £30 million had been spent on the scheme, the fishery was decimated and without a compensating improvement to agriculture in

the region. Once started though, it seemed impossible to stop, such was the narrow focus of official thinking. However, in the late sixties the Slane fishery was still producing some excellent fishing. Then, to our absolute horror, the nationalization of fisheries became a political issue, taken up by the Republican movement, and there was a disturbing level of agitation culminating in a series of fish-ins along the banks of the Boyne. The Slane fishery became a target, and my father in particular was singled out for abuse. It was far from pleasant to see and hear your father described in public as a 'Robber Baron'. It is hard to convey the sense of unease induced by all of this. I was horrified by the discrimination in the North of Ireland, and yet, my father a Robber Baron? Nothing could be further from the truth. It was, I suppose, the first time that I felt very much a stranger in my own country. It was certainly not to be the last.

By the summer of 1970 this agitation had reached its peak. I was staying with my father in Portugal at the time and my mother was at the Castle, with my elderly grandfather and step-grandmother. Communications were not of the best in Portugal in those days, and when we received word that a telegram had arrived, we both set off to the local post office to pick it up, because we had a deep sense of foreboding that it might be bad news. It was from my father's farm manager, Bruce Dean, a stalwart friend who worked for my father for twenty-five years, and is my father's contemporary. It was very brief. It read, 'House under siege'. To this day I have never seen anybody with a heavy tan lose colour so fast. But by the time the telegram reached us it was all over, and it was a night my mother was never to forget.

At around 8 o'clock in the evening, the back doorbell rang and it was answered by Joe Smith, the butler. My mother was having dinner with my grandparents. At the door was Mr Reynolds, a schoolteacher from nearby Drogheda, and well known as a supporter of the campaign for the nationalization of fisheries. Joe went to inform my mother, but he left Mr Reynolds at the entrance with the door open. Within seconds he entered the Castle with approximately a dozen men, and they headed for the top floor equipped with sleeping bags and pots and pans. They were obviously not paying a courtesy call. They barricaded themselves on the top floor, armed with fire extinguishers to repel boarders, took control of the telephone switchboard and locked all doors in and out of the Castle. Mary Browne in the meantime had hurtled into the dining

room and informed my mother what had happened. Undaunted, my mother headed for the invaders and demanded to speak to Mr Reynolds as their spokesperson, whereupon he announced that he was not their leader, but they were all equal and that they had 'to occupy the Castle until such time as Lord Mount Charles [my father] gives back the fishery to the people of Ireland'. My mother demanded they leave. They refused. She argued about the concept of nationalization. They argued back. She asked to make a phone call. They refused, and eventually on the pretext of needing to talk to a neighbour, who she said would be expecting her after dinner, they allowed her to leave the Castle. She insisted that they should re-admit her on her return. She located the local sergeant and returned to the Castle. After vigorous knocking and shouting they let her back in. There were five men at the door, and on her re-admission, she discovered they had taken possession of my father's firearms. This was becoming a very unamusing episode. My mother and grandparents retired to the sitting room for a few stiff drinks. My grandparents eventually retired to bed armed with a bottle of gin, and my mother went up to her room wondering what was going to happen next.

At this stage the farm manager, Bruce Dean, had been informed. He was familiar with Mr Reynolds and well acquainted with all the implications. Bruce decided to try and reach my mother on the telephone. He masqueraded as 'George Jones', a name my mother would recognize. Reynolds answered the telephone, and he explained that he was George Jones, and needed to speak to her on an urgent matter of business. With some difficulty, he persuaded Reynolds to bring my mother to the phone. They then had a conversation in terms of a deal, which Bruce conveyed he wanted to complete as soon as possible; he said 'he understood that she was reluctant to do this, and that of course some risk was involved', but that it was 'better to press ahead before the price went up'. My mother rapidly got the drift, and said she would leave the decision to him. He then said he understood the Castle was occupied and was everyone all right? My mother said, 'Yes,' but then there was an interruption and she continued: 'He says – "So far." ' Following this, Bruce decided that he must press the Guards to break in. Initially this presented some difficulty as they were only prepared to accept the instructions of either my father or mother, or the estate solicitors. Eventually they relented and the local sergeant in Slane asked Bruce whether he was prepared to take responsibility for the decision himself.

By 5 a.m., the force of Guards was assembled at Slane Barracks, numbering about sixty men, and including three inspectors. By this time Bruce had got hold of the family solicitor, John Sides, and asked him to come down from Dublin, as he had been tipped off, in confidence, that there might be some reluctance by the authorities to press effective charges. It was approximately 5.30 a.m. by the time the force was assembled in front of the Castle. At this point Reynolds started addressing everybody over a loud-hailer, announcing that the occupation was in protest against the private ownership of fisheries, and that any attempt to break in could result in considerable damage to the valuable antiques.

At this stage my mother, knowing that all the entrances were blocked or guarded, wrote a note on a piece of paper, wrapped it round a pot of face cream and hurled it out of her bedroom window. The note explained how the Guards could break into the Castle. By now the intruders had concentrated themselves on the top floor equipped with the fire extinguishers, which they proceeded to unleash on the Guards as they rushed them. The Guards retreated. Undeterred by this my mother marched up the stairs towards Mr Reynolds and his followers. The Guards followed and the siege was over. There is a strange twist to the story, which occurred some years later. During the early eighties when I first entered politics, I made my first major speech in a small hall in Kilbride in County Meath. The meeting was attended by a man who had much encouraged me to enter public life, Dick Burke, then our EEC Commissioner. After the speech, I retired with some friends to the pub for a few drinks, and then full of the joys of spring returned to the Castle to find there were still customers in the restaurant. I was pleasantly surprised to find a friend entertaining Sean Garland, General Secretary of the Workers' Party. We started talking politics. To my astonishment, my friend turned round to me and asked whether I remembered the night in question. I said, 'Yes,' and he said, 'Well, I have an admission to make: I put up their bail.'

By 1971 my father had returned to the Castle, and at this stage I was attending Harvard University in the United States. In September of the same year, I got married to Juliet Kitson, whom I had met when I was eighteen and staying with my father in Portugal. We were instantly drawn to each other. Juliet had had a fairly traumatic upbringing. Her father was an ex-soldier and landowner, who had a wonderful estate in

Cornwall called Morval, but he was also a reformed alcoholic. Her parents had split up when she was very young, and she still remembers with anguish her father's drinking days. He had moved out of a wonderful seventeenth-century house at the heart of the estate, leaving it empty and forlorn and eventually selling it years later. Despite all the trauma of her childhood, Juliet loved Cornwall, and Morval in particular. She had a deep affection for the estate, and all those involved in it. Amidst the confusion of her upbringing, it (like Slane) provided a thread of continuity, and something she could find peace with. Very much like me she had the 'call of the land'. She called Cornwall 'proper country'. Slane fell into the same category.

In 1973, I graduated from Harvard University and returned to London, where Juliet had a flat, appropriately located in Cornwall Gardens, just off the Gloucester Road. I had developed a deep interest in publishing as a possible career, for it seemed the only profession that I could think of which combined the rough and tumble of commerce and the dissemination of ideas. I toyed briefly with the idea of journalism, and even thought of studying law, but somehow I had been saturated by academic pursuits and wanted to get out into the big wide world. I secured a number of interviews, some of which showed promise, when my mother-in-law, Penelope Kitson, stepped in. Now she was, and still is, a rather remarkable woman. Over six feet tall and strikingly good-looking, she possessed a sort of old-world wisdom, and the kind of charm that melts icebergs. She was also a force to be reckoned with. Faced with a deeply unhappy marriage she had left Cornwall in 1955, and moved to London with her three young children, Jessica, Juliet and James. Before leaving Morval, however, she had met a man who was to alter the rest of her life, and in a way to affect, directly or indirectly, all those who came in touch with him – the American multi-millionaire J. Paul Getty. He had come to stay for a weekend at Morval in 1955, through the auspices of Sir Anthony Eden, the British Foreign Secretary, who was a friend of my father-in-law. Paul, who always had an eye for the ladies, was entranced by Penelope, and when she moved to London, he took her under his wing.

Penelope provided Getty with a sort of domesticity that had been missing from his somewhat Bohemian lifestyle. She was not remotely fazed by his vast wealth, and had no intention of becoming in succession the next Mrs Getty, and then the victim of the next divorce. Paul was essentially unsuited to marriage; he was far too much of an egomaniac,

and liked to be surrounded by a court of shallow women who flattered him. As a young married couple, we spent many happy weekends at Sutton Place, Paul's estate outside London. Penelope lived at the weekends in a converted cricket pavilion some distance from the house, but we often went up to the big house for lunch, only to find there the assembled court consisting of people such as Margaret, Duchess of Argyll, Lady Ursula D'Abo, Rosabella Burch and Mary Tessier, all of whom, in my opinion, were predictable and pretentious, and intent on flattering the old man. Paul himself was extraordinary. He looked like a sort of human bloodhound, lugubrious and almost hideous in his old age with skin stretched tightly over his face, his features exaggerated, no doubt, by cosmetic surgery. But his mind was razor-sharp, and he was enormously self-disciplined. He was far from one-dimensional. I can recall with astonishment walking around Sutton Place with him one Sunday afternoon, in earnest conversation, when he suddenly started quoting some lines from a poem by T. S. Eliot which he had read years before. It seems his mind did not totally revolve round oil, but he was a curious fellow. Towards the end of his life, somewhat incapacitated physically, he was confined to bed. Our son Alexander had just been born and was our pride and joy. Paul, who amongst other things was a crashing snob, and very impressed by titles, told Penelope that he wanted to see her young grandson. To give the old man his due he was also very fond of Juliet. We were summoned to his bedroom where he was lying in state. Babe in arms we moved towards his bedside. He gazed at the child and then looked up towards us. In his slow, ponderous, deep voice he said, 'Do you realize that in the year 2000 this young man will be twenty-five?' and that was that. To him young Alexander was a coincidence of numbers, to us he was a delight. I still have the christening cup he gave Alexander, which reads 'To Alexander from J. Paul Getty 27.4.75'; and I feel that Alexander should some day add '25 in the year 2000', in memory of Paul.

Paul, indirectly, had a very strong influence over my career. He was an avid art collector, as is witnessed by his extraordinary museum in Malibu in California, built around the designs of a Roman villa. In fact I would not have put it past him that he believed he was a Roman Emperor reincarnated. One of the pleasures of his life was having Penelope read to him about life in Ancient Rome, as if life as the world's most powerful oilman did not quite suffice. Naturally, with such an extensive art collection he required outside advice, which is where a

young arts graduate called Elizabeth Evans comes in. She worked for Paul at Sutton Place and she and Penelope became friends. Now Lizzie was married to Matthew Evans, son of the Welsh writer, George Ewart Evans, and a rising young star in the distinguished British publishing firm of Faber and Faber. Penelope arranged an interview for me. I still remember the day well. Bearded and nervous I called round to the Faber offices at Queen Square. Juliet came with me to bolster my courage and waited outside the building during the interview. It was immediately apparent that Matthew had a preconceived opinion of what I would be like, totally based on the premise that anybody with a title must be a bit of a jerk. This was not the first time I was to meet with such preconceptions and in a sense it was to be much worse when I returned home, because not only did I have a title, but I lived in a castle. Somehow I managed to surmount these disadvantages as Matthew offered me a job.

I started at Faber in November 1973, working initially for Peter du Sautoy, the then Chairman, and later for Matthew who had been appointed Managing Director. We have been firm friends ever since. Life at Faber was stimulating, although at the start I was somewhat of a general dogsbody, and it soon became clear that I was going to have to carve my own niche. I was thrown into all departments from sales to the warehouse in Harlow, Essex, from editorial to administration. I was adopted by a marvellous lady called Eileen Brooksbank who was the cookery editor and also handled what was affectionately called the 'muck and mysticism' list. I can still remember lugging piles of books into the book department at Harrods at Christmas. The same guy is still managing the floor. I see him whenever I go in there, but I don't think he remembers me. I dealt with authors as diverse as Christopher Priest and Harry Harrison, the science-fiction writers; the diplomat Sir Geoffrey Jackson who wrote about his experiences of being kidnapped by terrorists in South America, and General Frank Kitson, who wrote a highly controversial book, *Low Intensity Operations*, which has been cited frequently by members of the Republican movement as the blueprint for the alleged misdeeds of the British Military in the North of Ireland. One of the highlights of this time was meeting the poet Seamus Heaney. An additional attraction of Faber was its strong Irish orientation. In the short time I was there I carved out my territory. I was put in charge of negotiating the sale of subsidiary rights to paperback publishing houses and book clubs. In short, I had to advise the editorial committee how much I thought the book was worth, and then set about extracting the

best advance I could get on behalf of the author and Faber, as hardback publishers. I found out I was pretty adept at this.

During this happy period, I was aware that all was not well at Slane. I tried to visit the Castle as often as I could, both because I missed the place, and as it gave me an opportunity to support my father. Daddy was becoming increasingly depressed by the prospects of keeping the property together, escalating costs, the unwieldy size of the place and an increasingly hostile tax environment. He was also conscious of the fact that the property would almost certainly have to be opened to the public in some form, but dreaded the terrible invasion of privacy that this would entail. He had seen the fishery that he had loved and cherished so much decimated, and, to be honest, my stepmother did not really understand the extent of the problem he faced. The introduction of the wealth tax in 1974 by the then Fine Gael Minister of Finance, Richie Ryan, dubbed thereafter 'Red Richie', was the straw that broke the camel's back.

My father loves Slane as much as I do, and I don't think I would ever have been able to hold on to the place without his help and support. He inherited the property from my great-uncle, Victor, the fifth Marquess Conyngham, under the terms of a rather curious will. My great-uncle died unmarried as a result of contracting pneumonia in the trenches during the First World War. My grandfather, his younger brother, was heir to the title. Great-Uncle Victor did not have a very high opinion of his brother, who had developed a considerable reputation for fast and easy living, and a definite fondness for wine, women and song. His exploits are legendary in the family and when he went on one of his binges all hell broke loose. I don't think my great-grandmother was that impressed with his behaviour either. At the time of my great-uncle's death, my grandfather was married to an Australian cabaret singer, from whom he was separated, and it seemed very unclear what the future would hold. My great-uncle, possibly influenced by my great-grandmother, decided on a course of action that I can only presume he hoped would secure the future of the property. He cut my grandfather out of his will. He left Slane to my grandfather's first-born male issue, subject to a life interest for my great-grandmother. My father didn't exist at the time, nor indeed was my grandfather married to my grandmother. In short my father inherited everything my grandfather felt should rightfully be his. It was not conducive to a very easy relationship between them but, to be perfectly honest, it almost certainly secured the future of

the property. As a result of these arrangements, my father was not brought up at Slane where my great-grandmother lived until 1939. My grandfather eventually married my grandmother, who was the daughter of a wealthy provincial newspaper proprietor and city lawyer called Gustavus Thompson, who by any measure was a pretty tough customer. Old man Thompson took my grandparents under his wing and attempted to bring some semblance of order into their lives. My father duly appeared on the scene in 1924, and Gustavus Thompson set about getting control of his affairs, a situation that was subsequently to cause a considerable amount of aggravation.

As a result of these rather unusual arrangements my father was brought up in Scotland in a rented property, and although he came over to Ireland quite frequently as a child, it was to Mount Charles in County Donegal and not to the Castle. He only visited Slane once during those years, and he was not asked by my great-grandmother to stay the night. The one great advantage that I have had is that I was brought up at Slane from the beginning. Although I have sometimes suffered through the years from a confused sense of identity, it must have been a great deal more difficult for my father. My family has roots on this island dating back to 1611 when we came over from Scotland and settled in County Donegal. The first member of the family to arrive was Alexander, a Protestant clergyman, who with his wife had twenty-seven children. My family fought on both sides in the Battle of the Boyne and arrived at Slane in 1701. We have been there ever since. In a very real sense my father was in his youth exiled from his roots, and it must have been in every sense a destabilizing experience.

Daddy was educated at Eton and Sandhurst, and then joined the Irish Guards during the Second World War when he was commissioned as a captain. He fought in tanks and amongst other things did a short stint of guard duty at Chequers, where he enjoyed the privilege of being personally reprimanded by the British Prime Minister, Winston Churchill. During an exercise designed to test the defences of the place, somebody under my father's command succeeded in firing a smoke bomb into the house. The Prime Minister was enraged and demanded to know who was responsible. He severely reprimanded my father, who was appalled at the thought of being confronted by the great man. Later that day he invited my father to dinner. I would love to have met Churchill. Coincidentally I spent my first year at Harvard University studying the intricacies of his early life.

[15]

My father returned to Ireland in 1947, just after the war. He was immediately confronted by a serious problem. He also owned an enormous house in Kent called Bifrons, which was about the same size as the Castle. It was in a village called Patrixbourne which is near Canterbury. The family still has property there, although there is no trace of the house, except for the underground cellars and foundations of the building. Bifrons had been requisitioned by the authorities prior to the invasion of Europe and was occupied by the Canadian Army. Unfortunately they inflicted serious damage on the interior. In a sentence, he was confronted by two white elephants, and one had to go, because he was clearly not in a position to maintain two properties. During Daddy's minority, the family properties were seriously mismanaged by a collection of trustees that displayed scant regard for my father's real interests. By 1947 there was also another factor very dangerous to the well-being of old landed families trying to hold on to unwieldy properties: a disturbing shortage of cash. He made the right decision, for although he had not been brought up in Slane, he was drawn by the pull of the place. Bifrons went, Slane stayed. It is curious to think that I might easily have been brought up in the south-east of England, and maybe, just maybe, Patrixbourne rather than Slane would have seen The Rolling Stones.

By the time my father returned, my grandparents were already at Slane, eagerly supervising the modernization of the Castle – in my grandfather's case, perhaps, a little too enthusiastically. Bad blood takes a long time to simmer down and I think my grandfather really felt he was now in charge, which he was quite clearly not, thanks to Great-Uncle Victor's will. Although he incensed my father by flogging off a whole lot of Empire furniture without consulting him, not everything he embarked upon was a calamity. He initiated the installation of a hydro-electric scheme on the river, which still supplies power to the Castle nearly forty years later. He also set about improving the plumbing and kitchen facilities, which, to put it bluntly, were fairly primitive. However, there was still the thorny issue of who was in charge, and my father had my grandfather to deal with, and still more formidable, his own grandfather, that tough old buzzard, Gustavus Thompson.

Great-Grandfather Thompson had undoubtedly been an enormous help to my grandparents, particularly during the early years of their marriage, but he was also intent on controlling the Conyngham family

[16]

property, and my father had enormous problems wresting control of affairs from him. By the time things came to a head my mother had appeared on the scene, and she suggested that Lord Bicester, an old friend and a distinguished man, might be able to make old Thompson see sense. These two gentlemen were seriously advanced in years and my parents waited anxiously for the results of their meeting. Lord Bicester returned. My mother asked him, 'Well, what did he say?' 'Do you know why that man is so old? It is because God doesn't want him.' Lord Bicester was my godfather, although he died before I got an opportunity to know him. My father eventually got the better of old man Thompson. Many years later, when we were visiting Beau Parc House to see Lady Kathleen Lambart (mother of my future benefactor, Sir Oliver Lambart), Lady Kathleen suggested that I reminded her slightly of old man Thompson. My father looked rather pale. To this day I don't know whether she was joking.

These early days were very difficult for my father, but he had found a staunch ally in my mother. Mummy had been brought up in County Meath a few miles from Slane. She had known my great-grandmother Conyngham, and knew the territory well. She was the daughter of a retired British Army officer called Captain 'Kong' Newsam, who had married a young widow from County Mayo called Bourke. They had an estate in the west but had moved up to County Meath to a place called Ashfield, where my mother was brought up with her two half-sisters, Patita and Binkie. My grandfather did not relish the idea of supporting his wife and three young children off the income from his farm, and in any event he was not greatly inspired by agricultural pursuits; although like my father he was a passionate fisherman. In the early days of the new-born Irish state, the government was actively encouraging the fostering of new industries, and my grandfather decided that this was the solution to his problems. He headed for Dublin to see the relevant officials, because he had hit on the idea of manufacturing nails, an enterprise he reckoned he could set up at Ashfield. He returned home that evening in a deeply depressed state and announced to my grandmother that they had already found somebody willing to manufacture nails, but they were anxious to find someone to make either carpets or handbags. They went to bed. Later that night my grandmother awoke to find that my grandfather had ventured downstairs. She found him in the sitting room with the encyclopaedia open at the page dealing with carpets. My grandfather never looked back. He

returned to the authorities and convinced them that he was capable of setting up a carpet factory.

He managed to obtain from them sufficient official documentation to help him attract outside investment. Then he went out and borrowed a flashy motor car, and headed for Scotland and Templetons, the carpet manufacturers, where he met a bright and ambitious young accountant called Robert Maclean. Between them they built a company called Navan Carpets, a mere eight miles from Slane. The company went public many years ago now and my mother sold her shares. At the time we were all too young to have an interest and in those days there was considerable resistance to appointing a woman to the board. Sir Robert Maclean went on to become Chairman of Stoddards, one of the largest carpet manufacturers in the United Kingdom, and he was eventually knighted for his services to industry. He also married my mother's half-sister, Binkie. Navan Carpets is still going strong producing some fine carpets. The Castle is still furnished with carpets from old Navan designs specially made up at my grandfather's behest. 'Cong' was adored by all of us. As a child he was a master magician making things appear and disappear with great dexterity. He used to dash from the factory during the lunch-hour to fish the Mollies, a well-known salmon pool nearby. I have been told that he did some of his best business deals in his gumboots. He was also an enormous source of strength and advice to my father, with whom he shared many hours fishing and golfing. His loss, when we were young, was sorely felt by us all.

My paternal grandparents did not particularly relish the prospect of my parents getting married because they could see that this new alliance would enable my father to break free, and gain control of his own destiny. These were fraught and difficult times, but somehow they managed to battle through. Years later, mellowed by age, all differences were buried. My recollection of my grandfather does not reflect the turbulence of his youth. He was an endearing but highly emotional old man wrapped up in the past, and with a disconcertingly sentimental approach to life. My grandparents eventually moved to Jersey in the Channel Islands, and I have fond memories of long talks with him, when he would tell me what life was like at Slane at the end of the last century and the beginning of this. He was deeply attached to the place and had throughout his adult life to bear the cross that he had been disinherited by his own brother; status without wealth, a title without land, living in the past, surrounded by a new world. I remember vividly the last time I

saw him. He was staying at the Goring Hotel in London, an establishment of which he was very fond. He had invited us all to join him for dinner. He managed to engineer a set of circumstances in which I was left alone in his room with him. He started by showing me his meticulously arranged collection of ties – Grandfather had always been a very flashy dresser. I wasn't entirely sure what was coming next, and was conscious that everybody else had gone on to dinner. 'This is the last time I will see you, I have decided I'm going to die.' I was dumbfounded, and at the same time aware that he always had inclinations towards the melodramatic. We embraced and then went down to dinner. Shortly afterwards he returned to Jersey. The phone rang early one morning. It was my step-grandmother (my grandmother had died some years before), who told me Grandpa had died in his sleep. It was April Fool's Day. My father became the seventh Marquess Conyngham, and I, only a few months into my job at Faber, became, as his eldest son, the Earl of Mount Charles. Promotion through death is something that has never appealed to me.

My father eventually managed to gain control of his affairs and set about getting everything on an even financial keel. The property in Kent was seriously run down, and a farm had to be sold to inject some badly needed capital into the estate. He engaged Savills, leading specialists in estate management, to look after the property, and got himself a new firm of solicitors. Bifrons was pulled down in 1954, and my parents settled into Slane. In those early days things were, as I have suggested, very different from how they are today. There were, believe it or not, three stonemasons permanently employed at Slane in 1947. Today I struggle to maintain the estate wall against the triple ravages of falling timber, ivy and vandalism. The fifties and sixties were glorious days, when life seemed easy, but by 1976 the whole ball game had changed.

It was, I suppose, the wealth tax that started a whole chain of events that was eventually to lead to my father's departure and my return. Unfortunately, my father was particularly vulnerable. The bulk of his assets was in agricultural property, Slane and land in Kent. The land in Kent was producing rental income which, frankly, underpinned the cost of running the estate at Slane and the Castle. However, the rents in percentage terms did not reflect very favourably on the escalating value of the property. In short, he was caught in a classic squeeze. He was paying more in income tax and wealth tax combined than he had in real income. The message was very simple: he would have to dispose of

assets annually to meet his tax liabilities or he would have to sell Slane. I knew in my heart that this was all extremely depressing. His deep attachment to the place made even contemplating taking such extreme action disturbing. I would be lying, however, if I did not admit that at times such dark and gloomy thoughts have passed through my mind . . . However, he decided that if he was going to make any radical moves, and most particularly those that involved my returning, he would keep his thoughts from me so that I could pursue my career at Faber and have a short but decisive taste of freedom before being swallowed by Slane. He also felt very strongly that I should be given the opportunity to prove myself in a field totally detached from responsibilities in Ireland. To be honest, although I was aware storm clouds were gathering when he decided to make a move, it was a bolt out of the blue. I thought I was dreaming.

It was early 1976. We were living in a mews house near Paddington Station. Alexander was tiny, and had earned for himself the nickname 'Mr Boom'. I had taught him how to crawl by clambering across the floor and every time I thumped my hand on the ground I would yell, 'Boom, Boom,' in the hope that this would inspire him to copy me. He spent a lot of the time sitting firmly on his bottom, grinning and giggling at me. It really is terrible how anxious young parents are about their first-born. Juliet was pregnant with Henrietta, who was to be born in the Rotunda in Dublin later in the year. My job at Faber was going very well; I was thoroughly enjoying it, and was contemplating a long career in publishing, although at the time I must admit the salary left a little to be desired. I had just been involved in selling the paperback rights of a book called *Sky Fall* by Harry Harrison. I had succeeeded in obtaining a price far beyond anybody's expectations; everyone seemed delighted, most particularly Harry and his formidable agent, a charming and wily character called Hilary Rubinstein of the leading London literary agents, A. P. Watt. (Hilary is now perhaps equally well known as the author of *The Good Hotel Guide*, and he must bear some responsibility for my writing this book.)

Inspired by my prowess at wheeling and dealing on his author's behalf, Hilary rang me up and offered to take me out to lunch as a thank-you present. I was delighted and accepted. We met for lunch, but it soon became apparent that he had a deeper purpose. He offered me a job, with the prospect of a seat on the board in the foreseeable future and a better salary than I was getting at Faber. This was great; I had never been

head-hunted before, and it's always nice to know that you're wanted. I was a little confused by all of this. I loved working at Faber. It was a wonderful firm full of good people and I felt a strong sense of commitment to them. I thought the best thing to do was to sleep on it. However, I was never to have the opportunity of making the decision to stay at Faber or to move to A. P. Watt, for events overtook me. Thrilled with my new-found confidence, I rang Juliet and told her what had happened, and decided that this called for a night on the town. We went out to dinner, celebrated a little too vigorously and returned home late. The next morning the telephone rang about eight o'clock. I was wondering where my head was and thinking, 'Christ, I have to get to the office.' It was my father. There and then he told me that he was going to have to move and that Slane would have to be sold, or I had to come home. It was my decision. He would stand by me whatever I decided to do. I was shocked; it felt as if a ton of granite had just fallen on top of me. I put the phone down with a sense that I was living in a dream. Juliet looked at me with concern, having caught the direction of the conversation. What a way to get rid of a hangover! That was just the beginning.

2

Early Days

Initially I was at sea, floating on a raft with nothing on the horizon, and a sense of emptiness engulfed me. Then, as the scale of what had happened became clear, this was counterbalanced by a sense of excitement. I have always loved a challenge and this was going to be one hell of a task. However, there were many considerations, not the least of which was Juliet's pregnancy. We were also very happy with our new life in London, and I had a job I really enjoyed. I had also seen so many Anglo-Irish families struggling to stand against the tide and had often wondered whether it was all worth it. Then there was also my deep sense of unease. I was an Irishman born and bred, but viewed by many as a stranger in my own country. A 'West Brit', 'a Prod', I kicked with the wrong foot. My father was a peer. Ireland is a republic. My background I could not change; the surface contradictions were there. There was part of me that felt an outsider, and part that deeply resented those that have claimed to want to unite this island, and yet still persisted in treating me as British. This sort of ambivalence and hypocrisy often turns into blind prejudice. In the intervening years I have run up against it, most often in the political arena, and most depressingly I have found it alive and well in the party that chose Garret FitzGerald as its leader. Garret is a politician who has directly challenged all this ambivalence and double-think, and like him I have always believed that you cannot unite a country without uniting its people. That was what his Constitutional crusade was all about. In short, we were torn, and not really sure what to do.

The most immediate problem was Faber. Matthew Evans was about to leave on a trip to Australia and was going to be gone for a couple of weeks. I had no alternative but to tell him. When I went into his office and said I needed to see him, he said, 'I suppose Hilary has offered you a

job?' I said, 'Yes, but that is not what I want to talk to you about.' I told him what had happened, and I asked for leave to go back to Ireland to discuss the whole issue in detail. Matthew impressed upon me that he felt I was on the verge of making a grave mistake, speaking to me along the lines of 'going mad', and 'you'll be bored to tears, things are just beginning to happen for you, in no time you will have grass growing out of your ears, and you'll be drowning your sorrows in a bottle of whiskey'. He did not exactly offer me great encouragement. I assured him that I had taken no decision. Leaving his office I went next door and rang my father, then Aer Lingus to book my flight to Dublin. I had been drawn home – the pull seemed very strong – but had not yet made a decision.

The first crucial question was to fathom the depth of my father's resolve. Initially he proposed sharing control, and here was the real rub: we had to be brutally honest with each other. For me, it was 'all or nothing', for the ship could not be seen to have two captains. This was the most difficult part because I was so conscious of the heightened emotions involved. However, we had one great advantage, and this was our joint objective to save Slane, an objective over which we still stand resolutely united. The fact was that if I had to take on the endearing white elephant I had to charge into my own jungle. My father quickly responded by stating he understood my position. The truth of the matter, which he later admitted to me, was that he was going through the same exercise: he was testing my resolve.

Next we had the arduous task of examining whether this was at all possible. We were operating in a substantially more hostile tax environment, and this was no simple matter. We both headed for Dublin and sat for hours in the offices of Stokes, Kennedy, Crowley, a leading Dublin accountancy firm, throwing all the balls in the air to see if we could catch them all. Doubt started to seep through my mind. After the initial meeting, I decided to take a stroll round Trinity, hoping a meander through a seat of learning would help clear my head. On the way I ran into an old friend of my father, Sir Richard Musgrave. He expressed deep concern about my father, and asked what the future held for Slane. I pleaded ignorance. The gossip had started. In many respects Ireland is a small country, and if you are in any way in the public eye, privacy becomes a problem. As I have learnt over the years, publicity is a two-edged sword.

The lasting impression of this period was an endless series of meetings

[23]

and discussions. I sometimes ponder on who is the chief beneficiary of complex tax legislation, the Revenue authorities or the lawyers and accountants employed to protect you from their sometimes voracious appetite. This is not the proper place to enter into a debate on the problems inherent in the Irish tax system, but for the survival of Slane I have unfortunately had to acquaint myself with its intricacies, and will have to continue to do so if the property is to remain in the hands and care of the next generation. I only hope if there is a will there is a way.

Towards the end of April things were coming to a head, and all my father's key advisers came to a meeting in Dublin. It seemed a method could be found of getting him out and me in, but the tragedy of it all was that my father was going to have to leave Ireland and become a tax exile. If he was going to make a sacrifice, so would I. It was a joint decision. If properties like Slane are to survive, the generations must stand together. Too often in similar situations, disunity in the family ranks sows the seed of destruction. I handed in my notice to Faber, knowing that my life was going to have a serious gap in it, and that eventually the fire generated by that job would have to be rekindled. It remained smouldering for several years.

The summer of 1976 was one of the hottest I can remember. Hyde Park was like a dustbowl. Everywhere the grass was burnt and discoloured. There seemed so much to do. We had to sell our house, pack up our belongings and say farewell to numerous friends. For Juliet it must have been even more bewildering, pregnant and leaving home. At least I was going back to my own country. Paul Getty had died and the gossip columnists were having a field day dissecting his will. An article even appeared in the *New York Times* laced with innuendo about Juliet's mother. So many things seemed to be coming to an end, and so many new things happening.

News of my father's departure and my impending return started to percolate through the locality. I was inundated with advice, but an old friend said, 'When you come back, at first do nothing, but change all the locks.' I did not entirely heed his advice, and also knew that behind me was Bruce Dean, the farm manager, and Emer Mooney, my father's secretary, so I was not completely at sea. Fundamentally, however, a method of expressing my approach had to be found. Adjoining the Castle was a huge but dangerously decaying cypress tree, a vast specimen which in recent years had started to lose its top. The tree had to come down. Bertie Fox, the timber merchant, was summoned and the

tree was felled. I had announced my arrival. In the intervening years, thousands of trees have been planted at Slane, many of them broad-leaved. Planting trees is a bit of a passion and much of this activity has been encouraged by Bertie Fox's son, Frank.

Between all the travelling back and forth and the endless meetings and discussions, I was very conscious of the terrible wrench I felt giving up my job at Faber. All sorts of thoughts crossed my mind, including setting up a literary agency of my own. Then, quite by chance, my mother-in-law Penelope had yet another influence on my life, this time a little less directly. At a dinner party at her London home, I had the great pleasure of meeting Sir Philip Hay, who had joined the board of Sotheby's, the fine art auctioneers. After dinner we were deep in conversation about the task Juliet and I were facing on our return to Ireland, and I particularly expressed my anxiety that I would find it very frustrating not to have an outside interest. At the time Christie's, Sotheby's main rivals, seemed to be having a free run in Ireland, presided over by the Knight of Glin, who has successfully played the somewhat contradictory roles of conservationist and undertaker. Sotheby's were naturally distressed by this, and their anxieties were increased by the substantial publicity generated by the sale of the contents of Malahide Castle outside Dublin, the family home of the Talbots and now owned by Dublin Tourism. They needed somebody to take on the Knight of Glin as at that time they didn't have a representative in Ireland. Sir Philip explained their predicament, and asked me whether, without any commitment on either side, I would be willing to meet Lord Westmorland, a leading light in Sotheby's. I leapt at the opportunity. It was a lifeline. Works of art have always held a fascination for me and most particularly pictures. I had been collecting since my teens, initially items of family interest, and had had the opportunity of growing up surrounded by beautiful objects. Faber had also had an extensive arts list and it seemed a not entirely unrelated progression. However, I was under no illusions; Sotheby's also needed me for another reason, and it was a lot less attractive. I was well connected and they hoped I would give the Knight of Glin a run for his money down the corridors of decaying Anglo-Irish mansions. There was a joke going round at the time about Sotheby's and Christie's: 'Sotheby's were businessmen trying to be gentlemen and Christie's were gentlemen trying to be businessmen.' The real truth is that the essential components of both these organizations are intelligence and good social

connections. Death, birth, divorce or financial strain require people to raise cash, and the trick is to have your person on the spot. You have to know where everything is, who owns it (often not as straightforward as it seems), and whether a sale is imminent. A good sense of judgement is essential, but not an encyclopaedic knowledge in a specialist field, as the main thing is to know what is quality and what is not. However, caution is the key, because even the most reliable 'in-house' experts make mistakes, sometimes spectacular ones. The crucial factor as far as Sotheby's was concerned was to be in the right place at the right time, but when I was told by somebody in the international office that I should pay more attention to my style of dress, I knew this wasn't going to last. I remained Sotheby's representative in Ireland for eighteen months, which was an invaluable experience and enabled me to travel to the four corners of the island. I encountered many memorable characters and, I hope, gave people sensible advice. I made a few discoveries and was bitten by a good few dogs and upset the Knight of Glin. After resigning as Sotheby's representative, I stayed with the firm as a consultant and international representative, and finally severed my connection in the early eighties. It taught me a lot and I also met one of the most complex characters I have ever encountered, the mysterious Peter Wilson, the then Chairman of Sotheby's.

By June we were finally organized and my father and stepmother had found a suitable house in the Isle of Man. We moved in, and my father and stepmother moved out on the same day. It was a most bizarre climax to the endless meetings, discussions and signing of documents. We arrived early in the morning off the Liverpool–Dublin ferry, and headed for my mother's house, which is near Trim in County Meath and about thirty minutes from Slane. My mother had volunteered to look after a somewhat bewildered Alexander for the day. We then headed for the Castle and deposited our belongings and assisted my father and stepmother in packing their car. Exhausted and emotionally fraught we then retired to a restaurant in Navan owned by a very old friend, Tommy FitzHerbert, where we all had lunch and parted company. It was a most peculiar feeling to see Slane pass from one generation to the next in such a manner. We retrieved Alexander, and the three of us headed back to the Castle. Numb with the enormity of what we had let ourselves in for, we retired to bed early. It was an eerie feeling being entombed in the Castle that night. We slept in the King's room, where George IV was supposed to have stayed in 1821. We were both shattered. The tele-

phone rang at 10 o'clock. I struggled out of bed. It was an old friend of my father, wanting to know what I was going to do about the shoot for the forthcoming season. Good God, I'd only been in the place a few hours and people were already trying to bully me! Old friend or not, I got rid of him, and climbed back into bed. As I lay there thinking of the bloody nerve of it, I knew I was home. People will always have a go, and the meek have not yet inherited the earth.

On my return my most immediate concern was the Castle, as Bruce Dean had agreed to stay on as farm manager for the time being and my father's secretary, Emer, knew all the idiosyncrasies of the estate. There were problems in this area but the Castle seemed the most pressing priority. Many people in the United Kingdom fail to appreciate the difficulties faced by the owner of historic properties in the Republic. In the twelve years since I returned, I think that I have received approximately £2,500 from the State or, to put it another way, about £208 a year. It is only since the 1982 Finance Act that we have been granted income-tax relief on basic repairs and maintenance. We have been battling with high interest rates and escalating costs and, equally crucial, we have been operating in a country with a very small population in comparison with the United Kingdom, and hence it is not sufficient just to throw your doors open to the public.

It was with that sort of background that the idea of establishing a restaurant had appeal, because it would be open for a defined number of hours and it would help maintain a part of the Castle which was falling into disrepair. If nobody turned up at least we could eat well, and restaurants seem to have that special allure that so many find attractive, until they realize what incredibly hard work it is, and how at times it tries the patience. Neither of us knew much about catering, so we had to seek outside help. We approached Tommy FitzHerbert, my son's godfather and a friend of mine since childhood, whose restaurant in Navan, rather appropriately called Jaws, had been the setting of the farewell lunch.

Tommy's father, Tom, a highly flamboyant character, had been a stockbroker in Dublin. He had lost a leg in the Second World War, and you could always hear him coming, as his artificial leg creaked in a very distinctive manner. In his heyday he swanned around in a Bentley, lived in great style, had a string of racehorses, and endless lawnmowers. His children drank Coca-Cola and 7-Up while we drank orange squash. Unfortunately Tom had got his fingers burnt and was now in much-

reduced circumstances but, being made of very stern stuff, he refused to give up and had started a landscape-gardening firm. I had worked for him briefly when I was eighteen as a labourer to earn some extra money. Two things from that time stick firmly in my mind. He used to pick me up from the Castle about 6.30 in the morning. Now, I have never been at my best at that hour. One morning he arrived as usual and I clambered somewhat wearily into the van. As soon as we had set off and exchanged the usual pleasantries, he suddenly adopted a somewhat more serious tone. 'You know, Henry, that we are both descended from mistresses of King George IV, you from Lady Conyngham, and I from Mrs FitzHerbert [the last and first, respectively]. Well, I have decided that we should put this historical link between our two families to good use, and I am thinking that your father and I should go into business together.' I looked at him incredulously as I wasn't quite sure what was coming next. 'Well, you see, me being Mr FitzHerbert, and your father being Lord Mount Charles, I would have thought it was fairly obvious.' I was lost. 'We should open a brothel and call it "Mounts here and Fits there".' Even at about 6.30 in the morning he was capable of delivering that kind of humour. He was without doubt one of the best raconteurs I have ever come across, though mind you, Tommy could give him a run for his money.

There was another peculiar twist to this short period working in Tom's landscape-gardening firm that I was not to appreciate until many years later, after Tom died, which was a shame, because I'm sure it would have brought him pleasure. One of the jobs that Tom got the contract for was carrying our remedial work on the gardens below Beau Parc House, for Lady Kathleen Lambart. Little was I to know, as I slaved away on the banks under the watchful gaze of Lady Kathleen, that I was one day to inherit the property. But, all those years ago, it gave me an intimate feeling for the place, that to this day stands me in good stead.

I managed to work out a suitable arrangement with Tommy, and we then set about getting the show on the road. The original lay-out of the Castle facilitated our plans. It is built on a mound, and effectively has entrances on two levels. The lower floor, which was to be the restaurant, can be approached through the Castle courtyard and is quite separate from the front door. This was the floor that my grandfather had converted into the kitchen, larder storeroom, still-room, pantry and housekeeper's room. It had become somewhat run down in recent years and required refurbishment. We called in Sean Doonan, the local

builder from Slane who, with his father before him, had wrestled with structural problems at the Castle for as long as I can remember. We knocked down all the walls put up by my grandfather in the forties, and returned the old servants' hall to its original shape. As the walls came down, the room was revealed in all its splendour, with four massive pillars, which supported the floor of the main hall. Edie told us where to knock a hole in the wall to find the flue for the old fireplace. The whole thing had to be got together on a shoestring budget and to be honest I'm not quite sure how we managed it. The carpets were seconds, and we put hessian on the walls because we thought it would last and keep in the warmth. At this stage there was no central heating in the Castle, and in the early days we relied on portable gas heaters to keep the place warm. I will never forget lugging endless cylinders all over the Castle to provide heat where it was needed. We built a bar in an alcove, largely because it saved on cost and made the plumbing simpler. We used brick to build the fireplace because we ran out of money for anything more elaborate. The kitchen was fitted out with the minimum outlay. Tommy and his deputy, a Trojan lady called Eileen Gough, had to struggle initially over three domestic gas cookers, supplied from even larger gas cylinders. In those days we didn't even have a suitable bulk tank and I can still remember running out of gas with the restaurant fully booked. We decorated the room with a collection of old family portraits that I had brought home from a warehouse in Canterbury. The pace at which the whole thing happened was frantic. We started some time in September and were open by December. We decided that the best way to get the enterprise off the ground was to give an enormous launching party which we duly did on 17 December 1976. Hundreds turned up and thoroughly enjoyed themselves, although, frankly, there were quite a number who thought us quite off our rocker.

In the intervening months, much else had happened. Our daughter, Henrietta, was born in October. I will never forget it. Juliet was booked into the Rotunda in Dublin, where I was born. (Perhaps, in retrospect, it would have been more sensible to have chosen the Lourdes Hospital in Drogheda where my brother Patrick was born.) The hospital is in the centre of Dublin, 29 miles from Slane. Penelope, Juliet's mother, had come over to the Castle to stay for the impending event. Henrietta decided to enter this world on a night when the heavens opened. I do not remember driving through such rain before: it was like a perpetual curtain of water. Penelope kept urging me to drive faster; Juliet kept

groaning in the back seat, and I kept saying that if I went any faster we would all be killed. Eventually we arrived at the hospital, but Henrietta decided to postpone her appearance and wasn't born until an hour or so later. It was not an easy birth, as she came out upside down. I was present throughout, as I was at Alexander's birth. Fortunately, when I was working in a hospital in Zululand I had seen many children enter the world.

Life in the Castle during the first few months was very different from what it is now. It was in a sense the calm before the storm. Juliet struggled with the domestic arrangements. They were a great deal less convenient than those in our small mews house in London, and although my father had updated the kitchen and dining arrangements on his return in 1971, he had the advantage of having domestic staff to help run the Castle. Just prior to my return, I had to explain to my father's butler, Donald, that we simply could not afford to keep him on. Finally gone were the days when the laird could ring the bell for a cup of tea or a drink. I can still recall with affection sitting in the morning room with my brother Simon, as Joe, the butler, brought in afternoon tea. Mummy might have returned from hunting or my father from the river and we would be pleading with them to watch *The Lone Ranger* on television. Those images of how the aristocracy live still persist to this day. Penelope was very concerned by the daunting task facing Juliet, and arranged for us to get some additional help. She found a young girl from near Sutton Place. When she first arrived, she worked like a demon, astonishing us both. The rate at which she scrubbed floors and polished tables was simply breathtaking, but something seemed amiss. Nobody could fit the bill so perfectly. When her visits to the pubs in the village became more and more frequent, we knew what the problem was, and when she returned battered and cut, because she had fallen over in the road after obviously drinking heavily, we knew it was serious. When I started finding the empty bottles, that was it, she had to go. In the years that followed there were to be many scrapes with the demon drink.

The first summer was a period of adjustment to a whole new way of life. Suddenly we were living on top of each other. I no longer disappeared to the office every morning, to return in the evening. It also took me a while to feel I was really in control. Bruce Dean, the farm manager, had worked for my father for years. People constantly kept making demands on me, to which I did not know how to react. If I heard the words 'In your father's time' once, it seemed I heard them a

thousand times. I was reluctant to telephone my father over every minute detail and Emer Mooney, my father's secretary, who had kindly agreed to stay on, kept my nerve steady. These were days of long walks and deep thoughts; I was suffering from withdrawal, and finding my feet, but the weather throughout was glorious, and I had some close friends to talk to, who gave me the courage to tackle what seemed like a daunting task. And beneath it all I knew I had my father's backing.

One of the delights of the Slane estate from a sportsman's point of view is the shoot, which is now greatly enhanced by the addition of Beau Parc. It provides some of the most spectacular driven-pheasant shooting in Ireland, with the river beats in particular testing the finest shots. The Maiden's Rock is perhaps the jewel in the crown. According to local legend it is so named because a maiden, having been jilted by her lover, cast herself off the top of the precipice into the waters of the Boyne. The majority of the guns are placed on the far side of the river and the pheasants are driven over the edge of the Rock, where they come sailing across the river at considerable height and speed. On impact many plunge into the Boyne, to be retrieved by energetic and enthusiastic dogs, directed by their proud and anxious handlers, conscious of the fact that their performance is being scrutinized by an attentive audience. It has a special drama and ritual which cannot fail to impress all who see it.

Shooting in the seventies and eighties has become a very expensive business. In the fities and sixties my father covered much of the expense himself, and then decided to share the expense with two friends. The first of these was Tony Riddell-Martin, a racehorse trainer, who at one stage had a racing stables at Slane. He lived at nearby Ardmulchan Castle, an extraordinary red-brick building dating from the end of the last century, which smacks of the confidence peculiar to Scottish industrialists at the time. Tony was a friend and confidant of my father, and his advice, understanding and friendship were invaluable to me during the early years at Slane. For us as children he had a sort of hero status. He knew all about horses, wine, women and song, and he was nicknamed 'the hoary Greek God', because he quite definitely had the looks of a film-star, bearing a striking resemblance to Robert Taylor. He is still remembered with deep affection by all whose lives he enriched, and I count myself very lucky to have known him. The second partner in the shoot was Major Victor McCalmont, scion of the well-known bloodstock and racing family from Mount Juliet in County Kilkenny, a

wonderful property, originally belonging to the Earls of Carrick, set along the banks of the Nore. Victor is my father's first cousin. His mother, Lady Helen McCalmont, and my grandfather Conyngham were brother and sister. So complex are the interwoven intricacies of the history of the family that when I inherited Beau Parc House from Sir Oliver Lambart in 1986, I found an old photograph stuck into the side of a mirror in his mother's bedroom, like something in a time warp. It was taken on the front steps of the Castle on the morning of Helen McCalmont's wedding. She is on the arm of her brother, my Great-Uncle Victor, the fifth Marquess Conyngham. There is a wide-eyed little page boy in a tartan kilt. It is the young Sir Oliver Lambart. The McCalmonts stayed at Mount Juliet until 1987, when escalating costs and taxation forced them to sell the estate. Their hospitality was legendary, and they kept an amazing establishment, which over the years made a substantial contribution to the local economy in Kilkenny.

Eventually my father had to abandon this sort of arrangement between old friends, and he put together a number of syndicates. After his return to Ireland he made an arrangement with the McGrath brothers, Joe, Seamus and Paddy, of Waterford Glass fame. They were in every sense Ireland's first family, and by any definition riding on a wave of economic success. They descended regularly every Monday through-out the shooting season in a fleet of Range Rovers. The champagne flowed and the crack was mighty. The McGraths continued with the shoot for some years after my return, and it was then taken up by a new syndicate headed by Declan Lennon, a leading light in the Dublin insurance brokers, Coyle Hamilton. To me the real pleasure of this continuing arrangement is the family shoot, still held once a year, which is a very special gathering of friends, and enables me to entertain in a manner somewhat reminiscent of bygone years.

During the first winter at Slane we were prevailed upon to try an experiment. We agreed to have a group of American industrialists to stay as paying guests for one of the shoot's 'sold days'. It was an experience that we were unlikely to forget. It was an all-male group, mainly from Cleveland, Ohio. The manner of their arrival filled me with trepidation. A large black limousine hired to transport the group drew up at the Castle door. Out stepped a large man holding a half-full pint glass of Guinness. My heart sank. There was nothing for it but to get things straight immediately. I lined the lot of them up in the hall and delivered a short speech on how the Castle was still very much a private

home, and I would be grateful if they could treat it as such, and that I was also anxious that they should be careful not to damage any of the valuable antiques. Juliet and I exchanged nervous glances at each other as one gentleman in particular swayed slowly on his feet. Hoping that the message had penetrated the haze, I then offered to carry one of the party's bags up to his bedroom. As I deposited it in his room, and was about to depart, he seized me and shoved a pound note into my hand. 'Buy something for your wife,' he slurred. I felt a little dazed. His face the next morning when he arrived in the dining room to see me sitting at the head of the breakfast table, playing the laird of the manor, was a picture to see. Little did any of the assembled company know that Juliet and I had struggled out of bed at 6.30 a.m. to clean their boots and prepare their breakfast. Upstairs had definitely arrived downstairs, and we wondered if this was to be the rest of our life: our privacy shattered by carousing industrialists.

There is another aspect to this visit which I am almost reluctant to tell, because it relates to an unidentified flying object, and such yarns are normally treated with deep scepticism by all who come across them. A few years previously, Juliet and I had been staying the weekend at her mother's house on Paul Getty's estate, Sutton Place. We had invited two very close friends to stay, Marcus and Kate Agius. (Marcus is now a distinguished figure in the City of London, working for Lazards, and Kate has established a reputation for herself as a dealer in Old Master drawings.) It was a wonderful warm summer's evening, and we decided that it would be romantic to dine outside. While we were having dinner, the most extraordinary thing happened. Suddenly there seemed to be an oppressive silence, as if all sound was being sucked into a black hole. We looked towards the sky. Travelling from one horizon to the other was what appeared to be a huge circular object with an array of lights beneath it. It seemed to move in a zig-zag fashion right across the sky, as if scanning all below. Then it was gone. Well, how do you deal with that? We looked at each other in disbelief. 'Did you see that?' Marcus and I decided that we were definitely sane and sober, and yes, we had seen something, even if we were at a loss to know exactly what it was. We decided that this had to be put on record, so we looked up Northolt Royal Air Force base in the telephone directory, and asked for the duty officer. I stated that I wished to report an unidentified flying object, and would he please record it in his log. The guy obviously thought I was a nutter and asked me to give my name. I said that I thought this was

irrelevant and would he simply log the call. We then ended the conversation, as I had the clear impression that we were getting absolutely nowhere. To this day I have no way of knowing whether there is any official record of an unidentified flying object being sighted over Guildford in Surrey, but we all saw something for which there did not seem to be a normal explanation. This brings me back to breakfast with our group of visiting American industrialists. For some strange reason, I felt a strong compulsion to tell this story. One individual in particular showed an avid interest in my account and questioned me closely on the details of the sighting. Then, to my amazement, he said he had experienced exactly the same thing in Arizona in the United States, and even more startling, we calculated that it was quite possibly the same day of the same year. Close encounter near Guildford, close encounter in Arizona, meeting in Slane.

By December the restaurant was up and running. Those were boom times. It was in 1977 that Fianna Fail returned to power on the back of an election manifesto that seemed to imply that Christmas was going to come 365 days a year. If the opening party was entertaining, the opening night was something else. We were fully booked thanks to the loyal support of enthusiastic friends. We were all in a state of anxiety, Tommy gearing up in the kitchen, Juliet and I in the dining room. In the early days I acted as head waiter and general psychiatrist. The customers had all put on black tie and evening dresses to add a sense of occasion. I lit the fire, and the whole dining room filled with smoke. My brother Patrick had offered his services to assist with the drinks. Now, brother Patrick is, to put it mildly, a little unconventional. A good example of his flamboyant behaviour was his first appearance in the British tabloid press in an article in the *News of the World* entitled 'Lord C's guided tour of sin goes a sight too far'. The article described Patrick's efforts to compile 'a good vice guide' to Edinburgh, and he was quoted as saying, 'Edinburgh people are said to be so snotty that they only make love with their coats on, but I discovered more people who are willing to take them off than I could possibly imagine. It's a place, as an old saying goes, where it's all fur coats and nae knickers.' He ended the article by saying, 'I was doing my research quietly, but now the truth is out, I suppose I'll have to tell my father about it.' He was to display a similar disregard for convention on the opening night.

This brings me to one of the more ludicrous aspects of the restaurant

business in the Republic: the archaic licensing laws. Unique among Western European countries, Irish restaurants, unless they happen to have a full publican's licence, are only allowed to serve wine. It seems blatantly absurd that many Irish restaurants are therefore deprived of the opportunity to serve Guinness or Irish whiskey. Over the years I have had to explain this ridiculous position to puzzled tourists. Governments, until very recently, have failed to rectify this situation despite numerous approaches from representatives of the Irish Restaurant Owners' Association. We now have a full licence, because eventually we could no longer function without one. I had to acquire two publican's licences, then extinguish them, and then apply to the court for a new licence. If that sounds a bit confusing, it is. In this area the law is quite simply an ass. In any event, in the early days we only had a wine licence and occasionally, like most similar establishments in the country, we turned a blind eye to the law. We did exactly this on the opening night, which brings me back to brother Patrick. He was dispatched to take a drinks order from table number one. So far, so good. Then he returned to the table with the drinks. Amongst the assembled beverages was a gin and tonic and a vodka and tonic, mixers already in the glass. Then Patrick displayed his unique approach to life. Unsure which drink was which, he placed the tray on the table. Raising one glass to his lips, he said, 'Gin and tonic,' and passed it to the dumbfounded customer. Then to add flourish to his actions he applied the same treatment to the vodka. Thereafter we decided that Patrick was best suited to the more theatrical aspects of the Castle.

I sometimes feel that working in restaurants should be considered as essential a part of higher education as attending university, for there is no question that you learn a great deal about human nature. Fill people with a little wine and smile sweetly, and you'll often get their life history, which can be a good or bad thing, depending on the life. However, a good restaurateur sometimes fulfils the role of the local shrink. All-seeing, all-hearing, but in many instances not allowed to tell. After all, many people choose to dine with those they are not supposed to, and, Catholic country or not, we are all human underneath. There is no question about it, the early days were 'crack', especially when I was still in a position to be protected by anonymity. Lord Mount Charles was a name but not a face; I had a freer rein.

In the early days we needed to generate publicity, an essential but often wearing aspect of running a stately home. We had the excellent

good fortune to engage the services of Lean Scully, who has been a close friend and adviser ever since. Lean's efforts had their lighter moments. She would often bring potential customers or journalists down to the Castle to dine, in the hope of enrapturing them with our skills and the ambience. One evening in particular sticks in my mind. Lean was entertaining a very well-connected lady journalist, and had asked me to join them for dinner. Because I was under pressure I had declined, but promised to join them for a drink. By the time I sat down at the table the lady journalist was well away, and I wasn't exactly sure what to expect. It wasn't long before I felt a hand on my knee, and when it started to move upwards I stared at Lean in desperation. The expression on her face told me she thought this was a 'howl'. I quickly changed position.

Sometimes things got really out of control, and the reason was almost invariably associated with drink. One particular evening leaps to mind. Two gentlemen, with strong Northern accents, arrived in the restaurant, obviously well lubricated. They had endured an arduous day's entertainment at Navan Races and had obviously pulled off a betting coup. The money was practically falling out of their pockets. Initially we were somewhat reluctant to accept their custom, but they pleaded that they were famished, and what they really wanted was a good feed. I suppose on reflection you could interpret that as either fine food, or blotting paper. Rather foolishly, we let them in. Everything went smoothly for a while, until they started harassing two women at the next table. On the evening in question my cousin and close friend, Nicholas Nicholson, was helping in the restaurant. In those days he tended to be a semi-permanent resident in the Castle, where he came to escape from the isolation of his property in County Mayo. He was keeping a watchful eye on events as they unfolded. At this stage I was engaged in conversation with Gerry McGuinness, Chairman of the *Sunday World*, Ireland's leading tabloid. Then something good happened. They asked for their bill, which they discharged from their wad of dirty notes. Everybody heaved a sigh of relief, but then they decided they wanted just one more bottle. Nick came over and asked me what he should do, as things were getting a little sour. We opted for pacification, a bad idea. The bottle didn't last long. They got up to leave. By now, Nick's patience was wearing thin. He asked them to pay for the last bottle. He was met with a blank refusal, and a lot of effing and blinding. I decided this called for diplomacy and headed for the table. 'Gentlemen, you may have the bottle of wine with the compliments of the house.' One of them looked

at me in a very aggressive manner. 'I suppose our money's not good enough for the likes of you.' A classic no-win predicament. It was a step-outside situation. Nick and myself, accompanied by Gerry McGuinness, who had gallantly offered to assist, retired to the courtyard with these two drunks. Fists started flying, but fortunately they were both so smashed that their chances of landing an effective punch were fairly minimal. In any event, thanks to Gerry's support there were three of us and two of them. Outnumbered, they departed. The following day I was sitting in my car in Dublin at the traffic lights between Trinity College and the Bank of Ireland. A car drew up beside me, and to my horror next to me were these two characters. When the lights turned green I hit the pedal, and I am relieved to say I haven't seen them since.

The best restaurants are traditionally very much family affairs, and over the years many friends and relations have helped us out, from brothers to cousins, to all kinds of sundry characters. On one occasion we even managed to get my father on the job. Full of enthusiasm he volunteered for service behind the bar. We were going out to dinner and left him in charge. Daddy was a real hit, especially with a group of visiting Americans, who were enthralled to be looked after by a real live Marquess. When we returned, he appeared a little wobbly on his feet. In our absence, prompted by an order from the Americans, he had applied his talents to making Irish coffee. Now the trick with Irish coffee is making the cream float, and unfortunately his success ratio wasn't very high. However, Daddy hates to see things go to waste. If they weren't good enough for the customer, they were good enough for him, and he did the only sensible thing. The ones not served to the customers went down his throat. He was a little green the next day, but I'm sure Slane Castle still holds fond memories for a group of American visitors.

3

The Movies

When I was young we were taken to the cinema to see a movie called *Captain Lightfoot*, starring Rock Hudson and Barbara Rush. It was a swash-buckling adventure, typical of a genre in the fifties. There was a very special reason for seeing the film, as much of it was shot at Slane and my parents played a small part. They were held up by Rock Hudson in a coach. My parents up in lights, with full billing; now that was quite something. I was really looking forward to seeing it, but then the unexpected happened. Mummy appeared and she looked smashing, but then she opened her mouth and it wasn't her voice. I screamed with consternation and then sank into my seat with embarrassment. They had dubbed Mummy's voice and she had forgotten to tell me. Nothing in the movies is quite what it seems. Rock Hudson, the heart-throb of the fifties, was really a homosexual who was to die years later ravaged by AIDS. The ballroom became a bedroom and the Castle a prison. For a small child this was all a wonder; movies were fun.

By early 1977, we reckoned that it would be a good idea to go into the location business. I approached the Managing Director of the National Film Studios of Ireland, Sheamus Smith, and invited him to bring a party down to the restaurant. By the end of the year we had two movies. The first was with a German company, called Polyphon Productions, who had chosen Ireland to shoot a version of a P. G. Wodehouse novel for a television station based in Munich. That seemed pretty original, the quintessential Englishman played in German, shot in Ireland. The arrangements were tied up with Grania Shannon, then location manager for National Film Studios. They were to pay the princely sum of £150 a day for the location, and all catering services on top. It seemed like a good deal. For those of you tempted by the idea of using your home as a location, there are a few rules. Be prepared for a total invasion; these people take over, they are there to do a job, and your

privacy goes out of the window. Patience is a virtue; there is endless hanging around waiting for everything to be ready for 'the take'. The people in the prop department operate like ferrets, requests for 'Do you have . . .?' come fast and furious, cables run everywhere, people are everywhere, contractual arrangements for damage and insurance need to be tight. If you can keep your head through all of this, it can be very entertaining, and you meet some marvellous people.

Polyphon had hired a famous German actor called Heinz Ruhmann to play the lead. We were told that he was a sort of German Laurence Olivier. Lacking expertise in contemporary German theatre or films, we were not enormously impressed by this. However, he was a delightful old gentleman, possessing that wonderful aura that actors acquire who have been admired by generations. The production team was seriously good news, in particular the cameraman Peter Hassenstein, and his dramatic-looking red-haired English girlfriend, Kirsty Malcolm, and a lovely lady in charge of make-up called Beatrice Jarke, whose soft brown eyes made one's heart race. In every sense they enriched our lives.

One of the kicks of the movies shot at Slane were the cameo parts I have played, and the Polyphon Production was no exception. In fact the German crew collared quite a few of us for minor roles. Old Tom FitzHerbert got a small part, which gave him a thrill, and an old family friend, Jean McCarthy, who was living in a house on the estate at the time, played an 'elegant lady', which everybody thought was very appropriate, because that's exactly what she is. She was chauffeured to the front door by her son, Anthony, in his old 1947 Daimler, also hired out for the occasion. Juliet and I were offered thoroughly suitable parts as a waiter and waitress in a restaurant scene. All too familiar. I had to learn my lines in German. Subsequently when the film was screened on German television, we got a hysterical telephone call from Alexander's godmother, Didi Colville, who was living in The Hague, working as a nanny for the Dutch Royal Family. She asked me if I knew that I had a double living in Munich. Little did she know that she was seeing the real thing.

While the filming was going on, Peter Hassenstein and Kirsty Malcolm helped us through a terrible experience. Several months earlier, we had given a job in the restaurant to Roy Robinson, an old friend of my mother, who had fallen on very hard times. To be honest, I could never quite work out what Roy got up to when he was flying high, but

he had all the trappings: chauffeur-driven cars, large house outside London, mysterious trips to the Far East. He was extremely generous and entertained lavishly, and then suddenly everything went wallop. We took him on as a sort of wine waiter-cum-*maître d'h*. Unfortunately, after years of high living Roy found it almost impossible to come to terms with his changed circumstances. He tried his best, but the whole process was painful to watch, and his behaviour was such that he was causing considerable disruption. And then something awful happened. Roy had held on to his dreams and was intent on pursuing a scheme to revive his fortunes. He had gone off to Dublin for the day. The restaurant was extremely busy that evening, and by opening time there was no sign of Roy. I was ranting and raving, as we were short-staffed and, on top of our normal custom, we had a lot of the German film crew booked in. An hour or so later, when the chaos was over, there was still no sign of Roy, and I retired to a corner table with a bottle of wine to join Peter Hassenstein and Kirsty Malcolm. Then two members of the Gardai arrived, and asked to see me. Roy had been killed in a head-on collision on the Slane–Dublin road, and they had to take me to the morgue in Navan Hospital to identify the body. Peter got me a brandy, which I swallowed in one. Dazed, confused, feeling guilty about thinking Roy had been shirking, appalled at the thought of having to look at the corpse, I was driven by the Guards into Navan. All I can remember was that his face seemed very flat. They brought me back to the Castle, and we talked late into the night. Peter and Kirsty were marvellous. Roy was buried in County Mayo in the rain. The music at the service was provided by an old gramophone record. His son turned up for the service. I haven't heard from him since.

1977 was also the year of *The Flying Dragon*, and another lesson learnt about the location business. Film finances can often be very precarious, and especially if they are being used as a tax shelter rather than a straightforward investment. It is very wise to make sure that you get your money up front. This was certainly true of *The Flying Dragon*. It turned out to be a Gothic horror story of dubious merit. Throughout the production, there were rumours that they were running out of money, but somehow they struggled on and eventually managed to complete the film. On this occasion the invasion was on a much larger scale: on the fourth day there were about 150 people on location for a masked ball scene. My brother Patrick managed to secure a part as an extra but was enraged to discover that he had to wear a costume and a mask, and thus

would be totally unrecognizable. They also turned the ballroom into a casino and I was approached to play the part of a gigolo, which caused considerable amusement to all, especially as this entailed walking into the ballroom escorting an old lady, who was in reality a man in charge of the wardrobe. The most amusing episode was a side-show to all this. *The Flying Dragon* was being made in the middle of the shooting season, and as part of the arrangement with the McGraths, I retained a gun at each shoot. Being anxious to avoid entirely losing my day's shooting, but committed to playing the gigolo in this scene, it seemed only sensible to combine the two roles. The guns were greeted by the astonishing sight of the lord of the manor arriving to shoot the last drive before lunch, plastered with make-up and decked out in eighteenth-century dress. Joe McGrath's face was a picture to behold.

The following year brought a spate of activity. We were first approached by Tara Productions, one of whose directors was Teddy Donahue, an enterprising American who then owned Dowdstown Stud, just outside Maynooth in County Kildare. Teddy's daughter married one of my oldest friends, Anthony McCarthy, and their daughter Miranda is my god-daughter. Anthony had chauffeured his mother for a scene in the Polyphon production the previous year and knew we were only too happy to provide locations. Teddy's fellow directors were Morgan O'Sullivan and the internationally renowned author Frederick Forsyth. They were shooting a pilot for American television called *An Eye for an Eye*. This time the ballroom went through yet another metamorphosis, and was turned into a multi-millionaire's office. The film starred Nigel Davenport and Rod Taylor. We met Freddie Forsyth on a few occasions when he was living in Ireland, enjoying the tax holiday granted to writers and artists. He must have been impressed by the Castle for when he was writing *The Devil's Alternative* he rang me up and asked me whether he could weave Slane Castle and ourselves into his unique form of faction. He explained that there was no money in it, but that the publicity wouldn't do me any harm. I readily consented. The Earl and Countess of Mount Charles have the distinction of appearing in a work of fiction. The Castle was used for a meeting between the US Secretary of State and the Russian Foreign Minister. In the book, we were dispatched to the west of Ireland for a holiday.

April of that year brought us our first business with RTE, the Irish National Television station, and we had the privilege of playing host to Ireland's then leading soap opera, *The Riordans*, created and written by

Wesley Burrowes. On this occasion the ballroom reverted to normal. It provided the setting for 'The Council Dance' which was to be graced by the presence of 'Tom, Mary, Benjy, Maggie and Minnie', characters as familiar to Irish audiences as the characters in *Coronation Street* are to the British. Whether my ancestors would have felt that this was in keeping with the dignity of the building I shall never know, but as far as we were concerned, this was very much the arrival of contemporary Ireland at the Castle. It has always been my view that historic buildings like Slane must remain relevant to the community at large to survive. In the eighteenth century they were centres of the arts, culture and fashion. They had an energy and vitality often missing today. There is nothing more depressing than living in an atmosphere of decaying splendour. It is often difficult to balance economic considerations against the aesthetic integrity of the building and its identity as a family home. However, over the last twelve years walking this tightrope has been essential in preserving the Castle, and introducing new forms of activity.

After rural soap opera, we moved into the big league. We acted as a location for a major feature film, *The First Great Train Robbery*, a joint production between Dino de Laurentiis and John Foreman. The movie was directed by Michael Crichton, who also wrote the screenplay and the novel upon which the film was based. He had already established a name for himself with two movies: *Westworld*, a futuristic film about robots taking over in a fantasy vacation resort; and *Coma*, a gripping thriller revolving around the illicit trafficking of human organs. Crichton has an MD from the Harvard Medical School, and was a Post-Doctorate Fellow at the Salk Institute for Biological Studies at La Jolla in California. In 1969, after graduating in medicine, his first novel under his own name, *The Andromeda Strain*, was thirty weeks on the *New York Times* best-seller list. The good doctor was also 6 ft 10 ins. You couldn't miss him on the set. To be blunt he had quite a presence. The director of photography was the legendary Geoffrey Unsworth, one of Britain's leading cinematographers. Geoffrey had been awarded an Oscar for his work on *Cabaret* in 1972; he had also received awards for *2001* and *A Bridge Too Far*. Despite his enormous achievements, he was appealingly modest and a delight to converse with, and was enormously popular with cast and crew.

John Foreman, the producer, was a suave, entertaining and engaging character. Michael Crichton, despite his intellectual prowess, appeared rather cold and humourless, and was not universally popular. The real

appeal of this movie was not the management but the cast. They were a truly wonderful bunch. The film starred Sean Connery, Donald Sutherland and the delectable Lesley-Anne Down, ably assisted by Wayne Sleep and Michael Elphick.

Hollywood had taken over the Castle.

> Ireland's beautiful Slane Castle, standing strikingly on an eminence overlooking the river Boyne, in a picturesque natural landscape, is one of the principal attractions of County Meath. Its chief claim to fame is that Lady Conyngham, first Marchioness, was the mistress of George IV of England, and the Castle boasts a portrait of her by Sir Thomas Lawrence, as well as a Lawrence likeness of the Monarch, who visited the Castle in 1821. During a week in the lush Spring of May, the Castle has played host to another kind of royalty – the cinema world, for Sean Connery, Donald Sutherland and Lesley-Anne Down, have filmed in several of its richly appointed rooms, scenes from Michael Crichton's period thriller *The First Great Train Robbery*, a John Foreman Production for Dino de Laurentiis–Starling Productions, which United Artists will distribute world-wide.

The budget for the movie was $7 million.

Celluloid royalty or not, this was certainly spring fever. Sean Connery, in his role as James Bond, was the suave, disarming hero, remembered for tripping through the escapist world of international espionage, with the comfortable knowledge that the bad people were really bad, and the good people were really good. Sophistication could be defined by the guy who delivers the box of Black Magic and judges the temperature of a Martini or a fine bottle of claret. Wonderful escapism. In my own book, life has always been varying shades of grey with flashes of colour. Meeting movie stars is always on several levels, the roles they have played and the real person you encounter, although, without doubt, this intermingling often exists also within the heads of the stars themselves. Those who play hell-raisers are often hell-raisers in real life.

The most striking thing about Connery is that he is such an extraordinarily nice man, who takes his profession seriously and is very conscious of the benefits that have accrued to him from his acting. Modesty is not quite the right word, but he has that air of confidence that allows him to project modesty.

[43]

Donald Sutherland was a different kettle of fish: funny, intelligent, but seemingly very uptight. While he was staying at the Castle during the filming, I was woken up early one morning by the sound of the gravel being decisively crunched outside the front of the house. Leaning out of the window I saw Donald pacing up and down, reciting his lines and getting himself into the part. This actually struck me as rather comic at the time, because although I am always a deep admirer of the consummate professional, the attention he was lavishing on the movie seemed a bit overboard. *The First Great Train Robbery* wasn't quite *Klute* or *Don't Look Now*. However, wherever the gig, be it Madison Square Gardens or The Baggot Inn, give it the treatment. Donald Sutherland is an original. He wrote to me after he left:

> I'm sorry I haven't communicated with you sooner, but I was . . . whisked off to some wretched Victorian . . . hovel, swishing with nuns, freezing with cold, filled to the brim with pneumonia . . . I'm back now, antibiotic'd into deliriums, 3 rabid bacteria on the run, lawyers in havoc and I am settled quite peacefully in this too long sentence so I'll get out of it by wishing you and your charming wife well. Donald S.

I remember him with considerable affection.

Lesley-Anne Down was something else altogether. Nobody could fail to have been entranced by her portrayal of Georgina in the highly successful television series *Upstairs, Downstairs*. She is quite simply an amazingly good-looking woman, gifted, but with an alarming vitality, with which she tends to wind up those who surround her; and with laughing eyes and a voice that would warm the coldest heart. At the time it struck me as particularly funny that the description of Lesley-Anne in the *Press Information Manual* issued by the unit publicist ended with the words: 'Miss Down is single and makes her home where her work is.' In this instance I can say that if everybody who stayed at the Castle was as uninhibited and entertaining as Lesley-Anne, life during the last twelve years would have been an even more colourful tapestry. Two evenings with Lesley-Anne remain etched in the annals of the last twelve years. At dinner she developed an almost instantaneous passion for Irish Mist, a drink fine in small quantities but very sickly in volume. We all adopted the philosophy of 'if you can't beat them, join them'. Irish Mist has lost its attraction ever since. Lesley-Anne bubbled and fizzed and was disarmingly frank about her life. Such honesty was

deeply refreshing and part of her charm. It is also the kind of honesty that deserves privacy. As the evening drew on Lesley-Anne's vitality became almost exhausting, but the lady was irrepressible. Two images remain in my mind. The first is of Lesley-Anne joyfully riding Alexander's toy tractor down the bedroom corridor. The second is not so funny. An over-enthusiastic guest decided to visit Lesley-Anne in her slumbers. Juliet and I were awoken by the disturbance. Suffice it to say that it took the combined efforts of my brother Patrick and myself to deal with him. Lesley-Anne displayed her usual good humour. The following day she gracefully accepted the gentleman's apology.

Lesley-Anne also had a wicked sense of humour. She was based in the Shelbourne Hotel in Dublin. One evening during the filming she had been invited out to dinner by a senior executive of the National Film Studios of Ireland. He arrived at the Shelbourne to collect Lesley-Anne and came to her suite. What he didn't know was that Lesley-Anne had been entertaining Juliet and myself, and she made us hide in a cupboard while she spun some yarn why she couldn't join him for dinner. How the two of us, hiding in the cupboard, restrained ourselves while this charade unfolded is beyond me. Lesley-Anne thoroughly enjoyed camping the whole scene up. After he left, we consumed several bottles of champagne. Hours later Lesley-Anne joined his dinner party at the Mirabeau in Dun Laoghaire, with the two of us in tow. I think by that time we were all perhaps a little incoherent. Nobody who was at Slane during the filming of *The First Great Train Robbery* will ever forget her. She is quite simply unique.

The disruption inflicted upon us by *The First Great Train Robbery* was substantial. The drawing room was turned into a bedroom, the dining room into a room in a London house, and the ballroom was relegated to providing the location for a brothel. My occasional apprehension was diplomatically smoothed over by John Foreman, the producer. Anxiety about your possessions or the fabric of your house during filming can sometimes be a fraught experience. In the end it is a question of being calm, and of remaining vigilant.

Following *The First Great Train Robbery*, we were used as a location for a war movie called *The Big Red One*, and thankfully in this instance all the shooting was confined to the grounds. The director was a classic cigar-smoking type around whose war experiences the film revolved, and the lead was played by the legendary Lee Marvin, the ultimate macho hero. Lee Marvin seemed almost a caricature of his movie roles, but then my

[45]

memories of our discussions are a little hazy, in some cases blurred by what we were pouring down our throats.

As the seventies drew to a close and the eighties commenced, there was a definite drop in the number of films being shot in Ireland. The Castle was used by RTE for a dramatized documentary on Lady Gregory starring Siobhan McKenna, and by American television for the shooting of some of the scenes of a historical series called *The Mannions of America*, which was a sort of Irish version of *Roots*. I played a cameo role as a British cavalry officer, and suffered the indignity of being hijacked and semi-stripped by Pierce Brosnan of *Remington Steele* fame.

The Mannions was shot at Slane towards the end of 1980, and it became increasingly obvious that the spate of activity during the preceding few years was grinding to a halt. It seemed essential that we should generate other activities to continue to produce revenue for the Castle, and to bring vitality into the place. I had been watching developments at Knebworth House in England. In 1976 they had played host to The Rolling Stones. Desmond Guinness had let The Police play at Leixlip Castle, and Slane has one of the finest natural amphitheatres that I have ever cast eyes on. There seemed only one way to go.

4

The Gavel and the Land

In 1976 my father was confronted by the classic problem faced by landed Anglo-Irish families: land-rich and cash-poor, they were all too vulnerable to the ravages of taxation. When he was forced to move to the Isle of Man, he did at least have the benefit of operating in a less hostile environment. During this period, and on many occasions since, we have both realized that for the family to survive into the next century we must adopt some radical tactics, and be very balanced about mixing tradition, pride, social responsibility and economic survival. Above all else, hand in hand with trying to restore the health of the family finances went our overriding commitment to preserve Slane, and to secure its future for the next generation. While families rise and fall, and beautiful buildings must be preserved for their own intrinsic qualities, it has always been my view that they are usually best kept in the hands of the families that built them. However, for a family without resources this may prove an impossibility, and neither of us wished to fulfil the role of undertaker to the Conynghams at Slane, so a wider approach was necessary.

In 1977, almost exactly a year after we had returned to Slane, my father asked me to advise the family trust, which was at the time starved of cash resources. I readily accepted for two reasons. Firstly, it was clear that decisive action had to be taken, and secondly, it was an opportunity to spread my wings in other fields. Often the problem of wrestling with Slane can become so suffocating that oxygen from a different source is required. At the time I was still working very actively for Sotheby's, and was fast learning the intricacies of the international art market. Principally there were two types of assets in the family trust, the property in Kent, and works of art. The property in Kent was at least producing an income. Works of art, locked away in a vault, serve no purpose other than to commune with the darkness that engulfs them. This brings me

[47]

back to King George IV, who had the extraordinary good taste to choose the first Marchioness Conyngham as his last mistress. It has often struck me that there is little point in being the first mistress of a king, but every point in being the last, as you are the most likely beneficiary of his generosity. Lady Conyngham was extraordinarily proficient at getting the King to display this most noble of characteristics. This takes me directly to the question of six bronze plaques. During the French Revolution in 1789, an equestrian statue of Louis XIV, designed by Desjardins, was destroyed. It had stood in the Place des Victoires in Paris. Fortunately several bronze plaques, designed by Mignard, executed in relief and depicting scenes from the life of Louis XIV, were saved. They then subsequently appeared on the art market. The Prince Regent, always anxious to acquire works of art, had an agent in Paris who, I have been told, was also a chef of some considerable distinction. George IV was wont to satisfy both the eye and the stomach. The agent acquired six of these bronzes on the Prince Regent's behalf and they were sent to Windsor Castle. In 1826 they were dispatched from Windsor to Slane Castle as a gift from King George IV to Lady Conyngham. The family was, as always, grateful for his generosity. A further five surfaced, and eventually found their way to the Louvre. Early this century, Queen Mary tried to apply pressure on the family to give them back to the Royal Family. My great-grandmother wisely side-stepped such approaches. Following this, representations were made by the French government and the Louvre. All were resisted. When we were children the bronze plaques were in the main hall of the Castle but they were not conducive to a sense of warmth and my great-grandmother hung tapestries over them. The hall is now adorned with pictures much more sympathetic to its design and purpose. In 1976 when I returned to Slane, the plaques were gone, hidden away and unadmired. It seemed a logical conclusion that they should be sold, but nothing is ever so simple in the art market, most particularly with items of such rarity, which in many circumstances appeal to only a limited number of purchasers. Once the trust had made the decision to sell, the right strategy had to be adopted, and the best market found. There were essentially two paths that could be followed. The trust could try to arrange a private sale, or take the option of a public auction. The ground had to be very carefully considered. Initially I trod very warily. The first estimated values were in the £300,000 to £500,000 range, but my instincts told me that this was not enough. Then I had a stroke of luck. I received an approach from an

international art dealer, who had got a whiff that the plaques might be on the market. His intent was to acquire the bronzes and then sell them to the British Rail Pension Fund, who were very active in the art market at the time. The dealer concerned is a very shrewd operator, and all my defence mechanisms instinctively leapt into action. He knew the game and I was only a novice, but he was to fulfil a very important function. He would provide a marker to try and establish their true value. He was allowed to play out his role, but I felt so uncomfortable with him that he was never really at the races, partly a decision based on commercial judgement, and partly a gut feeling. He served his purpose. In the end, I advised the trust to opt for public auction. I had an inside track as an employee of Sotheby's, and in those days it was run by a past master of intrigue and salesmanship, the extraordinary Peter Wilson. It always struck me as rather strange that he was never given a knighthood.

Peter Wilson was a tall, imposing figure whose smile was a mask behind which hid a thousand faces. He had exquisite taste, and extensive knowlege. He was a showman and a superb auctioneer. To him, clients and potential clients had to be mentally massaged and embalmed. In truth, I felt that he had a sort of contempt for many of those in possession of some of the world's greatest art treasures. It was as if he judged that they belonged to them by accident, and they were not gifted with the intellect to appreciate them. However, nobody recognized more readily the need to comfort, flatter and cajole a client. He liked to pull the strings. A written instruction is a good illustration: 'The whole story is very long and complicated and I will tell you about it when we meet. In the meanwhile, just be friendly if you see her or she gets in touch with you but there is no need for action.'

He would make the moves, and he had the ability to unnerve others, to such an extent that you sometimes had the sensation that you were a mere pawn in his machinations. I remember distinctly sitting in a car parked by St Stephen's Green in Dublin, discussing a particular problem. Quite suddenly he switched the conversation to the price of gold. Was it going up or down? Was he buying or selling? The moment passed and he moved on to something completely different. He had many things on his mind.

It seemed sensible to enlist his services, and as a defence I had at least the good fortune that the approach from the international art dealer had given me a marker as to value. The negotiations began. The first crucial question was location. London is very much the centre of the

international art market, although in recent years New York has given it a hell of a run for its money. Initially London seemed a sensible option. However, it was essential to entice French bidders to the auction to help attain the target figure, and after all, the plaques had originally been round the base of a statue in the Place des Victoires in Paris. We chose Monte Carlo – a provocative venue. It was as near to French soil as one could get. However, the only aspect that bothered me was that Monte Carlo induced images of casinos and gambling, but this was counter-balanced by having a name such as Mount Charles: what could possibly be more appropriate? To add the final touch, the date chosen for the sale was 24 May 1980, the day after my birthday, which was a good omen. I have always been a touch superstitious.

The sale itself was murder. My cousin, Nicholas Nicholson, who had taken over from me as Sotheby's representative in Ireland, accompanied me on the trip. His advice was invaluable, and above all else it helped keep steel in my back. Between the two of us, we reckoned that we could cope with the circumstances, and above all be prepared for any little surprises that the urbane Peter Wilson might drop on us. The morning of the sale my stomach was churning. I drank copious quantities of milk. Nick Nicholson, as ever, was calm as if in the eye of a storm. It was a good combination. The previous evening we had developed our strategy. In the negotiations with Peter Wilson, Sotheby's were persuaded to accept a reserve of £750,000, and that was the mandate I had from the trust and we were determined not to shift from this. In addition I had managed to extract from Peter Wilson that this was very near 'the price asked to British Rail'. We were going to the limit, but sometimes in life, it is essential to push the boat out with vigour. The risk, of course, is that if the strategy adopted floundered we had queered the pitch for the bronzes for the foreseeable future. They would have to be put in cold storage.

The bronzes were to be sold separately. We decided on a fixed reserve of £125,000 on the first lot. If it exceeded the reserve, the difference between the reserve and the price realized could be used to reduce the reserve on the following lot. This difference between the reserve and the price achieved we termed 'the overage', and it could be used to reduce the reserve on any lot if there was sufficient leeway available. We also decided that the reserve on any one lot could not fall below £100,000, except on the last lot, on which, if there was a sufficient overage available, the reserve would fall to £75,000. It seemed a good plan. We

went to meet Peter Wilson. Then he sprang it on us. He expressed concern that the first lot wasn't going to make its reserve, and asked permission to be allowed to drop it by 10 per cent. That screwed up all our calculations. His face was a mask. We wondered what the hell he was playing at. I decided to take a gamble. 'You can reduce the reserve by 10 per cent on the first lot, but I am increasing the reserve by 10 per cent on the second lot.' He readily agreed. The sale itself was a blur, my stomach was in bits. Nick kept track. The last lot, the least impressive, failed to make its reserve. It was sold after the sale. We had reached our target: the net proceeds after expenses amounted to £750,000. Nick and I hit the town, but we kept well away from the casinos.

The next issue that I asked the trustees to confront was rather more controversial, as it required examining the trust's dependence on agricultural land. Since the mid seventies, it had become increasingly obvious that there were some fundamentally flawed aspects to the Common Agricultural Policy. In Ireland, in particular, land prices were moving to absurd heights, bearing no relation to the real levels of return in farming. The point had been reached where there was a strong element of speculative pressure driving land values in an upward direction. This speculative fuel was readily enhanced by the banks, whose approach bordered on irresponsibility. When land reached prices of between Ir. £3,000 and Ir. £4,000 an acre, its capital value far outstripped its capacity to produce income and something had to give. Those were heady days.

Traditionally, old families do not sell land, unless their backs are against the wall. My philosophy is a variation on this theme. My father's decision to leave Ireland and my decision to return were, in part, deeply rooted in this theory. Despite the ludicrous increase in the value of the land at Slane, and the financial problems that we were confronted with in Ireland, Slane was, as it were, inviolate, and straight commerce was far outweighed by an emotional and spiritual attachment to the place. The trust land in Kent had to be viewed differently. The family's connections with the county were firmly established by the beginning of the nineteenth century. Towards the end of the last century, the size of the estate was comfortably over 9,000 acres, but by the fifties it had been reduced to 2,500 acres. Bifrons House, the family residence, had been pulled down. I was thirteen years of age before I ever visited the area, and although in the intervening years I have developed a strong attachment to that part of Kent, most particularly to the village of

Patrixbourne, near Canterbury, I was in a better position to take a harder view. My father, naturally, had a stronger resistance. The Kent estate had served him well. He had been instrumental in putting it all in order, and the rental income he derived from the property had effectively subsidized the costs of running Slane. The estate was extremely well run by Savills, who amongst other things, specialized in estate management. Everything seemed very soundly based. However, in relation to the capital value of the estate, the yield was comparatively low, and all the land was tenanted which meant that we did not have vacant possession. Underlying this was a sense of nervousness about having so much tied up in inflexible agricultural assets. The first task was to persuade my father, and the trustees, that we needed to develop a broader spread, and that agricultural land was about to peak in value. After extensive discussion, they followed my inclinations. The next question was what to dispose of, because it was merely a matter of reducing the size of the estate, and not one of severing the family's connections with Kent. We decided that we should dispose of the purely agricultural holdings, which had no potential for any other form of activity. This was not greeted with overwhelming enthusiasm by all our advisers at Savills because, viewing the estate in purely agricultural terms, we were proposing to sell a prime holding of 764 acres, which was yielding a rent in 1981 of £23,000 per annum. In a sense it was viewed as the jewel in the crown. My view was somewhat different. In relation to capital value, this meant a return of between 2 and 3 per cent gross, before any consideration of expenses, or landlord's obligations. In addition to this, there was still strong institutional buying of tenanted agricultural land which was underpinning the market. Savills negotiated, and eventually agreed a price of £800,000 in 1982, and simultaneously sold another smaller farm. The trust had reduced its exposure in agricultural land, when prices were near their peak, and had retained the old heart of the estate. It was also now in a position to have a more diverse investment strategy, and pay its bills. Every year I visit Patrixbourne, Bridge and Minster, and see those who have been, and still are, involved in the estate. It is an experience I value very much. It is a part of my family's background I knew very little about as a young child, because for me Slane has always been my home. However, when I walk round the parish churchyard in Patrixbourne, and see almost as many Conynghams buried there as in the churchyard at Slane, it acts as a poignant reminder of the two strands in my background. My father has

a right to a seat in the House of Lords as Baron Minster, of Minster in Kent, a UK peerage granted to the first Marquess Conyngham in 1821, when George IV went on his state visit to Ireland. My children have never so far visited Kent. They are perhaps not yet troubled by what it is like to be referred to as Anglo-Irish. For them, as for me, Slane in County Meath is their true home.

In so many respects the approach to the property in Kent differs radically from my whole attitude to Slane. While I have some empathy with the environment around Patrixbourne and Bridge, and consider-able affection for those involved in the estate, my heart cannot be there. It is England, not Ireland. Bifrons Park, with the old house gone, is divided by the motorway. The Castle, still with all its magic, stands above the river Boyne. One park divided by traffic, another by water. Yet, with a place like Slane, you have to balance your commitment to its soul with a strategy that makes some economic sense. Sometimes this is a difficult tightrope to walk.

When I took over the Slane estate in 1976, there were eleven full-time employees, a farm manager, and a negative financial situation. It was clearly a worrying proposition. Although my father had moder-nized some of the farm buildings, many of them dated from the last century, and were really unsuited to modern agricultural purposes. The woodlands, which comprise a significant proportion of the estate, had been badly neglected since the beginning of the century. My father had started to address this problem by planting two new plantations. When he took over the property, there were three stonemasons employed. When we were children there was an estate carpenter, Tommy Tim-mons. He built us a summerhouse, where we could have picnic lunches. There were always two gardeners. Peaches, apples, figs and grapes, the sweet smell of a greenhouse on a hot summer's day – these things are not possible now, things have changed.

It was difficult in those early days, faced by what seemed daunting problems,to remain unaffected by the ludicrous rise in land values. On paper my wealth seemed to rise by leaps and bounds, and yet we were struggling to keep our heads above water. There were times when I was tempted to cash in some of the property, to keep everything on an even financial keel. However, this would have run counter to my entire philosophy. Owning a property like Slane implies much wider responsi-bilities. It is not yours simply to throw away at the roll of a dice. You are in a very deep sense a custodian for future generations. The burden this

entails is not just restricted to the interests of your family, but covers a far wider context. However, together with a more altruistic approach, you have to try to be practical, because one sentiment cannot survive without the other.

In 1978 Meath County Council wrote to me stating that they required approximately eight acres for the improvement of the national secondary route between Slane and Navan. They had been threatening action for some time, and my father had resisted earlier and more radical proposals, which would have cut an even more unsympathetic swathe through the estate. It was clear that if we failed to come to terms they would proceed with a compulsory purchase order. It was also at a time when land speculation was at fever pitch. They would have to pay the going rate. I adopted a very obstructive stance, and eventually they made an offer of £3,174.23 per acre, which totalled £27,000, and agreed to compensatory works to rectify damage to fences and walls. After months of negotiations we arrived at a price of £30,000. I had extracted something from the land boom. The funds were used to purchase a new combine harvester, and for general farm improvements. It took almost six years to get the County Council to deal with the question of compensatory works, and I also discovered a minor incursion on to my property not included in the original plans. We reached a settlement. Since taking over Slane in 1976 I have sold only one other piece of land. It was known as 'the Clump', and was a small section of a part of the property called the Deer Park, so christened because when we were children it was where the Ward Union Hunt kept its herd of deer. Cement Roadstone, the Irish building group, has a quarry adjoining this property, which they set up after acquiring some land from my father. He in turn had used the funds to buy back the Rock Farm, which is that part of the estate directly across the river Boyne from the Castle. It protects the integrity of the valley. The Rock Farm in turn borders Beau Parc, which I was to inherit from Sir Oliver Lambart in 1986. 'The Clump' was of very marginal use for agricultural purposes, and its sale would give me an opportunity to reduce the financial strain on the property when interest rates showed little sign of abating. There was also another factor. I was convinced that the Coalition government would introduce changes in the capital gains tax structure, which would materially reduce the benefit of such a transaction. Negotiations started in earnest towards the end of 1981. We reached an agreement by mid-November. Cement Roadstone agreed to pay me £85,000 for 16 acres of

land. The government changed the capital gains tax regulations in the following budget. The funds were used to reduce the farm loans. Finance is critical to the running of a place like Slane, and it was clear from the beginning that I must involve myself in a diverse number of activities. Since 1975 I have been an underwriting member of Lloyd's in London, which means in effect that I use my assets to underwrite insurance risks. I currently operate at the maximum level with the exposure spread over forty-eight different syndicates. Security is provided by bank guarantees, which are issued against the value of the land at Slane. There are, of course, risks involved. As a member of Lloyd's you accept the principle of unlimited liability. In the event of a calamity you can theoretically lose the shirt off your back. I take out personal stop-loss insurance, in effect re-insuring myself in the market. It is a method by which I generate additional income. In an economic sense, Slane works twice. In theory the estate is placed at risk. The way I look at it, if there is not a sufficient income to support it, it is also at risk. The funds generated by my first year's underwriting activities as a member of Lloyd's were used to pay for the resurfacing of the drives to the Castle.

Initially I was encouraged to turn to dairy farming in an effort to boost my income. Friends of mine who have operated successfully in this sector stood as fine examples of the enormous cash flow that could be derived from this enterprise. The banks, at this period, were only too delighted to lash out money to finance ventures of this sort. In the last decade I have not been impressed by their wish to plunge farmers into debt, without due regard for the long-term consequences of such action. A sense of nervousness about tying up so much money in inflexible agricultural assets, and a fear of significantly increasing my indebtedness to the banks, served to deter me from becoming a dairy farmer.

In the intervening years there has been a variety of enterprises on the estate, some successful, some not. It occurred to me that it would be an excellent idea to develop the old walled garden into a market-gardening enterprise. The greenhouses were restored, a new solid-fuel boiler was installed to provide heat, and a small water irrigation system rigged up. We were all enthused by the concept of being able to grow our own vegetables for the restaurant. Self-sufficiency is something that appeals to me. Unfortunately, this scheme collapsed. It was simply not an economic proposition. The garden is now a collection of paddocks for young stock, and the greenhouses house only memories. On the farm

we have essentially pursued two different activities, fattening cattle and growing barley. The estate staff has been reduced to five permanent employees, including the farm manager, Gus Doggett. Gussie also nurses our turbine, which has generated electricity from the river for approximately forty years. A significant section of the land at Beau Parc is now let to other farmers and produces a guaranteed income. We try to keep our overheads down, and adopt a flexible approach. Agriculture has taught me patience, and how to take the rough with the smooth. The sight of cattle in the field on a summer's evening soothes even the most troubled mind.

Straight farming is by no means the only activity. We struggle to maintain walls ravaged by time, falling timber and vandalism. There are now nearly four hundred acres of woodland on the estate, which we are slowly trying to reinvigorate. Nine and a half thousand trees were planted in the spring of 1988 – all hardwoods with a strong emphasis on ash, a crop ideally suited to the Irish climate. We have planted cherry, sycamore, beech and oak, trying to escape the dreaded conformity of endless batches of sitka spruce. My children will see these trees grow towards maturity, as the decades roll by. Shortly, there will be a salmon smolt unit sited on the Rock Farm, using a valuable source of ground water, and we still nurture the idea of producing our own mineral water. As the Castle is the centre around which the land revolves, so the land, the river and the trees form the body that surrounds the heart. One cannot exist without the other, and it is all part and parcel of the pull of Slane.

Black Flags and Rock and Roll

It is a disturbing sensation for an Irishman born and bred to be viewed by some as a stranger in his own country. It is deeply insulting to be referred to as a 'West Brit', a 'Prod' or worse. Since 1976 I have been spat at, threatened and abused in the name of nationalism. In July 1981 I received an anonymous letter through the post. It read: 'Irishmen are tortured to death by your British friends your class have an easy ride in Ireland Call off this vulgar Festival your promoting. While brave men are dying you British Toad Militant Tendency Meath.' It was the year the first rock concert was held at Slane. It was also the year of the hunger strike.

Many centuries earlier, St Patrick had lit his paschal fire on the Hill of Slane. It was seen by the High King of Ireland at Tara. St Patrick was summoned to his presence and subsequently converted the High King, and the people of Ireland, to Christianity. One of St Patrick's followers, St Erc, had founded a hermitage which is hidden in the demesne wood along the banks of the Boyne below the Castle. Below the hermitage is a Holy Well. Every 15 August, people from the locality descend to the well to drink the holy water and pray. Every year I solemnly do the same. If by chance we are not at Slane on 15 August I get somebody to draw the water for me, and I drink it on my return. When Alexander was christened at Holy Trinity, Brompton Road, in London in 1975, I produced an old soda-water bottle with 'Holy Water' scrawled over the label, and asked the astonished clergyman to pour it into the font. I explained it had been blessed centuries earlier. When we were children, 15 August was a great occasion. The lawn-field below the Castle was used for a Gaelic football match. There were side-shows, races and a greasy pole to climb up by the river. It was in every sense a festival, and the highlight of the summer. It opened up a somewhat enclosed world,

and the natural amphitheatre sprang to life. By 1976 people still came to the Holy Well, but the football match and the side-shows had gone. Years ago, when I was a small child, I used to dream about the field in front of the Castle. Great wooden fortifications, like those you see in old westerns, would shoot from the earth. Lines of soldiers on horses would emerge from the construction and march round the field. Periodically the dream would return. The Rolling Stones at Knebworth, The Police at Leixlip, and here in front of the Castle a lush green amphitheatre pleading for activity.

The rock and roll business is populated by a very diverse bunch of people, some good, some incompetent and some just plain unreliable. The multiplication factor if something goes wrong at a major event can be very frightening, and you have to work with people you have confidence in. Tentative approaches about staging concerts at Slane had been made, but all uninspiring. If we were going to take the plunge, it had to be with people I felt comfortable with, because we had no illusions that it was going to be easy. Then one day in the spring of 1981, a young promoter from Belfast, called Eamonn McCann, walked into my office. Here was somebody I felt at ease with, and who understood my anxieties.

Eamonn and his partner, Denis Desmond, had a firm called MCD Concerts, based jointly in Belfast and Dublin. Eamonn's forte was all the heavy-duty practical stuff, like security, sanitation and fencing. Denis dealt with the bands. They were a good combination. Eamonn had studied Engineering at Queen's University, Belfast, where he had started running gigs. He was brought up on a small farm in the North. We came from radically different backgrounds. When we first met, I called him 'Eamonn', he called me 'Sir'. That soon changed. We got to know each other very well over the next few months. At that initial meeting, I don't think either of us knew what heavy seas we were going to run into.

Eamonn and Denis were new to running large outdoor concerts. They linked up with an English outfit called Wall to Wall Stageshows, which helped with the organization and the finance. There were two main players in Wall to Wall, John Hinch and his colleague, a guy who rapidly acquired the nickname of 'Mister Everythink'. He left two lasting impressions. His constant reassurances that 'everythink' would be fine were like a cheese grater on sore skin. He wore a gold chain and medal round his neck, something that always makes me feel uncomfortable.

We had great difficulty in trying to keep him in the background. He was unlikely to inspire confidence in members of a small community like Slane. It rapidly became apparent that Eamonn and Denis had to be kept in the front line. Such situations are never easy. Large egos are in abundance in the music business.

Music has always played an important part in my life. I struggled at school with the piano, eventually giving it up because I wasn't particularly good at it, and I had developed a strong dislike for my music teacher. The first record I bought was 'She Loves You', by The Beatles; but to be blunt the bands that really appealed to me were The Rolling Stones, The Animals and The Who. They seemed rebellious, challenging and just a little raw. I'm never one to cast deep into the meaning of a song, but like to take from such music something that reflects an attitude or a mood. 'Satisfaction', 'We've Gotta Get Out Of This Place', and 'My Generation' had a sort of anthem status. The internal anger and frustration I have felt about being made to feel an outsider in my own country, and an irrelevant anachronism, has been eased by music, and most especially by the concerts at Slane. Eamonn and Denis had assembled a perfect bill to christen the site: Thin Lizzy, an up-and-coming young Irish band called U2, and Hazel O'Connor, then riding on the wave of the film called *Breaking Glass*.

The Slane concerts are always fundamentally about the music, the musicians, the hype and buzz of the day. Despite all the hassle they have become quite addictive. Adrenalin is a very potent force. However, behind all the drama and theatre of the occasion, there is a lot of hard grind and attention to detail. The biggest headaches are always security, litter and sanitation. By the beginning of June, the finer points were being hammered out with Eamonn, and by early July we had agreed most of the basic details.

However, events outside the vicinity of Slane were bringing dark clouds over the horizon. Prisoners were dying in the H-Blocks in the North of Ireland. The ghost of Bobby Sands had featured prominently in the St Patrick's Day parade in New York. Roads near Slane were festooned with black flags. Mock funerals were held in the nearby village of Duleek. I received threatening letters and phone calls. One member of the Castle staff expressed anxiety about coming in to work. Sinister and murderous slogans were daubed on the Castle gates. We were worried that the children would see them. July also witnessed some of the worst street clashes for decades between Republican

sympathizers and the Gardai outside the British Embassy in Ballsbridge, Dublin. The atmosphere was tense and not a little unnerving, but simultaneously the news broke that we were proposing to stage a rock concert at Slane. It was inevitable that the holding of the concert was going to prove controversial, and the prevailing temperature in the country allowed those who objected to our plans to fan people's fears and anxieties. When the news of the festival got out, we were asked to a public meeting in the Conyngham Arms, the local hotel. It was a nightmare. Eamonn tried his best to reduce the temperature, but he really hadn't a hope. I pleaded that I didn't wish to see the village divided, but I was largely ignored. Accusations and allegations flew thick and fast, and the whole thing descended into a bit of a shouting match. A young man at the back of the room who supported the concert was asked to leave. Somebody even suggested that with all the wire we were erecting round the concert site the place was beginning to look like a German prisoner of war camp. Following the meeting I was in a state of deep depression. The Sunday papers got in on the act. The local county councillor was quoted as saying, 'Litter is a big worry, but it's not so much that that they are against. It's just that they don't want this concert.' There were photographs of two local publicans. One stated, 'I am going to board up my premises,' the other, 'I'm happy about the concert.' There was a meeting of the Community Council, a body far from enthusiastic about the concert. They wrote to me and the letter concluded:

> Due to last weekend riots in Dublin, Monaghan and Castleblayney, the people of the area are gravely worried about the risk to person and property if the wrong kind of people should come to the village. They fear you are putting them, yourself and your family in danger by holding this festival. Also they feel that this event could be the cause of severing the bond of unity and good relations that has existed between them and the Cunninghams of Slane Castle for generations.

To be honest, I was in a quandary. I had considerable sympathy with some of the anxieties being expressed, and realized that external events were not helping matters, but deep down I felt much of the reaction was hysterical. There was a sense that some of the opposition was not simply based on the concerts, and something about the tone of the letter from the Community Council irked me. We clearly had the support of the

young people in the area, and others chose to put pen to paper to wish us success in our venture. Eamonn was distinctly worried. Plans were well advanced, and he was determined to keep steel in my back. Lengthy and even emotional conversations took place. Eamonn and Denis were both persuasive and supportive, and we decided the show must go on. I prayed there would be no trouble. There was a good omen. The concert was to be held on 16 August, the day after St Erc's Day. Plenty of holy water would be consumed in the Castle the night before the concert.

It is hard to describe the build-up: fencing, sanitation, dealing with traders, trying to make sure all the insurances are in order. In 1981 there was pressure. Nothing in comparison to future years, but pressure none the less. As the date moved closer sleep became more difficult. There was constant anxiety that some detail wasn't being covered, worries about security, worries about weather. Worries about H-Block protesters. Worries about worries. Eamonn came to stay. We erected a large banner, slung from the battlements, saying 'Welcome to Slane Castle'. The day before the concert we moved into the village and picked up thirteen bags of litter. The weather was a little mixed. Campers arrived in the car-park. It was very hard to sleep. We were up at 6.30 a.m. The fans were already queueing at the main concert entrance, and the sun burst across the lawn-field and the Boyne glistened. Tommy FitzHerbert, who had joined us to help run the restaurant, was living in the Yard House with his wife, Clare. It overlooked the concert site. He prepared a suitably dramatic breakfast to celebrate the occasion: black pudding, bacon and eggs and sausage washed down with champagne. A table was laid out in the garden in front of the house so the guests could watch the fans arriving on the site. Juliet, Tommy, Clare, together with some close friends, sat down to enjoy breakfast and the sunshine. Conflicting surges of exhaustion and excitement were travelling round our bodies and minds. There was a palpable sense of relief. The previous day had passed more or less without incident, although three joy-riders who had stolen a Ford Escort in Dublin had rammed a Garda patrol car in the middle of the village.

The day itself was magic. Approximately 18,000 fans arrived to hear the music. It seemed like a monumental crowd at the time, although the attendance was nothing compared to later years. All the guests were on the lawn in front of the Castle, and wandered in and out of the house. Denis was in a panic as he seemed to have mislaid Rose Tattoo, an Australian heavy metal band due to appear on the bill. After a frantic

telephone call he traced them to a hotel near Dublin Airport. When they appeared on stage we rapidly understood why Denis had been apprehensive. The lead singer was diminutive, and seemingly smashed out of his mind. Covered in tattoos, he swayed on to the stage swigging a bottle of vodka, and hurled the microphone around like a sledgehammer. He spat at the audience, and wound up the heavy metal crowd. Backstage all the liggers and shapers were sizing each other up. A certain rivalry between Thin Lizzy and U2 could be perceived — the young bloods challenging the King of Irish Rock and Roll. Phil Lynott arrived by helicopter, U2 by limousine. Paul McGuinness, the manager of U2, was starting to make his presence felt. Hazel O'Connor was striking. She related to her audience. Strutting around the stage clad in red and black, she ripped through her set, and reflected the spirit of the occasion by a haunting version of 'Danny Boy'. She then retired to the Castle lawn to watch the show and entranced the children. U2 displayed some of the potential that was to make them one of the most exciting live acts in the world. Bono stretched himself to the edge of the stage developing his later style. He also started to preach to the press about reporting violence at concerts, and then needled them by singing 'Brick Through A Window'. He was starting as he intended to go on. They were good, but not yet hot. Paul McGuinness showed the confidence and grip that set him apart from the rest. These were the ripples before the waves. Little did I know how many times I was to see them all in the coming years. However, there was no question about it, the day belonged to Thin Lizzy, and most particularly to Phil Lynott. A dramatic bang, fireworks and white smoke heralded their arrival. Their rendition of 'The Boys Are Back in Town' said it all. The only black spot in their set was when a bottle came hurtling on to the stage and cut Caroline Lynott's foot. She took it serenely. This was a high-energy end to a marvellous day. We were overcome by waves of relief; it had worked and the fans had loved it. Exhausted and emotional, having cleared the Castle of hangers-on, we retired to Tommy and Clare FitzHerbert's house in the yard. Time to unwind. The bottles were being opened when we were interrupted by a bang and a grinding noise. A catering truck had collided with one of the arches outside the house. It was almost a perfect day. Eamonn and Paul McGuinness helped me sort the driver out. The rest of the evening is a bit of a blur. We were all totally shattered.

If 1981 had its joys, there were also tragedies. Black flags on the road from Slane, but also death in the family. Juliet's older sister Jessica died. She was dramatic, beautiful and headstrong; a child of the sixties, but also one of its casualties. She was only thirty-four years old. I can still remember the first time we met. Wild and challenging eyes encased in an almost Red Indian face. Juliet's family has Red Indian blood and Jessica would change colour rapidly in the sun. We had all met in Portugal. You could not fail to be impressed by her, but she had a troubled and volatile temperament. She was a rebel without a cause, railing against the world, and against those nearest her. It was frightening to watch. In many senses it was all too much too fast. At seventeen she was Deb of the Year and Paul Getty threw a huge coming-out dance for her at Sutton Place. She did some modelling and hung around with the beautiful people. In my book, some of the beautiful people displayed a very ugly tarnish. Jessica developed a strong addiction to alcohol which, combined with a serious drug habit, was to be her undoing. Jessica also had a child. She was a single parent. Wolfe was born in 1978 in St Mary's, Paddington, where Alexander was born. When he was tiny Jessica took him everywhere, which under normal circumstances would have been fine, but her first major destination was Kabul in Afghanistan and her visit coincided with the Russian invasion. She was reported missing in the area of the Khyber Pass. It took two weeks to trace her to a hospital in Kabul where she was being treated for dysentery. Wolfe was less than a year old. All of this was understandably deeply distressing for both Juliet and her parents. It was part of the unfolding of a tragic picture. There was a very black and bleak ending. In October 1981, Jessica was found dead on the kitchen floor of her house in Shepherd's Bush, London. She had fallen over in front of Wolfe. The verdict was death by misadventure, caused by heroin and alcohol poisoning. Wolfe was only three years old. The funeral in Cornwall was a nightmare. She was buried in sheets of rain. Juliet's pain ran so deep. It all seemed such an appalling waste. However, anguish and laughter live in the same house. We decided that Wolfe must come to live with us. Alexander and Henrietta were delighted to have acquired a baby brother. He has enriched our life ever since.

In retrospect 1981 was a turning point. It made me more determined than ever to hold on to Slane, but it also rekindled old fires, which had been submerged since 1976. It brought to the surface a burning resentment about many of the aspects of the mould in which I had been

cast. It fuelled the anger that I felt by being treated like a stranger in my own land. All of this forced me to address some of the most crucial issues this island faces. How in God's name can we ever hope to unite this country if we cannot unite its people? How can we have the arrogance to aspire to national unity if we do not have a Constitution that reflects the diversity of its people? Why was the political landscape in the Republic such a spiritual desert in this respect? Why was politics treated like football when there was poverty, death and destruction in our island? Charles Haughey has stated that the North of Ireland as a political entity has failed. He is wrong in only one respect. He does not go far enough. So far, this entire island has failed as a political entity. We can only resolve these problems ourselves. As a Protestant, a South-erner, an Anglo-Irishman, and the son of a peer, who holds a deep wish to see this island united, it seemed as if I was directly confronted by all these contradictions. This island is 'a sea fed by many streams'; a way must be found to enhance its rich tapestry. Surrounded by so much ambivalence, double-think and a rich helping of insults thrown in for good measure, it was perhaps inevitable that the opinions that I had been expressing behind closed doors would have to come into the open.

In 1976 when I came home, it did not seem possible to do anything but mutter and watch. My first contact of any significance was with Fianna Fail, through my local TD (Member of Dail Eireann), the late Brendan Crinion. I was concentrating principally on seeking a sympath-etic approach from the then Fianna Fail government to preserving historic buildings. Brendan Crinion tried to persuade me to join Cairde Fail, a fund-raising group attached to the party. It seemed sensible to remain neutral. In any event, Fianna Fail's election package in 1977 was well-structured electoral washing powder, which was the first step to our present financial predicament. To so many of us there seemed little substantial difference between Fianna Fail and the main opposition party, Fine Gael. Like a lot of people I have made contributions to both parties. However, by 1981 my colours were showing. John Bruton, TD, the future Fine Gael Minister of Finance, asked me to allow a large poster to be erected on my land during the election of June 1981. By March 1982, I had started letting the local branch of the party use the Castle for meetings, but it was to be November 1982 before I formally joined the party. However, the seeds of all of this were really sown in 1979. After the defeat of the Coalition government in 1977, Fine Gael elected a new leader, Dr Garret FitzGerald, and the views and senti-

ments he expressed seemed to indicate a new departure in Irish politics. He was attempting to alter the political agenda, and had 'hijacked' a political party to do it. By 1979 the selling of Garret FitzGerald had started in earnest. Tony O'Reilly, Chief Executive Officer of Heinz, and one of Ireland's most successful businessmen, together with a close colleague, Vincent Ferguson, invited me to a small dinner at the St Stephen's Green Club in Dublin to meet Garret FitzGerald. Prior to the meeting I was sent a copy of an address that Garret FitzGerald had made to the Cork Chamber of Commerce the previous month. It was specifically pitched at the business community, having the appropriate title 'Business and Politics – The Missing Dimension'. One passage in particular struck me.

> This means that political parties must be more willing to accept as candidates people who may not up to the point of standing for election have been active members of those parties through their branches, but who may nevertheless have much to contribute to the political life of the nation. My own party has, I believe, given a good example in this respect recently in selecting three of its thirteen candidates for the European Parliament from amongst people who had hitherto no direct involvement in our party.

Fine Gael appeared to be opening a door. Here at last was a political leader who seemed willing to accept the variety of strands and traditions in this island and to be actively encouraging those who already played a role in the economic life of the country to participate in the political process.

> We shall not resolve the problem in Ireland unless, as in other countries, a certain number of people with business experience, including those with experience at the highest level, are willing to play some part in the political system by offering themselves for election as candidates of one or other of our political parties, and going through the democratic process, which, with all its aches and pains, leads to membership of the Dail or Seanad.

I looked forward to an interesting evening. The Fine Gael team consisted of Ted Nealon, a former head of the government information service in the previous Coalition government (elected to the Dail in 1981), who was also an experienced journalist and broadcaster. He was accompanied by one of the shrewdest and toughest political strategists

around, Peter Prendergast, the then General Secretary of Fine Gael. The evening struck me as rather strange; I felt very much a junior participant and, to be utterly cynical about it, the token Anglo type. Garret FitzGerald seemed slightly uncomfortable and, in a way which is rather difficult to explain, this reassured me. Ted Nealon was, as ever, affable, and Peter Prendergast seemed unfathomable. The discussion was wide ranging, although I recall feeling that Fine Gael had much work to do on the development of its policy towards agriculture. Tony O'Reilly and Vincent Ferguson had helped to dispel the notion that people from my background were not welcome to make a contribution to the mainstream of Irish life. Garret FitzGerald was later to reinforce these sentiments by the views he articulated in his Constitutional crusade. The seeds had been sown in my mind, then, in the summer of 1979, but it was not until the winter of 1982 that I found myself standing before a convention in a hotel in Athboy, County Meath, to select candidates to stand in the general election. At the end of 1982 a great friend of mine, Nick Koumarianos, known affectionately to all as 'Nick the Greek', sent me a quotation from *The Prince* by Machiavelli: 'There is nothing more difficult to take in hand, more perilous to conduct, or more uncertain in its success, than to take the lead in the introduction of a new order of things, because the innovator has for enemies all those who have done well under the old conditions, and lukewarm defenders in those who may do well under the new.' Cautionary words indeed. In fact most of my friends thought I was quite crazy to get involved in politics. However, before the winter of 1982, much water was to flow down the river Boyne, and the summer of 1982 was to be the year of The Rolling Stones.

6

Keeping the Home Fires Burning

In the late seventies the restaurant at Slane was a hive of activity. It taught us the meaning of toleration and exhaustion. We launched motor cars, catered for medical groups, gave endless tours of the Castle, and sometimes sat late into the night listening to people's woes, tribulations and triumphs. A wide variety of characters came through our doors, and it helped break down a good many barriers. Friends came to stay, the children got more mobile, and started to enjoy the space that surrounded them. The lasting impression of those years is endless bustle, lots of hassle, and frantic rushing about, not all of it productive. We also enjoyed ourselves, as is demonstrated by a letter I received after a New Year's Eve party given in 1977.

Our team considered the food superb in both quality and quantity. Wines and spirits flowed in a truly bacchanalian manner, and it was to this that our music critic attributed the somewhat free rendition of 'Auld Lang Syne' which followed. Our enjoyment was then further heightened by a most professional discotheque. The success of this part of the evening was evidenced through the active presence in the ballroom of some whom our social commentator had previously considered almost geriatric. (This commentator has since been 'promoted' to cover punk rock festivals.) In summary, a memorable party which enabled the entire team to view 1977 through rose-tinted spectacles and contributed to their inability to view 1978 at all.

If there was exuberance, there was also commerce. If there were successes, there were also failures. This brings me to our first disaster. The Slane Castle Ball held on Wednesday 9 August 1978. It has always struck me as rather peculiar that among certain sections of the

[67]

community, raising money for hunts acquires a sort of subliminal charitable status. If during the Dublin Horse Show, the various hunts, from the Meath to the Louth, should seek to raise funds for their sporting activities, why shouldn't we try a similar venture to raise money to help keep a wonderful building going. We were persuaded to embark upon this venture by a colourful character called Hamish A. McA. Gibson, who was then living in the Yard House at Slane. At the time he was handling a distribution agency, but he has been involved in everything from agriculture to film-making. He is currently living in California. His imagination at times tended to run riot a little. He volunteered to administer the project. On the basis of experience of a similar venture in England, Hamish became ball secretary. The brochure set out an ambitious programme: 'Fabulous Music — International Cabaret — Dinner — Disco — Champagne Riverboat — Nightclub — Irish Pipers — Maiden Rock Candlelight Walk — Breakfast — and much more!' In retrospect the last three words seemed the most relevant. Some of our friends referred to the whole episode as the 'Slane Castle Balls Up'. In truth, many people thoroughly enjoyed themselves, but it was a night Juliet and I wouldn't forget in a hurry. It was to be a rough experience.

At the time we were both thoroughly exhausted and had been persuaded by Juliet's mother to take a short break in Portugal. Hamish was very reassuring; everything was under control. I was apprehensive at being absent during the build-up, but we were desperate to get away from Slane. We returned, and on the surface everything seemed fine. My father and stepmother, brother Simon and his wife, Matthew and Lizzie Evans came to stay. Tommy FitzHerbert booked a room in the Shelbourne Hotel to sell the tickets. The whole event was generating considerable interest. The dance itself was like a bad dream. Hamish said he had booked Gerry and the Pacemakers. They didn't turn up. The secondary band turned up, but they had no equipment as they had planned to use the Pacemakers' gear. Hamish was nowhere to be found. Thank God the disco was operating, but people were naturally wondering what the hell had happened to the band. We were in the front line. I kept muttering about technical hitches, confused arrangements — anything I could think of. (Panic, must stay calm and find a solution.) The evening was saved by a true gentleman called Andrew Leonard, who had organized the lighting of the lawn-field, the river, marquees and parkland — one of the successes of the evening. He reckoned he could locate a band. I said, 'Do it, and to hell with the cost.' About an hour later

they arrived, and they were great. Everybody heaved a sigh of relief. In the meantime my father had descended to the river boat to dispense champagne to soften any grievances. He got a little carried away. Juliet waded her way through the breakfasts. Somebody threw a tray laden with food at her. Matthew and Lizzie Evans leapt into the breach. I had a series of altercations with the disgruntled and the drunk. Somebody emptied a drink into the equipment belonging to the DJ running the nightclub. To my total astonishment several people assured me they were having a ball. To all of us it felt like a battle zone. With the band playing, the champagne flowing on the river Boyne, and the blue light of morning breaking on the scene, we all retired to the restaurant vowing never to do it again.

During the late seventies I was still very much involved with Sotheby's, as although by 1978 my cousin Nicholas Nicholson had taken over as their Irish representative, I remained as a consultant. Nick and I felt strongly at the time that Irish works of art, such as paintings, silver and glass, should be offered for sale in Ireland to domestic buyers. This would have several advantages for Sotheby's. Firstly, it would heighten their profile with potential vendors (something that always appeals to them); and secondly, it would enable them to argue with justification that they were not merely indulging in the rape of Ireland's national heritage. Last but not least, it would enable them to steal a march on Christie's. Nothing like one in the eye for the opposition to appeal to their sensibilities. One of the most gratifying aspects of these sales was to be the significant proportion of the contents that were imported into the country. Approximately 60 per cent of the silver, and 70 per cent of the paintings for the first sale originated from London. Since then, the imposition of Value Added Tax has greatly limited the ability of Irish collectors to repatriate items of national interest. The choice for the venue was, of course, the Castle, and we were delighted to have the opportunity to introduce into the building the drama and excitement of the saleroom. The date of the first sale was fixed for 20 November 1978.

The auction was an outstanding success and totalled £245,674, way above Sotheby's original estimate. A large reception was held before the event. The sales always introduced welcome additional turnover to the restaurant. Several senior members of the firm graced us with their presence, including Lord Westmorland, who had been involved in getting me to join Sotheby's. Nick Nicholson took the glass section,

which he thoroughly enjoyed, and Andrew Festing, head of the English picture department, sold the pictures. The auction had its lively moments. A lady from Jersey rang up requesting permission to land her areoplane in the Castle grounds. She was politely told that we did not have such facilities, and that she would be well advised to try Dublin Airport. John Taylor, the Unionist politician, turned up, surrounded by eager Special Branch men, anxious to protect him. No doubt their eyebrows were raised when he chose to sit near a lady whose brother was then incarcerated in Portlaoise prison, where many subversives were held. Buyers arrived from both the UK and the United States. Considerable amusement and drama was generated by watching the Bond Street entourage deal with the Irish antique dealers. A world record price was established for an oil painting called *The Ejected Family* by Erskine Nicol, which to our delight was bought by a local collector. The whole event was a social occasion and a commercial success, and introduced a special buzz into the Castle. A rostrum was erected in the hall and the ballroom went through yet another metamorphosis, when it was turned into a picture gallery.

On the strength of the first auction, Sotheby's decided to make the Slane sale a regular feature of their calendar until 1981, when, concerned about the escalating costs, they decided to give it a miss. It created a gap in our lives because we enjoyed the annual invasion, the intricacies of the sale, the anxieties of the sellers, the acquisitiveness of the dealers, their display of contempt if a new private purchaser entered the market, interfering with their margins. They talked down objects they wished to purchase, to deter other bidders. They waxed lyrical about their own possessions which they were trying to unload on the market. The Bond Street team took over the Castle, setting up office in the drawing room. One year, to my consternation, our German Shepherd dog bit one of the accountants. Long evenings were full of banter about the characters that appeared, the Flash Harrys with their money and very little sense, and the studious and careful trying to capture a bargain; the hustle and bustle, the minor intrigue. One story in particular illustrates the push and shove of the sales. An art-dealer friend, recently flush with the success of a coup, decided he would flex his muscles by bidding on a rather attractive oil sketch by Sir John Lavery. He also calculated, correctly as it turned out, that I had instructions to bid on the painting by a major firm of art dealers. What he didn't know was the size of my limit. He decided that he would give me a run for my money. I was

[70]

enraged and decided to drop the picture on him. I bid carefully to the limit of my instructions, and then adopted an aggressive and even disdainful rhythm to my bidding, expressing as it were the sentiment, 'You don't stand a chance.' Underneath I knew, if it went wrong, I was landed with the picture at a price well in excess of its value. He responded readily to my bids. After his bid at around £8,000, I folded my arms and stared at him. He looked pleadingly in my direction. No reaction. The picture was knocked down to the dealer. It took quite a while for him to sell it. Auctions have a very special sort of appeal.

Andrew Festing, who conducted the sale of the pictures at the Slane sales, is now a portrait painter of some distinction. In the drawing room of the Castle a small oil sketch of the river Boyne which he painted during a sunny interlude on a viewing day, remains on display to the public. His portrait of my father, with the Castle in the background, hangs in his house in the Isle of Man. His assistant, a bubbly and entertaining lady called Anne Beckwith-Smith, with a Sloane appearance and a vigorous sense of humour, is now principal Lady-in-Waiting to the Princess of Wales. Some of the pictures in the sales now hang in the Castle: a haunting painting of *Soldiers at the Front Resting* by Sir William Orpen, and two intriguing landscapes of the river Boyne between the Castle and Beau Parc by Bartholomew Colles Watkins. They were purchased specifically to add to the Irish content of the collection – new layers acquired for Slane in an attempt to stem the tidal wave of antiques removed from the country by the international art auctioneers. Malahide Castle, Luttrellstown and Mount Juliet have sent the shudder of the gavel through the old houses of Ireland. I only hope that I will not live to see the plunderers at Slane.

7

Public Space – Private Life

If you are in the stately home business, you need publicity. If you promote rock concerts you need publicity. If you run a night-club you need publicity. If you decide to get involved in politics you need publicity. Public space, private life. The two don't always mix. The attention of the media is a two-edged sword. The next couple of years were going to teach me all about the kinds of wounds they could inflict. 'Sticks and stones may break my bones but words can never hurt me.' That maxim may be true on the surface, but the real rule is: if you feel it, don't show it, and above all else be careful with the press. They have a job to do, which is fine, but they also have to sell newspapers. Gossip columnists are the worst. They often have a vested interest in private anguish, indiscretions, wild behaviour, and in catching you off your guard. It is not just you they place under scrutiny, but they hassle your friends and your family. Limelight has its shortcomings.

The turning point at Slane, 1981, marked the beginning of a very difficult period. May of that year saw my thirtieth birthday and, looking back on my feelings then, I realize I had a deep sense of being incarcerated by the place. Financial problems, hunger strikes, the lord of the manor being cast solely in the traditional role: wait at table, listen to rubbish; sit at table, listen to rubbish. Shadows of the Anglo-Irish syndrome cast uncertainty over the recesses of the mind. The Castle loomed large and threatening, the call of the land seemed a burden. Life was flowing by as the river Boyne flowed, and heading out to sea. It seemed for a while that the end was inevitable: the last of the Mohicans without the style. We were moving towards a storm.

By 1981, I needed an escape valve. My aunt, Patita Nicholson, a painter, was due to have an exhibition in an art gallery in Palm Beach, Florida. The gallery in question was run by two very old friends,

Anthony and Mary Ellen McCarthy, whose eldest daughter, Miranda, is my godchild. They had brought her to Palm Beach because she suffered from rheumatoid arthritis, and they hoped the warm climate would help her to combat the disease. They invited Juliet and me out for the exhibition. It couldn't have been further removed from Slane and it was almost eight years since we had last set foot in the United States. We decided to go.

Palm Beach is quite unlike anywhere else, with the Atlantic Ocean, the sand, the warm air and pina colada, and I believe the largest Gucci building in the world. It is a haven for the rich. They flock to the place in the winter from New York, Chicago and the frozen cities in the north. It is heavily populated by the elderly, exhausted by a lifetime's devotion to the accumulation of wealth, living out their twilight years in a whirl of social activity, in impeccably manicured surroundings. It is known as God's waiting room; rather inappropriately in some cases, because I would never like to vouch for the entirely charitable motivation of some of the residents. Old Wall Street and industry war-horses parade around wearing outlandish checked trousers and fluorescent ties. Their wives, weighed down by Cartier and rocks from varied sources, gossip about the parties and who is next for the knife or the morgue. In the season, which runs from Thanksgiving to Easter, the young and mobile from New York come down for long weekends to play. The affluent of surrounding Florida descend on the shops and the restaurants.

Even Palm Beach is not immune from the influence of the drug trade. One evening, walking back from the famous Breakers Hotel, we had a head-on meeting with one of its local representatives. We were with two friends from Ireland, Penelope and Adrian Lindsay-Finn, and were walking down a side road which ran along the golf course in front of the hotel. Adrian and I were about forty to fifty yards in front of Juliet and Penelope, discussing the distinctive tranquillity of Palm Beach in comparison with the rest of Florida. There was a large car ahead with two men in the front. Something about their demeanour made us look inside as we sauntered past. They were dealing cocaine. I turned to Adrian and said, 'Jesus, did you see that?' Almost simultaneously one of them leapt out of the car and started waving a gun at us. We slipped into the most anglicized accents we could summon and pleaded ignorance, foreignness, blindness, anything to defuse the situation. By the time Juliet and Penelope arrived it was all over. Ever since then I have displayed a slight reluctance to walk down that road at night.

[73]

At the time of our first visit, sterling was riding high against the US dollar, and it seemed sensible for the family trust to put a toe into US real estate. Circumstances had brought me to Palm Beach, so I decided to take a close look at the local market. Prejudice is alive and well in Florida. Palm Beach is very much white and Anglo-Saxon, especially if you wish to acquire an apartment in the better buildings on the ocean front. The trust retained the services of a very entertaining lawyer called Bob Lewis, who is unfortunately no longer with us. He was murdered. At our first meeting, I expressed astonishment at one of the application forms produced by the board of a building in which I had found a suitable apartment. It required information about the religion of prospective tenants. I had also encountered what I can only describe as fairly strident anti-Semitism. Bob Lewis didn't mince his words. 'You want to know who I'd really like as a client in this town? Sammy Davis, Jr. He is black and Jewish. I'd have a lot of fun filing his application.' He then explained to me that he had another client in his early forties who was rejected by the board of a building because he was too young and single. Eventually we found a suitable location and in 1981 the trust bought an apartment. Sitting in Doherty's Bar watching the characters roll in and sway out; gazing at the boats ploughing the sea lanes; reading for long hours by the pool; watching the parade of the chic and the tacky, up and down Worth Avenue, laden with expensive purchases: all the hassle, the pressure, the aggravation and the weight of Slane disappears in these surroundings. It is the antithesis of everything at home, and this helps concentrate the mind. Even the conspicuous consumption makes you confront hard facts. I have returned many times.

Towards the end of 1981 an idea that had been germinating for a while came to fruition. It struck me that we should go one notch further up the entertainment scale, and open a night-club. At this stage, I think Juliet felt I was going a little beyond the Pale. To me it seemed a natural progression, and in any event I have always enjoyed night-clubs. Why not have one downstairs? Bright lights in the city, why not in the basement? It would also bring a different crowd into the Castle. It was all part of the drive for relevance but there was, of course, another purpose. The section of the building earmarked for this dramatic conversion was very run down. In truth its most active occupants on our return in 1976 were a series of rather large rodents. It was known as 'rat city'. In its

early incarnation the night-club had been the Castle kitchens. There was a large range which had been fuelled by gas, manufactured from coal which was piped into the Castle. Behind the glass wall of the dance floor, the old ovens remain intact, in case some future generation wants to create a museum of domestic science in place of the pulsating music and flashing lights. Every generation to its own. These kitchens were still in use in the thirties, in my great-grandmother's time. The poet Francis Ledwidge worked there at the beginning of the century. When we were children it was my father's workshop, illuminated by a single bulb suspended from the ceiling. By 1976 it had developed into a general glory-hole, piled high with junk and debris. My heart sank every time I looked at it. The place seemed to represent all the insurmountable problems. For the ill-fated Slane Castle Ball we had cleaned it up and given it a lick of paint. For Sotheby's it proved an inviting venue for a wine sale. The next move was to convert it from a place of dispersal to a theatre of consumption.

It was crucial in the setting up of this new venture to call in outside help. It was a bigger and more complex investment than the restaurant. By chance Tommy FitzHerbert had sold his house just a few miles from Slane to Ivan Rowan and Sue Wade, who had decided to move out of Dublin to County Meath. Sue had extensive experience in catering, including night-clubs. Tommy suggested she might be interested in getting involved in the new venture. To this day I am convinced that after her first visit to the Castle restaurant, she thought the patron was a little off the wall. I was still adopting a very theatrical style but, to be honest, many of the antics reflected the audience. Some of our customers were very unusual. One man in particular – the irrepressible Barney Mullen – remains engraved in my memory. Sometimes he was wonderful, sometimes awful. The nature of his behaviour rather depended on his state of intoxication. Barney was a character. A cattle dealer by profession, he was a good-looking man, whose appearance later in life was somewhat ravaged by what he had poured down his throat. He was a former rugby international, a member of the famous Irish side that won the Triple Crown in the forties. He was an incredible game shot. I was once told he had shot an impossibly high pheasant lying on his back – probably because he couldn't stand up. He was a raconteur and carouser of gargantuan proportions. A good friend of my father, he would take him off on his shooting exploits. The last time my father went on one of his expeditions, he returned rather pale and

somewhat incapable of speech. Barney tended to have that sort of effect on you. All of this brings me to the night that Grouse died. What, or who, you may ask, was Grouse? We all had the same problem the night Barney arrived at the restaurant to hold a wake for his departure. His appearance was quite unexpected. It usually was. It was a particularly busy night. I'm not quite sure where Barney had been, possibly at a cattle mart. He was in the company of a young farmer, who was, as I recall, still wearing his gumboots. At any rate there was a strong smell of agriculture. He announced himself by demanding 'the best fucking bottle of wine in the house'. Food did not seem a priority. Now I was always fond of Barney, even if at times he could be excruciating. We stuck him in a corner, hoping he was out of harm's way. Not for long. His banter became a crescendo, provoking glances, stern stares. I realized he had to be placated, and went over to his table. He was gesticulating strangely with his hand, displaying it like an upturned crab and muttering about Grouse. Confused, I sat down and listened to his explanation which was heavily laced with expletives. It transpired that Grouse was his dog, and the gesture was intended to depict his legs stiffened by death. Then, to my absolute horror, he said he wanted to buy a drink for everybody in the place, and if I didn't explain why, he would do it himself. The customers that night looked very respectable, but Barney had that dangerous gleam in his eye. There was no alternative. I began my rounds. 'The gentleman in the corner is very upset because his dog Grouse has died, and he would like to buy you a drink.' Barney watched and waited eagerly for the mayhem. At first I had no takers, just looks of astonishment. I cast my eye round the restaurant, looking for a suitable mark, a table ready to participate in the 'crack'. Soon a round of drinks was supplied, and others rapidly followed suit. Early refusals changed their minds. What followed was vintage Mullen. He indulged in a sort of cabaret, laced with song and blue language. The drink flowed at his expense; many joined in the song and the dance. It wound on into the night. At the end of it all, Barney summoned me, wanting to know the extent of the bill. I explained it would take a while to make up. He wrote out a cheque. It was clearly too much. 'Your mother is the best fucking woman in the world, and she loves the lifeboats. Give the difference to the lifeboats.' We duly did. That was the night that Grouse died.

The atmosphere in the restaurant tended to provoke such behaviour. Sometimes people went completely over the top. Stag parties were the worst. The departing guests tended to leave strays behind. One evening

we had terrible problems with a male customer who locked himself in the Gents, and then promptly passed out. It took hours to arouse him from his alcohol-induced slumber. On another occasion, a member of the House of Lords, incensed by a fellow diner, tried to seize a sword which was on display to settle his dispute. After being rapidly relieved of the weapon, he discovered an old riding crop in the laundry room, and then charged into the dining room, intent on inflicting damage. As a finale to this episode, he demanded a typewriter and some paper, so he could produce a letter to record the reasons behind this state of affairs. His contributions to the Upper House have always been limited. Others tended to display a more affectionate approach to each other. These proved equally embarrassing. Late one Saturday evening, a couple arrived and settled into the drinks room, prior to moving to their table. To our astonishment, they proceeded to construct a bed out of the furniture. Constant attention was lavished upon them to deflect them from their purpose. They were shifted to their table as soon as possible. On another more startling occasion a couple were so entranced with each other's company, and so oblivious of their surroundings, that their behaviour was starting to upset other customers. The table was rocking. A solution had to be found. I got hold of a side plate and stacked it with napkins, and placed it in front of the gentleman. 'Excuse me, sir, but the way you're going, you might be needing these.' The problem was quickly resolved. A sense of occasion was often called for, and this brings me back to Sue Wade's and Ivan Rowan's first visit to the restaurant. It seemed appropriate to greet them in an unusual manner. I rode into the dining room on a bicycle, parked it by their table, and then joined them for a drink.

By September Sue had agreed to come in with us, and the serious planning for the night-club began. We retained the services of the architect Denis Anderson, who had worked with Sue on a previous enterprise in Dublin, and who had a reputation for producing imaginative ideas. There was one major difficulty. Access to the old kitchen was via a rather precarious set of steps, totally unacceptable to the planning authorities. We had to excavate through the roof of an old coal bunker to create an entirely new entrance. Somehow a night-club is never the real McCoy unless you enter by descending underground. This rule applies whether it be Annabel's in London, or the most inauspicious dive. Sean Doonan, the local builder, was called in to help with the destruction. He had knocked down the walls in the old servants' hall to

create the restaurant. Now, five years later, he would literally break new ground. A new roof had to be put in over a dry moat, plumbing and cloakrooms installed in what were no more than old disused coal bunkers and stores. Gradually as tons of concrete, lengths of pipe, electrical wires and central heating were poured into a lifeless but dramatic portion of the Castle, the night-club took shape. Where pots had boiled, dancers would gyrate. A garden theme was chosen — a sense of being inside, but outside. A gazebo was built around the dance floor, with a canopied roof. It had the effect of reducing the height of the vaulted ceiling, and introducing a sense of intimacy. Contractors were cajoled and bullied, fabrics chosen and made up. We selected some special rattan furniture, which was imported in an unfinished state. Gus Doggett and some of the men dyed and treated it on the top floor of the Castle. The smell of sprays and paint filled the house for weeks. It was a case of all hands on deck. We brought in a disco consultant to deal with the light and sound. I was subjected to some good-spirited abuse for introducing central heating to the night-club while having failed to do so for our domestic quarters. The timetable was starting to slip in tandem with the budget. Our original target was to open by Christmas, but it went tantalizingly by. Eventually we settled on early February, and drove ourselves hard to meet the deadline. We had three opening parties. There should have been just one. The attendance at the first night was a bit thin, the second a great success; but by the third we were all totally exhausted and the smiles were hurting the face muscles. Still, numerous friends came to support us. We were particularly flattered when Eamonn Andrews broke his frantic schedule to inject a little glamour into the festivities. The right members of the press turned up and we received good coverage in the Sunday papers. Everybody started to relax, until the publication of an article in the *Meath Chronicle*. The copy was excellent, describing the place as a 'winner'. The problem was a photograph of Juliet, myself and Sue, taken with a flash. Whatever exposure was used it made Sue's perfectly normal black evening dress look almost totally transparent. She was mortified and muttered about leaving the Castle. Then, to cap the insensitivity of the paper for publishing the photograph (the same picture had been used in other papers but suitably doctored), she received a letter from a collection of self-appointed moral crusaders from Kells, in County Meath. They stated that they were sure she 'could very easily get a contract with *Playboy*, or any other revolting magazine', and continued by saying that

[78]

she would 'probably be employing people to erect red lights outside your "*so-called*" respectable Slane Castle Nite Club'. One of the final touches to this classic epistle was that they judged it 'inevitable that Lord and Lady Mount Charles would hold the same opinion'. My sole concern was that Sue might leave before we had even got the venture off the ground. She was persuaded to stay and ignore the inevitable jibes and taunts. In the beginning Ivan Rowan and I handled the security at the door. Admission was free, so we screened the customers to exclude troublemakers. If running the restaurant was an education, this was a more serious eye-opener. In the early days we only had a wine licence. There was a group of customers who would drink bottles of wine by the neck.

> Will they or won't they? Do you think they will or is it all lies? If they decide to do it, where would it be? And if they decide to do it, and they get a place to hold it, how much will they get?
>
> The answer to the above questions is, I don't know and increasingly I'm getting to the point where I don't care. For the past few months, Dublin has been awash with rumours of a Rolling Stones Concert in Ireland, but the latest word is that there are difficulties, and that the ageing brats have still not made up their minds.

Joe Breen, the rock critic for the *Irish Times*, hit the nail on the head. 1982 was the year of The Rolling Stones, and the year when life went a bit mad. Mick Jagger had been to Slane before, in the early seventies. He was brought by Desmond Guinness. He was still with Bianca then. Daddy had phoned me in a mild state of panic. 'There's a Mr Jogger, something to do with records, coming with Desmond. Any chance you could be here?' 'You have to mean Mick Jagger,' I uttered in vague disbelief, thinking simultaneously that Juliet and I had already accepted an invitation to dinner elsewhere. Damn. My father didn't sound very relaxed about the prospect of handling a rock star. Mick Jagger was, after all, the archetypal *enfant terrible* of rock'n' roll. The Rolling Stones were always in sharp contrast to the clean-cut lads from Liverpool. In any event, Daddy needn't have worried. Mick is comfortable on many stages. I think my father was astonished that he seemed so civilized. Perhaps he had read too many stories about sex, drugs and rock'n' roll, and musicians smashing guitars. We agreed to join the party after dinner. How could we possibly miss the opportunity to meet one of our teenage idols? I mean, in anyone's book, Mick was it.

By the time we arrived, the ladies had left the dining room; the gentlemen remained, drinking port. It was a black tie affair. Life in the Castle had a certain formality in those days. Mick was wearing a white suit, and had the assembled company enthralled. I was mesmerized by how easily he got on with my father's friends. It all seemed in such stark contrast to his public image. But then, Mick Jagger has always been flexible and smart. It is often forgotten that he was a student at the London School of Economics. You have to be very determined and shrewd to survive in the music business, with all the hype, the narcissism and, at that time, the almost obligatory excess. Amongst the great survivors, top ranking goes to Mick Jagger, David Bowie and Pete Townshend. They have all been to Slane, two to perform, one to stay as a guest — all special artists in a public space.

After a suitable interval the gentlemen joined the ladies in the drawing room. Bianca stood at one end, glancing constantly at herself in the mirror. Mick held court at the other end. Conversation with Bianca was a real uphill struggle, but she did look stunning, swathed in a cream dress. There was a coldness, a distance about her, the very opposite to Mick. There is something masculine about her appearance. We all thought she was a bit of a pain in the neck. Mick was a totally different kettle of fish. He was funny, entertaining and relaxed. Adulation aside, he is the sort of person you feel instantly comfortable with; a rock star who keeps all the hype in perspective. Over the years, Mick Jagger has spent a lot of time in Ireland, staying with Desmond Guinness at Leixlip, or with Lord Gowrie at Castlemartin, before he sold the property to Tony O'Reilly. He has developed a genuine affection for the place, and without this sentiment, I don't honestly think the Stones concert at Slane would ever have happened. Apart from this visit to Slane, and with one appalling exception, I wasn't to see Mick until he came down to the Castle a few days before the concert. The exception was at a dance at the Shelbourne Hotel in Dublin, not long after his first visit to the Castle. Mick was there with Bianca. Together with a couple of friends I joined the hotel band for perhaps the most incoherent and incompetent rendering of 'I Can't Get No Satisfaction' that he has ever heard. I still wince when I think about it.

There are two lasting memories about the Stones concert, the day itself and the hassle of putting the whole thing together. Joe Breen wasn't the only one driven demented by the endless speculation. It drove me up the wall as well. The Thin Lizzy and U2 concert the

previous year had clearly illustrated what a stunning setting Slane was for an open-air rock show. However, I was also very conscious that for the site to gain serious credibility we had to secure a major international act. U2's status was still too embryonic to qualify them for the big time. The Rolling Stones had played at Knebworth in 1976. That concert had created lasting images. Slane needed a similar blessing. As soon as rumours started to circulate that the band were contemplating a European tour it was clear I had to go for it. There was also the danger that if they decided to come to Ireland they might play elsewhere, and that was a very real possibility. It would have been a major set-back for the Castle. In my heart, I know there is nothing to compare with the drama provided by the great natural amphitheatre in front of the house. The trees, the sweep of the lawn-field, the Castle and the sparkle of the Boyne. It makes the concerts at Slane something very special. Springsteen at Wembley; anybody at Wembley: at Slane it's an event. In early 1982 we hadn't yet made the grade. In every sense The Rolling Stones were the key. I had to secure 'the ageing brats', and in any event Mick was still the main man.

The first problem was Desmond Guinness. There is no question that I have substantial admiration for him. He has done more than any other individual to heighten public interest in preserving our rapidly diminishing Georgian heritage, the most dramatic example of his altruism being the rescue of Castletown House, built for the legendary Speaker Connolly in the eighteenth century. (Apart from being responsible for such a fine building, Connolly also showed good taste in his choice of a wife. He married a Conyngham.) Desmond is a complex individual. Now in his fifties, he still retains his good looks, and those infamous blue eyes, that sparkle like ice and mask a deep sense of mischievousness. He oozes charm with great polish. Leixlip Castle, his home outside Dublin, has always had a certain cachet. It strikes me that the Guinnesses like to hold court. Desmond is no exception. He and Garech Browne have waved the family flag in Ireland, and had fun in the process. They have both in their own way made considerable contributions to contemporary Irish life. They have their followers and detractors. For myself, I am a biased observer. They are both good news. In the seventies, Desmond had played host to The Police at Leixlip, and although there had been considerable fall-out after the concert, with complaints about sanitation and security, he had acquired a certain taste for the buzz involved in staging a show. He also had the option of using Castletown as a site.

Desmond wanted the Stones, and he was close to Mick. Paul Charles, the promoter who had staged the Police concert at Leixlip, had a contact in the Stones' organization. There was no question about it: the prospects of getting the band to Slane were looking a little grim. However, I was driven by the conviction that Slane outshone any other setting, and, to be blunt, I couldn't afford to see the concert staged elsewhere. After long discussions with Eamonn McCann, one of the co-promoters of the Thin Lizzy/U2 show, we decided to talk to Desmond Guinness. We hoped that involving him in the prospective Slane show would neutralize his desire to see the Stones play at either Leixlip or Castletown. He didn't bite. We were in open competition. It eventually surfaced in the press, described as the 'Genteel tug of war', and 'a certain amount of oh-so-gentlemanly rivalry . . . between Lord Mount Charles and the Hon. Desmond Guinness to see which of them will get the Stones'. This was definitely public space.

By the end of March 1982, a clearer picture emerged. The Stones' European tour was being arranged by the legendary Bill Graham, a daunting character based in San Francisco. Bill had handled their tour in the States. It takes a lot to cut ice with Bill Graham. At this juncture they had decided to come to Ireland, but had not as yet chosen the venue. I was then informed by a reliable source that Paul Charles was the front runner to get the act. To add further confusion, Paul Charles had been quoted in the press as having come to some arrangement with me. No agreement existed. This was now as clear as mud. There was the additional anxiety that to stage the Stones was to move into a whole new league, and it seemed imperative to have Irish-based promoters running the show as they would have a better understanding of the local idiosyncrasies. Eamonn McCann and his co-promoter Denis Desmond had extensive knowledge, but were they going to manage to strike a deal with Bill Graham? I had already entered into discussions with them the previous December about a show featuring Rod Stewart and AC/DC. As if all of this wasn't sufficient to induce a mild ulcer, another player entered the field in the form of Jim Aiken, the major promoter from Belfast. He appeared in the restaurant one evening with John Coughlan, a Dublin-based publisher. One of John's ventures was a weekly news-paper called *The Weekend Star* to which I was a regular contributor. It was evident from the beginning that Jim was equally determined to get the act. This was all becoming a bit of a nightmare. I had to talk to Bill Graham. During the early months of 1982 I had spent some time in New

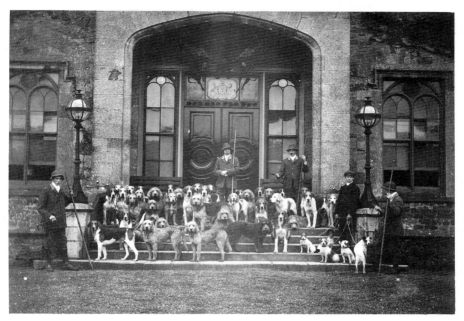

1. Great-Uncle Victor with his Otter Hounds at Slane.

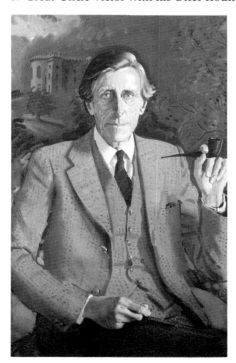

2. My father, painted by Andrew Festing.

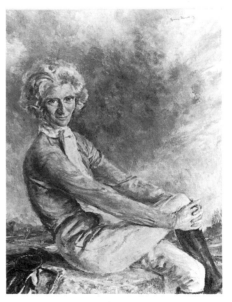

3. My mother, painted by Simon Elwes.

4. My parents with Rock Hudson.

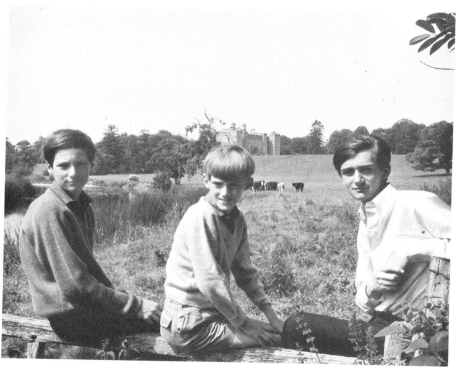

5. Three brothers at Slane (*Photo*: Jeremy Whitaker).

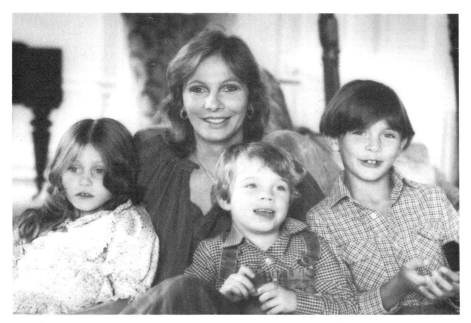

6. Juliet, Henrietta, Wolfe and Alexander (*Photo*: Sheila Donahue).

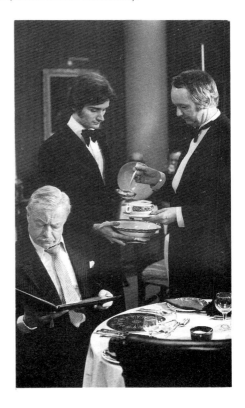

7. Actor and waiter, serving Heinz Ruhmann (*Photo*: Tu Höran und Sehen, Manfred Sohr).

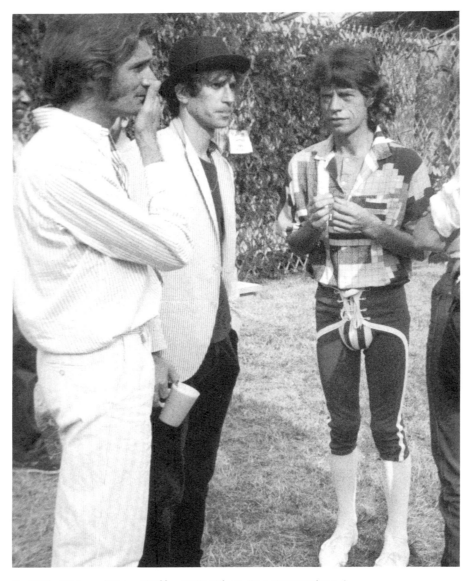

8. With Mick and Peter Wolfe, 1982 (*Photo*: Sue Koumarianos).

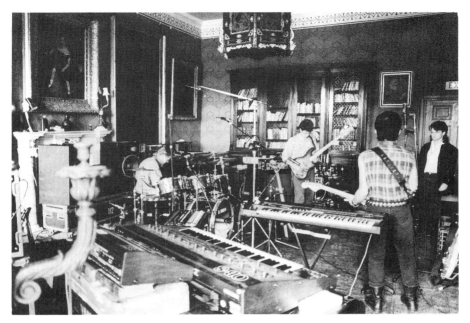

9. The third Marquess watches U2 (*Photo*: Colm Henry).

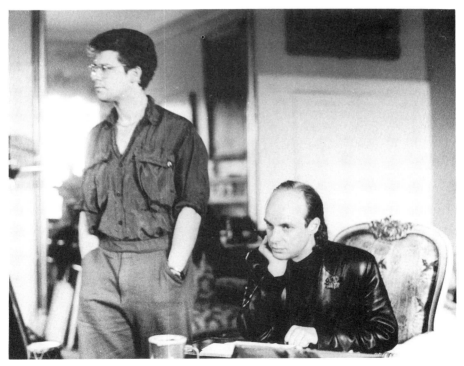

10. Adam Clayton and Brian Eno – wisdom in the drawing room (*Photo*: Colm Henry).

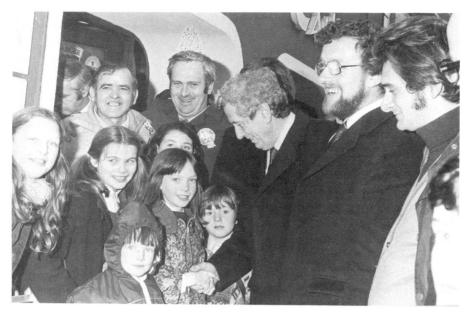

11. Campaigning with Garret FitzGerald, John Bruton and John Farrelly (*Photo*: Carol Lee, *Meath Chronicle*).

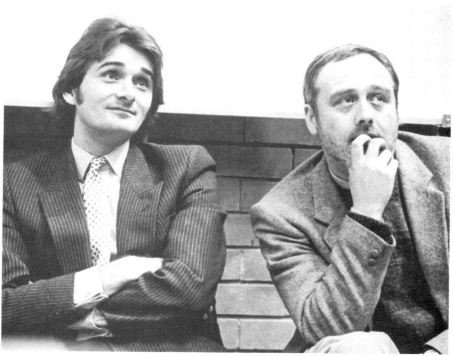

12. Debating with Danny Morrison (*Photo*: Matt Walsh, *Evening Herald*).

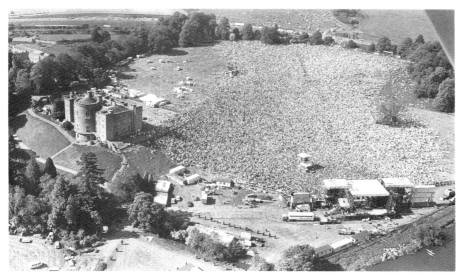

13. Springsteen from the air (*Photo*: Jack McManus, *Irish Times*).

14. 'What's your problem?' (*Photo*: Richard Young).

15. Boy at window. Queen, 1986 (*Photo*: Terry Thorp, *Irish Times*).

16. Celebrating Slane's 200th birthday with Iona (*Photo*: Andy Spearman).

York investigating the possibility of making a real-estate investment for the family trust. Quite by chance, I had met a New York dress designer called Jan Pedersen, with whom I had discussed my predicament. She suggested that I talk to Ahmet Ertegun of Atlantic Records. Ahmet is friendly with both Mick and Bill Graham. He opened a new line of communication. Things were beginning to flow in Slane's favour. By May, the Stones' advance team had visited the site, and I had flown over to London to meet Bill Graham at the Stones' office in Munro Terrace. Paul Charles was beginning to feel the heat of the combined opposition of Jim Aiken, Eamonn McCann and Denis Desmond. I was strongly backing the Irish-based promoters, as I was firmly convinced that their involvement would ensure the smooth running of the show. Paul Charles gathered I was talking direct to the Stones' management, and sent a telex to Emer Mooney stating, 'Please advise Henry that all, repeat all, communications on this matter is to go thro this office.' I was getting there, but trying to steer a diplomatic course. Jim Aiken was fighting hard to secure the act, and I was struggling to keep Eamonn in on the deal. We had been through a lot the previous year, and both he and Denis had been instrumental in building the reputation of the site. There was another factor: I hardly knew Jim Aiken, and Eamonn would prove an excellent counterbalance. In the intervening years Jim and I have become very good friends, as we have battled through riots, court cases and general aggravation, but these were early days. We were still moving around each other. Everyone edged towards a deal. Jim displayed a strong determination to be the sole promoter. There had to be push and shove. There was a strange evening by the banks of the Boyne. Jim paced the lawn-field. Eamonn brooded in the Castle. I walked backwards and forwards between them. Eventually a compromise was reached. Jim would promote the show. Eamonn was in as consultant and site manager, and to protect my back. Jim struck a deal with Bill Graham. I struck a deal with Jim. The date selected was Saturday 24 July. 'The world's greatest rock'n' roll band, The Rolling Stones, are coming to Slane Castle, and that is official.' The show was on the road.

From here on in, it was an education. A tidal wave hit the Castle. People crawled from the woodwork. Popularity had a purpose. It seemed everybody wanted to see the Stones. The onslaught began. Emer was living in a bunker. I had stopped answering the telephone. Elaborate fencing was erected, telephone lines put into the site, sanitation installed. Discussions with health authorities, the Gardai, and the

Slane Community Council. Telexes flew back and forth, as the Stones moved around Europe. Insurance details had to be tied up and security arranged for the Castle. Vendors had to be dealt with. There was an endless barrage of inquiries. There was always somebody who wanted something they couldn't, or shouldn't, have. As the date of the concert approached, the pressure mounted. Eamonn moved into the Castle. Jim and his team stayed in the Conyngham Arms Hotel in Slane. Free tickets had to be distributed. Emer was climbing the walls. Juliet was trying to stay calm. I was praying. As the day approached, the media started to focus on Slane. All angles were explored. The Rolling Stones were in Italy. The seventy-three-year-old Archbishop of Naples, Cardinal Corrado Ursi, launched a vicious attack on the Stones, by stating the band was 'the bearer of principles of violence and drugs'. I was asked for a reaction. I responded by saying that 'he probably doesn't like rock and roll', and that the rest of my response would be 'unprintable'. Whatever next.

Work commenced at a serious pitch on Monday 19 July. The Stones' front man, site co-ordinator Joe Baptista, a real rock and roll veteran who had been in the business since 1959, arrived on the scene. A huge man, heavily tanned, with long flowing locks and a beard to match, he had a husky voice and well-developed sense of humour. He started careering around the site on a mini-motorbike, making sure that everything was on schedule. Bill Graham was yet to arrive with his entourage. We all waited with slight apprehension. He had a reputation for being very exacting, and not necessarily gentle in the way in which he expressed himself. He still remains etched in my memory for his cameo role as the impresario in *Apocalypse Now*, who arrives in a helicopter with the dancing girls to entertain the front-line troops in Vietnam. Bill is the sort of person who will walk all over you given half a chance. I don't believe that this is always a deliberate act of aggression, but part of his nature. He has swarthy Romany looks and talks with a rasping rhythm. Compared with him, Mick Jagger was a breeze; but then Mick had hired him. Hard man in the front line. He arrived with caravan and mini-motorbike in matching colours. I consider my encounters with Bill Graham very much part of my education. Once you get used to his methods he grows on you.

As the concert approached, you could feel the electricity in the air. In every sense it was a build-up. The weather was glorious. The stage crew played football in the evening. Juliet and Sue Wade struggled with the

catering arrangements. Eamonn stalked the site watching everything from sanitation to outside caterers. Jim Aiken and his lieutenants, the tireless Micky Connolly and Jim's brother Michael, wrestled with everything from the local Gardai to meeting the demands made by the Stones for the backstage area. I blathered endlessly on the walkie-talkie. Emer was besieged by our suddenly very friendly friends all angling for VIP passes for the Castle compound, which remained exclusively under our control. We parried with the media. It seemed that the entire workforce of RTE (the Irish National Radio and Television station) had a good reason to be there. This is what is called ligger pressure. All the movers and shakers wanted to be part of the scene. My primary concern was to look after the working press, and my real friends. Not always easy.

On the Thursday, Mick appeared. He was filmed for the RTE News. Excitement was reaching fever pitch. The buzz was on. He arrived in mid-afternoon with Peter Wolfe, the lead singer of the J. Geils Band. The children were running round singing 'Satisfaction', their new puppy Morval in seventh heaven. The massive stage was nearing completion. Bill Graham was being difficult. Amongst other things he had suddenly taken exception to the siting of the catering concessions. Eamonn was going spare. Michael Ahern the chief production co-ordinator, destined to return to Slane for the riot in 1984, was trying to keep the peace. I had to stand my ground against the Graham steamroller. The temperature was rising. Mick and Peter Wolfe were in the ballroom in the Castle, drinking Guinness. Mick asked me if there was a problem. I said there was nothing I couldn't handle. I was muttering about lawyers and contracts to Bill Graham. It was down to scoring points. He probably thought I was an awkward son-of-a-bitch. Eventually things were settled. I kept Gussie Doggett, the farm manager, and Eamonn near at hand. 'Suppose there was a row of trees in front of those vans, would that solve the problem?' A nod of affirmation. I turned to Gus and said, 'Dig twelve holes in the ground, go and cut down twelve trees and plant them in the ground.' Honour was satisfied. A new role for conifers. I retired to the Castle ballroom to drink Guinness with Peter Wolfe and Mick. It was the beginning of a long night.

Mick was feeling comfortable. He called his hotel to get his girlfriend, Jerry Hall, to join us for dinner. Thank God Bianca had gone. Mick's minder had joined the evening football match, and when Jerry arrived we retired into the small dining room for dinner. There is no question

about it, she cuts a pretty dramatic figure: lots of hair, lots of teeth, lots of mouth, and lots and lots of leg. My brother Patrick joined the party. Eamonn, ever vigilant, wandered in and out. The conversation was wide-ranging and bounced around the world. Politics and money, horses and rock'n' roll: you name it, we discussed it. Mick's extensive repertoire complemented by Jerry's Texan drawl. Then, the first note of alarm: Mick was called to the phone. Keith Richards was still in Italy. The IRA had launched a murderous attack in London earlier in the week. Images of dead horses in Rotten Row had flashed round the world. The words of George Paxton, a warden in Regent's Park, had said it all: 'How in the hell in such a beautiful spot as this did they have the stomach to cold-bloodedly blow to shreds so many people? It was obscene, just bloody obscene.' This was not the first nor was it to be the last time that the name of Ireland has been tainted with blood by the callousness of the Provisional IRA. It did not go down at all well with Keith Richards. Mick seemed very concerned that he would refuse to come to Ireland. Visions of the concert falling apart streaked across my brain. I went to find Eamonn. In a short statement, clearly enunciated in his strong Northern accent, he said there would be no problem on the site. I winked at Mick. We hoped he was convinced. After all, the previous year's concert had taken place in the middle of the hunger strike. This is where Mick's affection for Ireland wins through. He sees everything in perspective. In my travels round the world, I have run into so many, particularly in the United States, who equate parts of Ireland with Beirut. They do not see the intimacy, the beauty and the character of this country, but merely images of brutality and savagery, part of a never-ending cycle.

The conversation turned. The wine started to flow, humour always prevailed. It was beginning to get late. We descended into the bowels of the earth. In those days the night-club was still open on a Thursday night. It was far from packed. Mick and I sat up at the bar. Patrick took Jerry on to the dance floor. A guy nearby muttered in disbelief, 'Yer man is the fucking image of Mick Jagger,' not believing for a minute he was looking at the man himself. At this stage my recollection becomes a little blurred. One of us fell off the bar stool. I can't remember which. The last memory of the evening is of Mick charging down the kitchen corridor yelling, 'Ramadan, Ramadan.' It was something to do with staying on the dry until Saturday. They left between 4 and 5 o'clock. When I woke up I felt terrible. I only hoped that Mick would have recovered by

Saturday. Mick was supposed to be having lunch with Garech Browne. He didn't make it. He decided to rest up. Work and play have their place.

We were now moving into overdrive. People started pouring into the area. Jim had put out announcements that there would be no camping, to try and restrict the pressure, but we provided a site opposite the main concert entrance. Patrick and a friend of ours, Cobby Knight, were in frantic and earnest discussions about the baked potato concession. They had chosen a prime site and hoped to make a killing. Patrick had dreams of a good summer holiday. Bill Graham and Michael Ahern charged round the site on their motorbikes checking every detail. Emer and I were battling with the passes to the Castle compound. There were two grades, 'Special Guests' and 'Very Special Guests'. The 'Very Special Guests' got into the Castle ballroom and drawing room, and were entertained by us. Like all such systems at concerts it wasn't water-tight. There is a special sport for gatecrashers, getting to be where they are not meant to be. Some have developed it into a fine art and you acquire an almost grudging admiration for them.

Patrick and I had discussed how best to develop the image of the Castle. Hosting the Stones was going to give Slane cachet. I wanted to copper-fasten it. It was all part of the formula for survival. Patrick was friendly with Nick Coleridge of *Harpers and Queen*. We invited him and a photographer called Alex James to stay for the duration of the concert. Patrick helped him with the article. It provided some welcome light relief. On Friday afternoon Nick and I swanned around the area in a 1954 R-type Bentley, which had been lovingly restored, with 'Honky Tonk Woman' and 'Satisfaction' blaring out of the stereo system to put us in the right frame of mind. Walkie-talkie chatter with Emer, a last-minute panic with insurance. Telex to the broker: 'Attention Steve Salmon, I hold indemnity required from Jim Aiken. Please confirm insurance is placed.' Steve had never been to any of the shows, but he has an intimate knowledge of the events – a key figure in the team. People were pouring into the locality from the four corners of Ireland. The pubs in Slane were doing a roaring trade. The following day some enterprising individual was flogging flagons of cider. It was christened 'Jagger Juice'.

As the afternoon grew into evening, everything was checked. Talk to Mike Ahern, talk to Bill Graham, talk to Jim, talk to Eamonn. Talk. Talk. Talk. Rush about. Exhaustion setting in. That evening two friends, Sean and Gina Galvin, who live at Ardmulchan Castle a few miles from Slane,

gave a large dinner party. I told Juliet to go ahead with our guests. We had been joined by Robert McCrum and his then wife Olivia. Robert was fiction editor at Faber. They had been stopped on the way to Slane by the Gardai, one of whom had leaned in the window and said, 'Have you got any drugs?' As the evening wore on and all seemed under control, I retired to the Castle with several of the Stones' management team. Then Robin Magruder, the technical manager, and I headed for Ardmulchan. They were starting to wind down as we were winding up. We stayed for a while and then headed back to the Castle. People were sleeping everywhere. Ivan Rowan and Sue were camped on the dance floor of the night-club. We joined them for a nightcap and some music. Micky Brigden, the creative administrator, and Michael Ahern were sleeping in the drawing room, surrounded by hangings for the back of the stage. The Castle security guys were sleeping on the sofas in the hall. All round the concert site, camp fires flickered like those of a medieval army before battle. I retired to bed for a rest. Sleep was not possible.

The sun rose, making the Boyne sparkle. It was going to be a glorious day. The thud of the generators driving the site lighting reverberated in time with the birds' early morning song. The huge stage lay dormant below the Castle window. We hauled ourselves from bed. Juliet started on the catering arrangements with Tommy FitzHerbert and Sue. She put Pink Floyd's *The Wall* on in the ballroom. I woke Robin Magruder and Micky Bridgen from their slumbers in the drawing room. They didn't look very well. Outside in the campsite people were nursing hangovers, and fighting the early morning cold. In company with the Castle's security, I ventured towards the village to see if there was any devastation. Relief, none at all. Just a few sleeping bodies on the pavements. All was calm on the perimeter. We returned to drink the first of many cups of coffee. As time wore on, Jim's security arrived in droves. They were positioned around the site to get it tight before the gates were open. My own security arrived to secure the Castle compound. The children charged about with Morval more or less out of control. Bill Graham started roaming around on his motorbike keeping everyone on edge. Tension was building up at the gates. Jim was anxious to open up to release the pressure into the twenty-two-acre site. After much deliberation the gates were opened. People coursed down the slopes in splashes of colour across the green to get a prime position in front of the stage. The helicopters started moving in and out carrying VIPs and guests. Dick Burke, the EEC Commissioner, arrived and got a cheer; not

because of his status but because everyone thought he was Mick Jagger. Phil Lynott arrived, and wandered round, cutting an interesting shape. Bill Graham didn't seem very pleased that the Castle compound had such a festive feel and was grabbing so much attention. We had all put up with so much aggravation we were determined to make the most of it. At around 12 o'clock, eyes smarting behind dark shades, and smelling of sweat and stale coffee, I retreated upstairs for a bath and a shave, and to get my head together to slip into another role. I lay in the water for half an hour ignoring my walkie-talkie until I started to feel vaguely normal. Little sleep had been had for several days. I donned a multi-coloured Brooks Brothers shirt and a pair of trousers with odd legs, one striped and one white. They had been made by a friend of ours, Jo Patton, to bring us good luck. I have said I am a little superstitious.

Outside the Castle I boarded a helicopter and went aloft with Alex James, the photographer. What met our eyes was a huge seething patchwork quilt of colour spreading out from the stage, which was bathed in a sea of purple, yellow and red and straddled by two semicircles of green, yellow, red and blue balloons. The Castle looked like a grey sugar cake, the trees an intense green, and the river danced in the light. It seemed like a twentieth-century fairy-tale. We descended to the ground.

People were hassling the security trying to get into the Castle compound. Jim was at the gate. Juliet and Sue looked worried that the Castle loos would run out of water. People started to arrive for lunch. They were a diverse collection. A batch of Guinnesses, Phil Lynott, and the Irish Prime Minister's daughter, Eimear Haughey. My aunt, Patita Nicholson, gave a somewhat bizarre radio interview about The Rolling Stones song 'Brown Sugar'. Patrick and Cobby Knight were flogging baked potatoes behind the row of newly planted conifers. A strange girl from California, decked out in a purple ra-ra skirt, chased around after us with a collection of poems for Mick Jagger and it took days to get rid of her. At 1 o'clock, the Chieftains went on stage. I think Garech Browne had prevailed on Mick to include them on the bill. It wasn't rock and roll, but at least it was Irish. They were followed by George Thorogood and the Destroyers who put the show on course. Peter Wolfe was in the Castle doing press-ups in the dining room and drinking coffee from Juliet's mug. His subsequent performance was slick and polished; the atmosphere was set.

The Stones arrived to enjoy the garden by the Boyne created for them

backstage at vast expense. Bill Wyman played ping-pong and was friendly and engaging. I kept well clear of Keith Richards. Mick kitted himself out in gear which made him look like a jester at a medieval court. There was a maypole in the garden. At 6.15 p.m. the band went on; large pink curtains drew back and they broke into 'Under My Thumb'. I was beginning to relax, when Jim Callaghan, the Stones' head security man, started bawling at me about a BBC camera crew in the audience. Abuse flew between us. 'It was nothing to do with me,' etc. Eventually somebody calmed us down, which was a relief. He's a very big man. At this stage the stress was over, we could all relax and enjoy the show. An *Irish Times* reporter wrote the following Monday, 'Lord Mount Charles, who owns Slane Castle, acted throughout the day as if he was hosting a garden party in front of the Castle, with the Stones playing especially for him and his guests.' One interpretation. The media always have their slant. Jagger twisted, gyrated and pranced about the set, the band supporting him in every sense. Bill Graham cooled the crowd with a water hose. Security pulled those who had fainted over the barriers, with almost rhythmic dexterity. The crowd rose to the occasion as they thundered through the classics, 'Honky Tonk Woman', 'Brown Sugar' and 'Jumping Jack Flash'. I took Alexander on stage. Garech Browne was dancing with his wife Princess Purna and Jerry Hall. Time flashed by. They ended their set with 'Satisfaction' to thunderous applause. The show terminated with fireworks, the '1812 Overture' and the release of the balloons. A local farmer complained it scared his cattle. Mick dashed for the helicopters en route for Leeds. Ron Wood stayed a while and thrust a triple vodka into my hand. I was nearing the end of my tether. According to Nick Coleridge I then 'stomped about the house, turfing out the gatecrashers, bouncers, tipsy Irish policemen and lingering guests with such ferocity that the few of us who were staying there cowered in a corner and hoped not to be noticed'. We then locked the door and started to unwind. I cannot remember going to bed. Somehow we managed to stagger out the next morning at 5.30 a.m. to collect litter in the village. We managed to make the place look passable before the local people went to Mass. The concert site itself was littered with commercial snow, which was being eagerly harvested by seagulls, enthralled by a diet of stale chips and hamburgers. The crew were already dismantling the stage. Patrick was wandering around in a state of some distress. Almost the entire proceeds of his baked potato concession had been stolen. Gone were the dreams of his summer holiday.

We all retired to Cobby Knight's house nearby for a sun-drenched post-mortem. That night I hit Dublin with Sue and Ivan Rowan; Juliet stayed behind. I was finding it hard to wind down. We went to a night-club called Parkers. The owner, Pierre Doyle, was very tolerant. Steaks flew into ice buckets and the table-cloth was in shreds. I was deposited back at the Castle. The children found me the next morning asleep at the bottom of the stairs. Bill Graham had told me that after this my life would never be quite the same. He was right. That was The Rolling Stones.

After the concert I received a letter from a sergeant in the Garda Siochana from Headquarters in Dublin:

Dear Sir,

I am a Sergeant in the Garda Siochana and was on duty at The Rolling Stones Concert last Saturday. The organization put into it by yourself and your men was excellent and I feel a word of congratulations is in order.

Considering the sheer size of the event, you had covered practically all foreseeable situations, and it is certainly a case of 'credit where credit is due'. It certainly made our task much easier and I wish you well with any future concerts at Slane Castle.

By the way, the Castle and grounds are magnificent.

More than any other of the numerous letters we received after the concert, this was perhaps the most gratifying, because it showed some understanding of the effort and care taken by all involved. It also, perhaps, lulled everybody into a false sense of security. The atmosphere was to be very different following 1984. I also got a letter from Shay Healy, the composer of 'What's Another Year', the song that won the 1980 Eurovision Song Contest. It started off, 'I have just been released from intensive care.' He had attended the concert as one of our guests.

1982 was also a year of confusion and turmoil of a different variety, as my personal life started to fall apart. When Juliet and I had met in Portugal just after I left school, we were drawn together with a very particular intensity. We were very much in love. In many senses the strength of our bond had much to do with the domestic chaos that surrounded us. Between our respective sets of parents, there were well over half a dozen marriages — hardly conducive to stability. It was our

belief that we could reverse this trend, and cocoon ourselves from a harrowing past. It was not easy at Slane to lead a structured family life. In a very real sense, there was a conflict between the public space and our private lives. My thinking was dominated by Slane, and how to hold on to it, and simultaneously I was trying to break free from everything that the Castle represented in other people's perception. There was also a burning desire to involve myself in the mainstream of Irish life, and from 1981 I was increasingly conscious of the need to break through a barrier. Perhaps this was induced by reaching thirty years of age but, whatever the reasons, I was driven into a period of frenetic activity. I think Juliet found it both difficult and intimidating to live with, and I was displaying a very different pattern of thought and behaviour from a decade earlier when we had got married, when I was only twenty. In retrospect, we were too young, but then that never explains the way it was, and the feelings and passions of the time. I do not regret a moment of it, only the sense of failure and emptiness at the end. We were moving in different directions. Communications broke down. Then, perhaps inevitably, I got involved with somebody else. It was the symptom not the cause. That relationship was also to falter. It was perhaps the loneliest period of my life. Throughout it all, the only element that brought me peace was Slane, and yet it was also part of the cause. It has always been like that, giving succour and causing grief. It is both my friend and my enemy.

Before the Stones there was an element I had seen, but perhaps not properly understood: the two-edged sword of exposure. From here on in I was labelled 'The Lord who wants to rock', 'Rock Peer', or 'the colourful Earl of Mount Charles'. Promoting the Castle became intertwined with moving into public space. The kick of recognition is balanced by the quest for privacy. In Slane this becomes very difficult, as at times you feel like one of the exhibits. A sort of living ancestor. It is not unique; many owners of stately homes are confronted by it. Television makes this conflict worse, and in 1982 I got my first baptism. I was invited to be a guest on *The Late Late Show* hosted by Gay Byrne, one of Ireland's longest running and most successful television programmes. This was moving into a whole new arena, and I faced the prospect with some trepidation. The show was live and on occasions Gay Byrne could give his guests a rough ride. It also coincided with my somewhat nervous entry into politics, and it seemed inevitable that this aspect of my life, and indeed the peculiar circumstances of my background,

would be open territory on the show. I was advised by my friends that if I wished to enter public life, I had to learn to handle this sort of thing. I accepted and then realized there was another problem. Gay Byrne was experimenting with a new formula, and had invited both Ulick O'Connor, the writer, and Barbara Cluskey, a leading model, to join the programme to play the role of foil and fellow interviewer. There was no problem with Barbara Cluskey, but my last meeting with Ulick had not been particularly friendly. He had arrived at Slane in far from the best of shape. The occasion was a birthday party given for the late Ken Besson, whose family had owned the Hibernian Hotel in Dublin. Ken was a wonderful character, but subject to wild swings of mood, which made life difficult for both himself and those close to him. He was very friendly with Tommy FitzHerbert, and always very supportive of everything we were trying to do at Slane. He came down for his celebration in a helicopter. The party ended early. Just as we were retiring to bed, there was a commotion at the restaurant entrance and a member of the staff came rushing to find me. I charged downstairs to find a truculent and abusive Ulick, demanding entry and drink, and claiming he had been invited to Ken's party. He was accompanied by two ladies, whom he had brought from Dublin in a taxi. It was even suggested that the taxi fare should be put on the bill. The polite way to describe the end to this episode was, 'No way, sunshine.' Our next meeting was in the hospitality room before the programme. He was remarkably friendly. We had a conversation about my grandfather, whom he said he remembered. No mention was made of our previous encounter. Following the advice of a friend, I drank copious quantities of sweet tea before I went on. I was told it would help me if I was tongue-tied or in shock. Just the sort of advice really to inspire confidence.

The first few minutes were hell, but I had been given some indication of the initial questions, presumably to give me an opportunity to collect my thoughts and get used to the surroundings. Just as I was starting to relax, Gay Byrne came in with what was perhaps, in retrospect, predictable: 'Do you consider yourself English, or Irish, or some sort of strange colonial mixture?' This is the type of question that enrages me. There are fewer things more insulting than to have one's nationality questioned, but at the same time many see it as a legitimate question to ask. The surface contradictions are there. This strikes at the very heart of the predicament of the Anglo-Irish. 'I'm Irish,' was the answer, but as always I was reminded of the sense of feeling a stranger in my own land.

Many people have articulated the view that the Anglo-Irish have isolated themselves from the mainstream of Irish life. To a large extent that is true, but in many instances this is born out of apprehension, even alienation, which translates itself into 'lie low or get out'. When Gay asked the question he was stirring a cauldron that had been simmering for decades. Ulick then got in on the act. He asked me whether I was a member of any party. I had just joined Fine Gael. He said my support for the incoming Coalition government was inconsistent with my belief in private enterprise. I said I believed in a 'mixed economy'. Then he said my claim to be an Irishman was inconsistent with my using my title, and quoted Tony Benn, and then Thomas Pakenham (who, he said, had given his title to his motorboat. To my response, 'Why should I pretend to be something I'm not?', he came back with 'a cheap shot'. Barbara Cluskey then commented that I was wearing odd socks. A habit of mine for years, since I had worn such a pair by accident at school and I had won a race against all the odds. It brings me luck. As it happened on this occasion, one was red and one was blue. He then asked me whether there was any significance in the colour of my socks and shirt — 'Red, white and blue'. The shirt was blue, but might look white on the screen. I let it pass. At this stage Gay shifted the emphasis. Ulick was beginning to get up his nose as well. He asked me about my work in an Anglican Mission in South Africa. We then talked about the evils of apartheid. Ulick came back. He accused me of being 'indignant about South Africa and not about the North'. This was clearly a rather crude slur and I treated it with the contempt it deserved. Then back he came again with 'Throw the lord overboard.' By this stage Gay Byrne was on my side. 'Stick to that title, it's all right,' and it was over. Television had bestowed on me a new nickname — 'Lord Odd Socks'.

November had also marked another first: I finally decided to get off the fence, nail my colours to the mast, and join Fine Gael. Under FitzGerald's leadership the party seemed to be moving rapidly towards creating a more open and pluralist society. He seemed prepared to challenge directly all the ambivalence and double-think that bedevilled the country, and appeared to be a substantial enough individual to direct proper care and attention to the public finances, which were clearly moving out of control. Since meeting Garret FitzGerald in 1979 at the behest of Tony O'Reilly, I had been watching political developments with increasing dismay. By March 1982 I was toying with the idea of getting involved with a new political party. There were hours of

discussions, and a gradual realization that this would be an impossible task. In any event I lacked plausibility. 'A party of earls? of restaurateurs? of disco-owners? Well, they have political experience. They could stand candidates in a few constituencies. They have worked out many of their policies. But they remain firmly anonymous.' (*Sunday Tribune*) We really hadn't a hope. By the end of 1982 what was termed 'the national situation' had deteriorated further. Politicians' credibility was at an all-time low, and the country was facing its third general election in eighteen months. Fianna Fail would be happy to take any financial contributions, but I would be clearly unacceptable as an activist, nor would they be acceptable to me. Garret FitzGerald, at least, encapsulated so many of my beliefs. It was just before the government collapsed, and I was in bed with a mild dose of flu. I rang John Bruton, my local TD, who was shortly to become Minister for Trade and Industry in the new government, and told him I wished to join the party, and help in whatever way I could. He gave every indication of being delighted.

My father and Juliet did not greet this new involvement with such enthusiasm. What happened next turned into a bit of an ordeal. My arrival in the party caused more than just a ripple. The press had their fun with 'Fine Gael's Noble Lord', but I was starting to develop armour against this sort of label. The real problem was the local branch in Slane. To my consternation I was approached by the chairman and secretary asking me whether I would like to seek a nomination to stand in the general election. The mechanics of such matters were beyond me, after all I had only been in the party a few days. Outside advice was sought. It was then clear that the branch had some sort of commitment to another candidate. The solution to this matter, without showing a lack of political bottle, was to agree to let my name go forward only if the branch would give me their unanimous support. On the surface this seemed an unlikely possibility, but unexpectedly they called my bluff. Things were gathering a momentum of their own. Following this meeting, I was requested to attend a district meeting in a local hotel. It took place the same night as a charity dance at Slane, and we had arranged a private dinner party beforehand, and invited a considerable number of guests. Explanations for my initial absence were received with some disbelief. Arriving at the hotel, I discovered the meeting in full swing. I was the subject of heated discussion, and clearly several people resented what they saw as a 'blow-in'. I made a short speech explaining that the last reason in the world I had joined Fine Gael was to

be a source of dissension. I then retired to the comfort of the Castle feeling battered and bruised. So much for an invitation into party politics, but there was still my commitment to the local branch. They had chosen me to appear as their nominee at the convention held at the Kirwan Arms Hotel, Athboy, to select candidates. It was an extra-ordinary evening. Several of my supporters took me along, and fairly rapidly I realized that I was regarded by some as a joke, by many as a curiosity, and by a few as serious. John Bruton, TD, to whom just a few days before I had announced my wish to join the party, did not seem particularly pleased to see me. I muttered somewhat incoherently that allowing my name to go forward was not really my doing. It seemed to fall on deaf ears. The voting slips were distributed, and inexplicably some of the branch's slips seemed to have vanished. Annihilation was looming. Nicotine consumed. There were a couple of hundred people there. My name began with 'M'. There were seven people seeking nomination, I was second to last on the list to speak. The previous evening I had decided not to work from a written text. This was a new experience, and anything could happen. The theme chosen for the speech was a 'New Deal' for Ireland. Franklin Roosevelt is one of the twentieth century's giants. It was going to be well laced with rhetoric. John Bruton spoke first, and chose the same theme. I was trying to reconstruct the speech in my head and concentrate on assessing the audience. Panic and adrenalin. The rest of the speeches became a blur. Then it was my turn. Conscious of shaking, and hoping nobody would notice, I rose to speak. Hardly had I begun when I was challenged by a heckler, who referred to me as 'a bloody landlord', and questioned my right to be involved in Irish politics. That was the correct button to hit, but he didn't know it. 'I was born in this country; I was brought up in this country; I believe in this country – so I have as much bloody right as anybody else.' The audience was with me and I was away lambasting the opposition and calling for national reconstruction. I got a standing ovation, and made a respectable showing of votes, fifth out of seven, and gave Fine Gael headquarters a jolt. It was not an expected reaction. In the election campaign that followed I campaigned for Fine Gael. The local branch even persuaded Garret FitzGerald to visit Slane on the campaign trail. Fianna Fail lost the election and Garret FitzGerald was returned to power to head a Coalition government. John Bruton, TD, was appointed Minister for Trade and Industry. The post that he had wanted as Minister for Finance was given to Alan Dukes, TD, the present

[96]

leader of Fine Gael. Alan Dukes was first elected to the Dail in 1981. John Bruton was first elected in 1969. He is the present deputy leader of the party.

1982 had been a dramatic year. Things at Slane had moved into another gear. People had danced in the basement and danced on the lawn. Activity had been frenzied and placed a strain on the machinery. I seemed to travel more and more. Privacy had diminished, dimensions had changed. Things were never going to be the same.

8

Turbulence

Slane is the core of my life. However, as I moved through 1982, it became apparent that I was neglecting certain aspects of the place, with too much time spent in England, America and elsewhere, and the distraction and disruption of the concert. Gone were the days when I could act as head waiter, or spend hours lugging gas cylinders around the house. My hand was not entirely on the rudder. Somebody had to be put in overall charge of commercial operations of the Castle. Tommy FitzHerbert had been involved in the restaurant from the beginning, but Sue Wade had a wider experience in all aspects of catering. It became increasingly obvious that we were going to be doing more weddings and banquets, and in November I put Sue Wade in charge.

By early 1983 I was already making efforts to secure an act for that summer. In fact the first contacts had been established five days before the Rolling Stones concert, but these proved abortive. Then along the grapevine came the news that David Bowie was going on his 'Serious Moonlight' tour. It soon became apparent that Paul Charles, Jim Aiken and Eamonn McCann were all chasing the act. Visions of more complex and arduous negotiations flashed across my brain. In January Juliet and I were skiing in Courcheval in France. Trying to keep trace of developments, I made contact via telex with David Bowie's agent in New York, Wayne Forte of the International Talent Group, and secured a meeting with him in New York on 10 March. It had to be cancelled because I was rushed to the Lourdes Hospital in Drogheda for observation. I subsequently had an allergic reaction to a drug I was given. Not pleasant. A meeting in London on 14 March went by the board. We eventually caught up with each other on 24 March in New York. Negotiations ensued. Hopes were raised and then dashed. Speculation in the media was rife. By May it was apparent his tour wouldn't include Slane.

Defeat. However, contact had been established with Wayne Forte. In 1987 David Bowie embarked on his 'Glass Spider' tour. He came to Slane. There are many strands to a web.

On the home front relations with the local community were improving, but I was still profoundly aware that there was a group implacably opposed to the concerts. They were vocal and well organized. However, the benefits accruing to the locality from the Rolling Stones concert had copper-fastened majority support; and the drama, colour and excitement of the show provided the highlight of the year for many young people. The Slane Community Council were caught in a quandary. The intensity of the arguments was heightened by the attention of the media and RTE decided to do a feature on the controversy. Amongst others, I was interviewed by Carolyn Fisher for a programme called *Ireland's Eye*. The Community Council decided to hold a ballot, but on the basis of householders only, which I interpreted as a move to load the dice. 'To carry out a vote on the basis of householders is a practice which has not been pursued since the nineteenth century.' Their argument was that householders had most to lose. They distributed 555 ballot papers. Only 282 were returned. 228 favoured continuing the concerts. It was a good result. The following night's *Evening Press* ran a headline, 'Rock on, Mount Charles.' The next time we ran a show, we knew we had local support. I had a meeting with representatives of the local Community Council and discussed future co-operation. They were offered a free site on the estate to build a Community Centre. To date not a brick has been laid. The offer still stands.

The beginning of the year started to see an entirely different project come together. It was dissociated from Slane in both distance and atmosphere, but yet in essence its very appeal was its contrast. It helped keep all things in perspective. Following the trust's decision to reduce their investment in agricultural land in England, steps had to be taken to re-invest the proceeds. Old families tend to have an affection for tangibles. Again we were compelled to look across the Atlantic, this time to New York, where residential real estate looked interesting. The pace and verve of the city appealed to me. At the time Michael Miller, an old friend of mine since childhood, was based there. I went out to stay with him in March 1982, and with his help started pounding the pavements to find a suitable investment. The initial forays proved fruitless and I returned home. What was available seemed expensive and tacky – nothing with any real character. Slane had given me a strong taste for

the unusual. Mike enlisted the help of an Iranian real-estate agent with the exotic name of Chista Shashani. She found an apartment in a wonderful old townhouse on East 63rd Street, between Madison and Fifth Avenue – an ideal address. Mike went to inspect. The building was a bit of a shambles. It had been bought by a lawyer called Alfred Koeppel, who was in the process of converting the building into apartments, keeping the penthouse for himself. Mike telephoned and said I should get on a plane, explaining that he had found something that displayed shades of Slane. One of the apartments was on the old drawing-room floor, with three large french windows, a dramatic fireplace, and imposing late nineteenth-century plasterwork. The building was dated 1901. None of the apartments had been sold. Arny Copper, a leading New York interior designer, with whom Juliet and I had stayed in the early seventies when I was still at Harvard, vetted it, and we established that it showed enormous potential. The internal reconstruction was not completed until early 1983. Then came the time-consuming task of decorating and finishing the apartment. The end result was a sort of 'Slane in the Sixties', an atmosphere created by the imaginative eye of Arny Copper. It proved a stimulating distraction from the turbulence at home.

Politics was becoming an absorbing interest. During the political upheaval of the past eighteen months, the pro-life groups had exerted enormous pressure on both main political parties to include an amendment to the Constitution protecting the rights of the unborn. I watched with dismay as the advocate of a pluralist society moved towards introducing a referendum, which if passed would reflect an even deeper Catholic ethos in our Constitution. In the 11 March issue of the *Drogheda Independent* I declared: 'The main aim of all political parties here should be to work towards a United Ireland. However, the amendment will not be of assistance in this respect. Loyalist opinion will see us as sectarian. The role of government is to govern. At the moment there is rampant unemployment and major social problems are facing us. This referendum is a distraction, divisive nonsense, and a waste of Dail time and taxpayers' money.' It was to cost a million pounds. It was the first indication of Garret FitzGerald's incapacity to deliver on his 'Constitutional crusade'.

At the end of March, I was invited to address a public meeting in Kilbride, a small village in County Meath. It was organized by the local branch of Fine Gael. It gave me an opportunity to articulate my views on

what the government's priority should be. With a shade of melodrama the title of 'What Future for our Country?' was chosen for my speech. As an act of great kindness, Dick Burke, our then EEC Commissioner, turned up to lend support. Dick had been partially instrumental in persuading me to enter politics, for which I respect him, because he does not share my views on all matters. Several friends turned up to swell the ranks. There was a small crowd. John Bruton turned up as I was beginning my speech. He looked decidedly surprised to see Dick Burke in the audience. The speech went down well. I had been advised to distribute it to the press. No reaction was expected. It was the Thursday before Easter. To everybody's astonishment it was carried on the front page of the *Sunday Independent*. The headline was mildly unfortunate: 'Coalition can't manage accounts – FG Peer.' It declared that I 'slammed the Taoiseach and the Coalition Government for failing to properly manage public spending', and outlined my continuing opposition to the referendum, but the quote that struck a raw nerve was as follows:

> Which way we turn is in the hands of the Government . . . they must act and act swiftly, before the very fabric of government as we know it comes crashing down around their ears. No wonder the ITGWU is incensed. All the self-employed are incensed, and every farmer in this country is incensed. The anger embraces the entire nation. It is not surprising the black economy grows daily and that corporate and entrepreneurial energies are dissipated in pursuit of reducing the burden of taxation. Our money is plucked from us and thrown back in our faces.

Such remarks were not greeted with universal approval within the party, but few could deny their relevance. I was also reminded of the activities of the moral crusaders, those that sought a Catholic Constitution for a Catholic people. A few days later I received a letter on the proposed pro-life amendment: 'If it costs one million, five million or ten million to save one unborn baby from being slaughtered in its mother's womb, it would be worth it. What price human life – God's gift?'

There was another form of turbulence roaring to the surface. It was of a much more painful and private kind. Juliet and I had decided to separate. She moved with the children to the Isle of Man at the end of March. Anybody who has lived through the trauma of a disintegrating marriage will understand the extraordinary stress it induces. Failure, guilt, recrimination, a well of emotion. Alone at Slane, with the children

gone, no small feet in the house, I was gripped by a kind of paranoia, not helped by the press. The chief bloodhound of the Irish gossip columnists, Trevor Danker of the *Sunday Independent*, got hold of the story. This was the kind of thing that was grist to his mill. He caught me on the telephone and put such awful words in my mouth as 'I know there are people trying to throw a lot of dirt at me. I have heard stories that I am supposed to be womanizing, that my wife has left me, and all sorts of mischievous nonsense.' I was in such a state of anxiety I couldn't recall what I'd said. The day before publication, the *Independent* ran a flyer to promote the article stating, 'Lord Henry fights the rumours', accompanied by an appalling photograph of me in a dinner jacket, looking as if I had my nose stuck permanently in the air. The only joke about the article was that the *Independent*, in a display of wonderful photographic accuracy, used a photograph of Adare Manor, then the property of Lord Dunraven, instead of the Castle. Ever since I have always been reluctant to take calls from Trevor Danker.

Amidst this private turmoil, life had to go on. Frustrated by the Republic's archaic licensing laws, which restricted us to selling wines, sherries and similar types of drinks, but not our native produce, it became increasingly apparent that action had to be taken to rectify the situation. If any large receptions were held, we had to rely on the goodwill of a local publican to take out an occasional licence, with all the attached additional costs, and loss of profit. There seemed little prospect of the laws being changed, such was the government's inertia in this area. Now, some five years later, they are finally coming to grips with the problem. In late 1982, I purchased two 7-day publican's licences from a solicitor in Limerick for £12,500. This was the first step towards being granted a new licence. The local publicans in Slane started to grumble about the moves we were making. Considering the income that some of these establishments have generated from our activities, my sympathy for their objections was severely tempered. In early February we made an application to Naas District Court, a suitable distance from Slane to deter all but the most determined objectors. The licence was granted. It enabled us to develop our reception business, but at a cost. Following receipt of the licence a permanent bar was constructed in the main hall of the Castle, much to the consternation of architectural purists, who saw this as an act of desecration amidst Francis Johnston's classic work. Such individuals are quick to criticize what they see as vulgarity, but possess little understanding of the mechanics required to

maintain a stately home. I have to walk a fine line between aesthetic considerations, memories of the past, the commercially viable and the interests of future generations. In any event, it can easily be removed, leaving no trace. Many outside observers are possessed of tunnel vision, seeing only the gem, not the many facets that go to make it. The end of 1983 also saw another step towards modernization of the Castle. We installed central heating. It may have interfered with the muscular development of all concerned, courtesy of the gas cylinders, and denied us the sensation of seeing our breath on a cold winter's morning before venturing out of bed, but it did have the virtue of allaying the fears of potential clients that they were going to have to endure stoically a cold and draughty Irish Castle. The final flourish to this drive to improve our facilities was to add a fitted carpet to the main hall, covering the old stone flags. This may have disturbed some nostalgia merchants; it brought back my own vivid memories of noise and the running of youthful feet. I got Stoddards Carpets in Scotland to repeat an old design made up for the Castle from my grandfather's days in Navan Carpets. It gave the present a past.

Disconsolate at the failure to get David Bowie to Slane, I leapt at the offer of a joint promotion with Eamonn McCann and Denis Desmond of MCD. The suggestion was to put together a show with 'U2 and Special Guests', and the proposed venue was the Phoenix Park Racecourse, just outside Dublin. U2 were starting to blaze a furious trail. Their last album *War* had been an outstanding success in England and Ireland, and they were beginning to make a significant impact in the United States. I set up an additional company called Slane Castle Productions, and talked to the bank. Financing shows costs a great deal of money. The next problem was Phoenix Park Racecourse. Would the board accept the proposition of rock and roll at a venue used to thundering hooves and placing of bets? We were fortunate in that Jonathan Irwin, the Chief Executive of the course, has more than a touch of the impresario in him, and that Mark Kavanagh, then a member of the board, has aspects of his character a similar construction. Following extensive discussions the deal was put together, and the date chosen: Sunday 14 August, the day before St Erc's Day. U2 had played at the first concert in the Castle in 1981. The date had been 16 August – a coincidence.

Denis and Eamonn then set about putting together the rest of the line-up. It was to be a unique bill, in my view one of the most exciting

combinations seen in Ireland for years: U2, Eurythmics, Simple Minds, Big Country, a reggae band called Steel Pulse, and Perfect Crime from Belfast. It was, to Eamonn and Denis's credit, the hottest ticket possible; and therein lay the rub: we should have staged the show at Slane. In 1983, U2, Eurythmics, Simple Minds and Big Country all rose like rockets. The Phoenix Park Racecourse was a venue with a limited capacity, not the twenty-two acres at the Castle. However, for several reasons, following the huge attendance at the Rolling Stones concert, it would have been crucial to have drawn a crowd comparable in scale. It was also essential for U2 at this critical stage in their career to be riding on a sell-out, or playing to a near-capacity crowd. Slane is a daunting venue to headline, but at the end of the day this bill was big enough to have played Slane.

Staging a show at the Phoenix Park presented certain logistical difficulties, not the least of which was the parade ring, a central feature of the course, which Jonathan Irwin and his colleagues wanted carefully protected. There were lengthy discussions about roses and grass. Such problems didn't exist at Slane. The decision was made to have the stage straddling the parade ring, which had the added advantages of protecting the jockeys' changing rooms, and providing space for the bands. It was erected by an entertaining part-time farmer from England called Steve Corfield. His firm was Up Front Productions Ltd, 'because that's the way we like our money'. The disadvantage was that this position did not afford the maximum sight-lines, but seemed the only method by which we could protect the ring, and avoid causing a dangerous obstruction.

When we put the tickets on sale, they started going like hot cakes. There was a gap in the market and, from a fan's point of view, this was a mouth-watering bill. Usually promoters like the solace of fast ticket sales, most particularly when costs start creeping up. However, this initial well-being began to dissolve when we discovered we were going to have a sell-out on our hands. Then the inevitable happened: a group of Dublin-based racketeers printed between 4,000 and 5,000 forged tickets, and started distributing them on the Thursday before the gig. As the tickets had a face value of £10.50, the forgers stood to gain between £40,000 and £50,000 – a very substantial amount of money. The forgeries were good, and were going to be difficult to identify. That wasn't the only problem. It would create huge pressure at the entrances, and present the possibility of a crowd too big for the site. We had good

information, and hence a strong indication of who was behind the fraud. In addition, we had discovered at least one outlet where the forgeries were being sold. We informed the Garda Siochana, the Fraud Squad, and even a minister in the government to look into this, not only as a serious case of fraud, but also as an issue of public safety. Assurances were given that at least fifteen members of the Garda Siochana would be present at the entrances. On the day itself, I could find only five. Two arrests were made for selling forged tickets. Threats were flying around. This was all beginning to turn into a very rough ride.

Tension was running high the night before the show. My brother Patrick was at Slane helping to keep me calm, and three friends had flown in from the States: Tony and Cynthia Maltese and my then girlfriend Jan Pedersen, the New York-based dress designer. I rose early on the morning of 14 August. Looking out of the window I saw mist rising from the river, and heard the soft rushing of water over the weir below the Castle. It was so serene and peaceful compared to the onslaught ahead. There was hardly a cloud in the sky. We were going to be blessed with a scorcher. I swallowed a pint of milk, and a cup of strong sweet coffee, and headed for the Phoenix Park. The others would come on later via helicopter.

The day itself is a patchwork of memories composed of aggravation and triumph. From the beginning there seemed to be pressure at the gates. Initially we tried hard to lift the forgeries, but this started to cause more problems than it solved, because it created congestion, and impeded the flow of people. However, by allowing those with forged tickets admittance, we were placing strain on the capacity of the venue. As at all concerts I have been involved with, we were running a dry site. The confiscation of alcohol is always a hassle. Huge bins filled with plastic containers full of beer and cider and all sorts of concoctions. Some argued vociferously that there was no information about an alcohol ban printed on the tickets. 'No drink, and that's it,' we repeated over and over, watching the counting of tickets and taking of money. We had kept some tickets to sell on the day to ease the pressure.

If the entrance provided problems, security induced permanent migraine. This proved to be a very heavy gig. I hired a helicopter to help cover the security on the site. Up in the air it was possible to see what was happening, and one had the added advantage of being able to travel to the far end of the racecourse. The entire track was a huge area to cover. Then there was the problem that is always a hard nut to crack.

[105]

Slip the guy a fiver and he'll turn the other way; you are in at a healthy discount, and he's developing a nice little side-line. Let in one and get away with it. Why not a hundred? At the Phoenix Park we had a very specific problem. It took a while to work out what was going on, for the straight security to sort out the problems caused by the bent guys. More people in, more stress on capacity.

The worst aggravation of the entire day was at the gate by the car-park, adjoining the Navan Road, which runs down one side of the racecourse. This particular point was selected by a group of punks for their afternoon's entertainment. Their first act of violence was to start stoning the helicopter. The somewhat distraught pilot, looking at the dents in the cockpit, decided to flee to Dublin Airport. No longer having a machine to vent their spleen on, they turned their attention to the security men and started to charge the gate. Mark Kavanagh and I looked on with alarm. Security started to withdraw under the barrage. The gate was going to give. Mark and I exchanged glances. It was a case of 'Once more into the breach, dear friends.' We hurtled towards the gate and led a charge to re-secure the area. The gate gave way, and in came the punks. They had knives, and one hurled a stone which whistled past my face. One delightful representative of this gentle collection showered me with spit as he careered past. We recaptured the gate but the worst of the punks were in. They then started to fight in the middle of the crowd, and seized portable chairs and started smashing them to bits. Eventually Eamonn marshalled sufficient security to cope with them. If this were not enough drama, some adventurous characters decided to climb on to the roof of the stands. Jonathan Irwin and Mark Kavanagh started to lose their cool. The Master of Ceremonies pleaded from the centre of the stage. Eamonn, together with Frank and Harry McEwen, who were running the security, coaxed them down. The crowd were getting restless waiting for Eurythmics to come on stage. Eventually the stand-clamberers descended to the ground. Annie Lennox strode on. She was greeted by hecklers who shouted 'Go home to England', and hurled fruit at her. She is Scottish. She rose to the occasion, only interrupting her set to admonish a bottle-hurling cretin near the front of the barrier. Lennox has style, and one of the most exciting singing voices around, in stark contrast to the strong Scottish accent with which she had greeted us backstage. Big Country, Simple Minds and Eurythmics were magnificent. U2 were electric. They went on stage at 8.30 p.m. precisely and broke into a number called 'Out of

Control'. The crowd went berserk. It charged up the band. Paul McGuinness was smiling. 'Two Hearts Beat As One.' My American guests and the Minister for the Arts, Ted Nealon, TD, were wide-eyed. Patrick was enjoying the company of Simple Minds. This was U2 at their best – raw. The show ended at 9.50 p.m. Exhaustion. Voice hoarse. Thirst quenched, unwind. Much later, we made for home at snail's pace. The next day the *Evening Herald* ran a headline: 'U2 – a huge triumph', but others were not so good: 'Punk chaos at gig: we lost control, admits Lord'; 'Henry under fire at the Park' (*Evening Press*). The following day Michael Barrett, the Fianna Fail TD for Dublin North West, was quoted as saying, 'These Rock Concerts and festivals have turned into orgies of sex, violence and drug abuse and seem to attract the very worst elements of society.' In 1984 we would have Bob Dylan at Slane. We thought it would be a soft gig.

In early June 1983, an idea that had been germinating in the back of my mind started to surface. The European parliamentary elections were due to take place the following summer. Dick Burke, our EEC Commissioner, whom I had first met in 1981, had encouraged in me a growing interest in European affairs. Developments within the community have been crucial to the future of Ireland, not least because of our disproportionately high dependence on agriculture, and our position as a less affluent and populous nation than the European norm. There were other considerations that made the prospect of a seat in the European Parliament attractive. It was an ideal arena in which to raise the issue of Sellafield. It has always struck me as ironic that if there was a major nuclear accident at this installation, the levels of radioactivity endured by members of Dail Eireann would be significantly higher than those of parliamentarians at Westminster. Sellafield's far from distinguished record since the first major accident in 1957 has done little to inspire confidence that the British authorities will show any respect for the anxieties of the Irish nation, a nation exposed to all the dangers, and yet without one iota of the economic benefits.

The European Parliament was also to create an interesting precedent by issuing a report on the North of Ireland, much to the indignation of the British Prime Minister, Margaret Thatcher, who saw it as an interference in the internal affairs of the United Kingdom. It was the stark statistics included in the report that had the most impact. Between 1969 and the summer of 1983, 2,300 people died in the North, and

24,000 were maimed or injured. In addition, the security provisions made by both the Irish and British governments had absorbed in excess of a billion pounds. What an indictment. What a waste. It was the European Parliament that saw the island of Ireland as a whole. Far in the future, perhaps European development would dissipate the degenerative effects of atavistic loyalties. One other significant factor remained. We are a neutral nation, the only member of the European Economic Community to remain outside NATO. Our neutrality, which has seldom been properly thought out or articulated, could be used in a positive and active sense to question the enormous resources devoted to nuclear and other forms of military expenditure. As a small nation outside the military alliance and yet within the community, we are placed in a unique position of responsibility in this area. We can rightly claim that the decisions emanating from NATO affect us, and yet we do not participate in those decisions. The precipitation of a conflict in Europe would involve many other nations outside the Alliance. Within the Community we would help to voice this concern.

However, it was one thing to hold these strong beliefs and quite another to find a way of expressing them. The constituency of Leinster, in which County Meath is situated, stretches from County Wexford to County Louth, and although since joining Fine Gael I had made some impact, in this respect it was merely a ripple in a pond. I had what is politely referred to as a major credibility problem. I consulted a few of my closest friends. The consensus was that it would be an extraordinarily difficult task to accomplish. However, because of the size of the constituency, it presented an excellent opportunity to articulate my views, and to try and break down the prejudices that existed against somebody from my background – prejudices which were alive and well, even within the ranks of Fine Gael. I decided at least to float the idea and wait for a reaction. The first step was at the beginning of June. I was interviewed by a journalist called Michael O'Toole for the *Irish Press*. The headline for the article said it all: 'Odd Man Out – The Lord with a credibility problem', but it gave me an opportunity to start blazing the trail.

> I believe I have something to offer and want to make a contribution just as many other young men and young women of my age want to make a contribution to the life of the country. For over fifty years now people of my background have lived with their heads in the

sand. They have adopted such a low political profile that the people at large are barely aware of their existence. Now I happen to believe that we have to break out of this historical prison.

Approximately two weeks later I let slip that I intended to seek a Fine Gael nomination for the constituency of Leinster. The *Sunday Press* savaged me in a small article entitled 'Mount Charles or Don Quixote', stating that I had been mounting a 'Don Quixote type assault against the battlements of Irish politics for quite some time, and now he has announced that he is set to tilt against the windmills of the European Parliament'. Sharp words run deep, and to keep a sense of humour is paramount. In a similar vein, some two years later as I staggered round Ireland with actress Jeananne Crowley and the Irish comedian Frank Kelly, judging the Black and White Whiskey Pub-of-the-Year Competition, Frank looked at me straight in the eye and said, 'The problem with you, Mount Charles, is that you were born with a silver dagger in your back.'

During June, July and most of August, I let the hare sit. In any event there were many other factors playing on my mind, not the least of which was the U2 Concert at the Phoenix Park. There was, however, one exception. I offered to open the house to the public to raise funds for the Slane District Executive of the Fine Gael Party. The house was not open then on a regular basis as it is now, and thousands turned up driven by curiosity and the publicity generated in the national press. To add a little colour to the event, we had the jazz band from the Phoenix Park Racecourse playing on the lawn. We were bringing their music to us; a week later we would be bringing our kind of music to them. After it was all over, I was hoarse talking about our ancestors. The Slane District Executive had swelled the local party's coffers, and it had been made perfectly clear that my shot at a nomination for the European Parliament was no straw in the wind.

In Ireland the political season does not start gathering momentum before September. Dail Eireann tends to be in recess for an inordinately long time, which may suit fragile administrations eager to hold on to power without being answerable to parliament, but greatly inhibits the efficient working of the legislature. For years this practice has continued. Frankly it is inexcusable. As the scars of the Phoenix Park concert receded into the background, I turned my attention to seeking the nomination. If there was to be any chance at all, it was a question of

starting early. The opposition was fairly formidable: Mark Clinton, the sitting Member of the European Parliament, and a distinguished former Minister of Agriculture (it was not to my advantage that he too came from Meath); Deirdre Bolger, a Wexford County Councillor, who had been elected to the Senate in 1981 and 1982; Senator Charlie McDonald, a former TD and MEP, and Patsy Lawlor, a County Councillor from Kildare. There were others too, contemplating flexing their political muscles, including Councillor Tom Kelly from my own district, who had been a candidate for the party in the last general election. At the end of August, a meeting was held at the Castle with a group of local supporters to discuss strategy. There was a total number of 739 delegates who would eventually vote at the convention, and they were scattered all over Leinster. It was going to be hard enough getting bedrock support in my own constituency before looking to outside support. Since then I have learnt only too well about scraps in the backyard. Those attending the meeting were very blunt about my image – everything from my title, my role as landlord, sex, drugs and rock and roll. There was, however, one reassuring factor. They all felt that if I got a nomination, I could take a seat. The nomination was the problem.

Then came a piece of good fortune. The editorial team of the party newspaper asked whether I would like to write an article for the September issue. It was an opportunity not to be refused. It was rather poignantly entitled, 'In search of an identity'. It was then picked up by the *Sunday Independent*: 'New boy, Mount Charles, sets a poser for FG.' They quoted the right passage:

> What dusty shelf has the Constitutional crusade been cast upon? Where lies the imaginative thinking in our approach to economic matters? Most important of all, are we as a party providing the impetus to enable our leaders to carry out the tasks for which we all worked so hard to put them in a position to achieve? . . . Are we to be a party of reform? Will we have the courage to realistically address the question of family planning? Are we to be a party that will seriously tackle the question of marital breakdown?

Mind you, not everybody in Fine Gael was receptive to this kind of thinking, but it was an opening to show the kind of territory that I wanted to carve out.

Then quite unexpectedly I received an invitation to join a group of Fine Gael politicians and party activists on a trip to West Germany. We

were all to be guests of the Konrad Adenauer Foundation. It is what some people call a junket. To be honest, it couldn't have come at a more inconvenient time. I had planned a short holiday. I was also a little wary of leaving myself open to a crew like this for a week. Still, West Germany was a new country to visit. It would certainly be educational, and possibly helpful in trying to secure the nomination.

There were nineteen in the party. They included Bernard Allen, TD for Cork North Central, and the current Lord Mayor of Cork City; Gay Mitchell, TD for Dublin South Central; a collection of Senators; Jim Corr, Councillor and former TD and Lord Mayor of Cork, who was a potential European candidate for the constituency of Munster; a series of constituency public relations officers, and a party activist from Dublin West called Joe Kenny. It didn't take me long to realize that this team regarded me, at best, as something of an oddity, and, at worst, as a bit of a joke. Joe Kenny, who has in the intervening years become one of my closest friends, admitted that he thought I was probably a 'bit of a prat'. If I developed a mild case of anxiety when we gathered at the airport, by the time I eventually clambered into bed at the Hotel Vier Jahreszeiten in the heart of West Germany it had dawned on me that I was regarded as more of a victim. Most of the furniture had been removed from my bedroom. I had been worrying about getting delegate votes, when my whole credibility was at stake. If you can't beat them, join them. When we arrived in Berlin, in an effort at retaliation, and with Joe Kenny's help, I got the key to Gay Mitchell's room, ripped the sheets off his bed and stuffed them in a bath of cold water. Apart from such frivolous and childish pursuits, the trip was extremely informative, and gave me an opportunity to get an insight into the problems confronted by a divided Germany, and to discuss at some length my hopes of getting a nomination to stand as a candidate for the European Parliament. However, believe me, after encountering that crew there were no illusions: it wasn't going to be easy.

I returned home from Berlin via London. It was a chance to spend some time with the children. I missed them desperately. On Monday 10 October, I arrived back at Slane. In the early afternoon, a rather serious and efficient character with a remarkable eye for detail arrived at the Castle, accompanied by a mass of equipment. He proceeded to move into the Chinese lantern room. He returned the following day with the second instalment. His arrival caused a mixture of amusement and excitement amongst the staff. His name was Dennis Sheehan, and he

was the tour manager of U2. It was the beginning of an invasion. It marked the birth of *The Unforgettable Fire*. The arrangements had been tied up with Paul McGuinness, the band's manager, and their all-seeing eyes. He likes to think of himself as number five to their four. They are the front line of the music. He provides the orchestration. They too call him 'the fifth member of the band'. Paul had first been at Slane during 1977 for the shooting of the ill-fated *Flying Dragon*, in which I played the cameo part of a gigolo. Paul was an assistant director. By a curious twist of fate, he has now acquired the rights to this celluloid masterpiece. For the sake of all concerned, I hope it never sees the light of day.

Following the Phoenix Park show, Paul and I had been discussing the band's plans for their next album. He explained that they were looking for a location to rehearse, and possibly record, outside of Dublin city. *The Unforgettable Fire* was going to be a very different record from its predecessors. Under normal circumstances, I would not have considered offering Slane as a facility for a band, because it necessitated sharing my own private quarters, and I did not yet have the tranquillity of Beau Parc for solace. However, this was not a normal situation. U2 had helped inaugurate Slane as a venue, and they were sympathetic to the pull and the atmosphere and the great antiquity that pervades the Boyne Valley. Most important of all, they had an unusual affection for Slane and I for them. With U2 I could share my space, with others I could not; Paul and I made a loose arrangement. U2 breathed a different form of life into the Castle, and new friendships entered my life.

The European nomination was still very much on my mind, and while the Castle reverberated to the collective creativity of Bono, Adam, Edge and Larry, I endured the seemingly endless round of meetings and consultations, culminating in the Fine Gael Ard Fheis (Party Conference) at the end of October. After all this my level of tolerance was stretched to the maximum and I was tired of hearing what an impossible task lay ahead of me. It was a moment of weakness and introspection. Shades of the outsider. Shades of isolation. Conversations in Berlin. It seemed momentarily as if political involvement was useless, and that I was dissipating energy in an arena in which I would never be accepted. It was not the last time such feelings surfaced. I took a plane to New York and stayed there a week. The buzz of the place cleared the depression. While there I wrote a speech, which was due to be delivered three days after I returned.

During the summer, David Burke, son of the EEC Commissioner, and

public relations officer of the University College Dublin Law Society, had approached me to inquire whether I would be willing to participate in a debate on the motion that 'Violence no longer serves the interests of the people of Northern Ireland'. This presented no problem, but there was another aspect to the proceedings that was relatively more controversial. They also proposed to invite the President of Sinn Fein, Gerry Adams, MP, to join the debate. In Ireland there exists a very peculiar piece of legislation, Section 31 of the 1957 Broadcasting Act. Similar legislation was introduced in Britain in 1988. It prohibits Sinn Fein, among others, from access to the air waves, or television. In Ireland it is renewed every year. In effect this meant that British television was at liberty to interview, dissect, and analyse all strands of opinion in the North of Ireland, while the Irish National Television station was restricted in its ability to reflect the true nature of events. The extension of this stance is that members of the Fine Gael Party should not share a platform with Sinn Fein. For years I have believed that Sinn Fein should be out where we can see them. The photocall merely perpetuates the shallow examination of the smiling face of terrorism. There have been in excess of 80,000 people in the North of Ireland who have voted for an organization that openly advocates the use of a ballot box in one hand and an Armalite in the other. If we cannot confront the underlying issues behind such a state of affairs, what hope is there of ceasing all this wanton carnage. I utterly reject the hideous campaign of murder waged by the Provisional IRA but I defend absolutely the right to freedom of speech. The sole restrictions that should be placed on public utterances are those designed to inhibit those who seek to incite others to violent acts. I chose to participate for all of these reasons, 'but above all because I reject completely those of any political hue, who choose to seize the Red Hand of Ulster, and to take it dripping with the blood of the innocent and wipe it across the face of Ireland'. When I returned from New York, David Burke informed me that the motion had been changed at the insistence of Gerry Adams to 'The Use of Force is not now legitimate in the cause of Northern Ireland'. This was a capitulation, and seen as such. There was no doubt in my mind that the second wording was chosen specifically because of its superior merit as an instrument of propaganda. In response, I made my appearance conditional on the inclusion of a card-carrying member of the SDLP on the platform. The Law Society had managed to persuade Sean Fearon, Chairman of the SDLP, to attend. The stage was set. There was the predictable hype: 'Peer versus Provo' and publicity of a similar nature.

[113]

To be honest, when the evening arrived I felt remarkably tense. Several friends had come along to give moral support, including Adrian and Penelope Lindsay-Fynn and Adam Clayton, who sat in the front row clutching a tape recorder. Anxiety was reduced by the presence of Eamonn McCann, the radical journalist from Derry, who appeared clad in a black leather bomber jacket, in sharp contrast to my pin-stripe suit. Eamonn and I come from different ends of the spectrum, but we share a healthy contempt for hypocrisy and a knowledge that there is something amiss with the established order of things. Eamonn has a wonderful pithy sense of humour, and as we posed for photographs and exchanged jokes, I felt more at ease. Eamonn was to save my sanity after the Dylan concert, but that was to be in a different world, and the cure lay more in the liver than in the head.

By the time we went into the auditorium, Adams still hadn't appeared. The theatricals were fairly predictable. He arrived when Eamonn was in full swing. He still got a very warm reception. Eamonn, articulate as always, and speaking without notes, homed in on nuclear defence. In the event of war 'Do you know that US defence estimates include the provision of fifteen 500-bed hospitals in England? And Margaret Thatcher can actually stand up and say she condemns violence'. Definitely vintage McCann. I was watching Adams. Surprisingly, he was extremely nervous, at variance with the public image. Eventually it was the turn of Captain James Kelly, the man reputed to wear cuff-links made from gun metal, shaped in the form of crossed rifles. His speech was dreadful, and I was losing the drift of his argument, when suddenly – terrible moment – he launched into a tirade against General Frank Kitson and his controversial book *Low Intensity Operations*, which was the definitive work on counter-insurgency. A cold prickling sensation ran up and down my back, and I glanced towards Adrian Lindsay-Finn, who had some conception of what was going through my mind. Visions of Captain Kelly turning on me raced through my brain. General Kitson was a Faber author, and I had done some work on one of his books. I could even remember taking him out to lunch. Nearer to the bone, he was a relation of Juliet's – not especially close, but a relation. I was convinced Captain Kelly had made the connection. The irrelevance would not matter, it would have a suitably dramatic effect. He drifted on. The moment had passed. I regained my composure. Adrian smiled. It was moving to my turn. When I stood up, I got the catcalls. It was, after all, a student debate. 'Lord Henry is actually very good, once he gets over

the audience's jeers at his accent. "I can whistle just as well as you can," he tells them and that shuts the brats up.' (*Sunday Tribune*) Adams followed, his speech almost inaudible, although the content was quite well structured. He had a comb sticking out of his back pocket. We did not shake hands. Although I have met Danny Morrison since, it is the only occasion I have met Adams.

Section 31 of the 1957 Broadcasting Act is still in existence, and people are still being slaughtered in the North. In my speech I quoted a passage from a book entitled *The Irish Free State and Its Senate* written by Donal O'Sullivan and published in 1940: 'Tragedy, in Hegel's words, is the conflict not of right with wrong, but of right with right; and this philosophic truth is here exemplified. The Irish nation has an inalienable and sacred right to territorial unity. The Northern Protestants have a right to retain that allegiance which has been theirs for centuries. Until these two rights are acknowledged and reconciled, we shall make no progress.' Forty-eight years later, these words still have a chilling relevance. As expected, my participation in this debate was not greeted with enthusiastic approval by the Fine Gael establishment, and interestingly enough, one of those who chose to express his indignation most strongly was a journalist called Eamonn Dunphy. In 1987, he had a book published by Viking. It was called *Unforgettable Fire: The Story of U2*. To my knowledge, he does not know that Adam Clayton was in the audience, kindly lending me his support.

1983 was a painful and traumatic year, and it ended in a flurry of activity, scrambling to meetings, openings, debates and functions, from Kilkenny to County Cork. The Castle played host to the Christmas season's activities, including the Meath Hunt Ball. All this bustle kept the pangs of personal anguish at bay. Juliet and I had irreconcilable differences. We were going our separate ways. Her lawyer got involved. I do not hesitate to say that I found the man insensitive beyond belief. It was only through our shared desire to avoid a conflict that we averted a pitched battle. We agreed to change our lawyers. My new solicitor's surname was Faith. As Christmas approached, I needed to escape and left for New York. From New York, I went to Connecticut, where my old friend Arny Copper had a house. It was cold, but conducive to thought. The year had been turbulent, at the end of it there was a growing sense of isolation. Distance drew me home. I returned to Ireland on 2 January. Driving my car from the airport, and sweeping down the Dublin–Slane road to the river Boyne, I knew I did not want to be anywhere else.

9

Kill, Fire and Riots

The Orwellian year began with a bang – literally. The traditional family shoot was held on 4 January. This emphasis on continuity seemed important. Old family friends gathered, some of my father's generation. Memories past fused with the present, something unchanging: the whole day has a reassuring ritual about it. It marks the passing of a year, and a path back to childhood. Long may it continue.

The following day saw the unfolding of a different scenario. Towards the end of the previous year I had been approached by Harold Clarke, Chairman of the Irish Book Marketing Group, and asked whether I would agree to be one of the judges of the 'Top of the Irish', a selection of the twelve great contemporary Irish writers. The other judges were Rita Childers, the widow of the former President, and Robert Kee. About 100 books were submitted. Robert Kee dropped out because of pressure of work, and if I had been possessed of all my faculties, I would have done the same. Robert Kee was replaced by Colm O'Briain, a founder of the Project Arts Centre in Dublin, and a Director of the Arts Council. In July 1983, he had been appointed General Secretary of the Irish Labour Party. Fortunately I had read some of the books, but it was impossible to cover all the material. The process was somewhat haphazard. The selection of the judges was treated in some quarters with contempt. 'Now what, you may well ask, qualifies these mini-celebrities to sit in judgement on modern Irish fiction? If you have the answer, the Irish Publishers Association, CLE, would like to hear from you, because as far as they are concerned, the appointment of Robert, Rita and Henry is as Paddy Donegan might say "a fucking disgrace".' (*Phoenix Magazine*) Paddy Donegan is a former Fine Gael Minister of Defence. He had insulted the President Cathal O' Dalaigh in somewhat similar terms. The President had resigned. Frustrated by the drive for consensus that meant

excluding such contemporary giants as Molly Keane, I stuck out for subversion. Instead of twelve, we selected thirteen, and I got a book by Mannix Flynn called *Nothing to Say* included in the list. It is a rough and vital work, not recommended for the weak-hearted. 'Mannix has been chosen among a dozen of the "greats" of contemporary Irish literature. A panel of judges, including that self-confessed nose picker, Lord Henry Mount Charles of Slane Castle, have singled him out for greatness this year, while writers like Hugh Leonard and Maeve Binchy can stew in the shade. I am now forced to reappraise his great masterpiece *Nothing to Say* which I had considered to be a most apt title. Dammit, I may even have to read it.' (*Evening Herald*) On a New Year's Eve Special for RTE, recorded before I left for the States, I had been asked what was going to be my New Year's resolution. I had declared solemnly I was going to give up picking my nose. Some members of Fine Gael said this was bad for my image. Good God, there is always the nose-picking vote.

On 29 November I had written to the Taoiseach, Garret FitzGerald, formally indicating my intention to seek a nomination for the European elections in Leinster. There was no turning back. At the beginning of October, I had persuaded Susan Devane, the secretary of the Slane branch of Fine Gael, to help co-ordinate my campaign. Beneath her demure and attractive exterior is a retentive and sharp mind. She acted as a sort of pathfinder, sniffing out trouble before it arose. We made an excellent team and she worked well with Emer Mooney, my secretary for over eight years. At the beginning we turned my chief disadvantage on its head. If I was going to be treated as a mild form of political amusement, at least we could make use of that curiosity value. Inquisitiveness made an audience and that was stage one. At the beginning I also had another advantage. None of the other candidates took me seriously. So night after night, I drove all over the province of Leinster from Louth to Wexford, addressing meetings and just occasionally asking myself, was all this madness? Then the fun started: the 'dark horse' had become a vague possibility. Parallel to all of this, I had to keep myself in the public eye, and take speaking engagements from such diverse institutions as University College, Cork, and An Taisce in Louth. It all helped build credibility and profile, which are two very important ingredients in a European campaign. In January such efforts took me to Trinity College to listen to the Taoiseach address a Young Fine Gael meeting. Some students hurled eggs at Garret, but these missed their target and landed on me. The end of a velvet dinner jacket, but all part of

the campaign. Throughout this time I had no illusions, the convention was going to be one hell of a battle. Susan Devane and I got sick of hearing, 'You will make a great candidate for the party, if only you can get through the convention,' or 'Why don't you run in the local elections?' and, most depressing of all, references to the West Brit syndrome, or snide attacks on my background, laced with the dour condemnation, 'You have not been in the party long enough.' Still, we were making progress. I got a note from the General Secretary of the party, Finbarr Fitzpatrick, stating that he believed I was 'causing quite a stir up and down Leinster!!!'. The 'vague possibility' became in some quarters 'He just might make it,' but many were still laughing, so we made the conscious decision to move into the areas where the laughter was coming from, and then about two weeks before the convention, take stock and analyse all the feed-back. There was no question that the speaking engagements had made an impression, but this had to be capitalized upon and translated into delegate votes. I was suffering from several disadvantages. The front runner, Mark Clinton, came orginally from Meath. Deirdre Bolger hailed from Wexford, the far end of the constituency, and had the unequivocal support of the Wexford TDs Michael D'Arcy, Avril Doyle and Ivan Yates. In Meath the situation was very different. John Bruton was backing Mark Clinton, and I felt it necessary to request him to adopt at least a neutral stance towards my camp. The other TD, John Farrelly, was kicking for touch. To cap all of this, Michael D'Arcy had been appointed director of elections, and along the grapevine there were murmurings of a concerted campaign to stop me. I was in trouble, but having gone that far, no stone was going to be left unturned.

Not everything was black. We were building up strong pockets of support all over Leinster, in particular an enthusiastic and energetic group in County Kilkenny, my own supporters in Meath, and many members of Young Fine Gael. If we lacked anything, it was hard political experience. Enter Berlin. Since that trip I had struck up a strong friendship with Joe Kenny, an astute political operator from Dublin West, and although younger than me, a long-standing member of the party, who had been through the mill, and knew what was required. Joe had other qualities essential in such matters, a savage sense of humour and a great eye for detail, and what I can only describe as a comprehensive understanding of the mechanics involved. Last but not least, he believes in the same sort of things as I do, and his engaging personality

soon won over Susan and Emer. He also loved Slane. Joe joined the team.

Joe concentrated my mind on consolidating delegate votes. We got into a car. It seemed as if we lived in it for ten days. We combed Leinster, calling on county councillors, party officers, anybody who could influence anybody on a delegate vote. The laughter died down and we kept on plugging. It all became deadly serious, and in politics when things become serious, they usually become dirty. The knives were out. Those ten days were an enriching experience, teaching me a great deal about human nature, and cementing a good friendship that would stand me in good stead.

As the convention approached I knew many votes would hinge on my delivery. By Saturday 10 March we had done everything possible. Some miscalculations, some worries, but I had to relax and write my speech. It was already in my head. It had been there for a week, but I knew how critical it was. I retreated to Slane with Joe Kenny, Susan Devane and Annette Connolly, a member of the National Executive of Young Fine Gael, who was to be one of my proposers. I locked myself in the ballroom with a tape recorder and started pacing the floor. If the speech was to have maximum effect, I must speak from only the barest outline. I worked at it over and over, until I had rehearsed every word. Then I honed my delivery using the acoustics of the room that I had played in as a child, cavorted in as a teenager and sat in as an adult alone with my thoughts. Eventually it rang true. I joined the others for dinner in the restaurant. I felt like a boxer before a prize fight.

The convention was to be held at Goff's Bloodstock Sales ring in Kill, County Kildare, the following day. Jagged nerves. Managed entrance. Keeping head straight. So much work, time and effort defined in a few hours. Then the first disappointment. Garret Fitzgerald wasn't there. It was the only European convention that he did not attend. He had left for the United States to celebrate St Patrick's Day. Damn. He wouldn't hear my speech. Colours bright, light intense, sweat in the palms, a blur of faces. Words over and over rolling around my brain. Adrenalin. My turn. I was on the podium. I concentrated on the issues that I had hammered out at every meeting I had attended: Sellafield, the Common Agricultural Policy, NATO, neutrality, the importance of the European Parliament to Ireland, the Haagerup Report on the North. I savaged Fianna Fail: 'I have no time for the narrow-minded bigoted nationalism of Charles J. Haughey. I have no time for the hypocrisy and the pious lip

[119]

service that he pays to Irish Unity. The kind of policies that he pursues in relation to Northern Ireland belong better to the desert sands of Libya than the green fields of Ireland.' The audience were practically on their feet. The speech was greeted with thunderous applause. The count was murder. It seemed to go on for ever. Joe and I went for a walk to get some fresh air into our heads. The elation at the reaction to the speech started to evaporate. This was down to the mathematics of delegate votes, and all forms of influence were being brought to bear. Then the result: Clinton 196, Bolger 184, Mount Charles 178, McDonald 156 and Lawlor 25. I was out by six votes. Defeat. An old member of the party came to me in tears in the company of his friends. 'We should have given you our votes, but they were committed elsewhere. A terrible mistake.' A report in the *Irish Times* painted a somewhat similar picture: 'It was all to no avail, however, and when the votes were cast an old Fine Gael hand said he might have been nominated if he was a member of Meath County Council or something.'

We left Kill for the nearest hotel, Joe, Susan and I, and some of our closest supporters. We were joined by Miriam Kearney, Assistant General Secretary of the party, a close friend. Sorrows drowned. Laughter and tears. Then Joe, Miriam and I headed for Dublin to unwind further. No recrimination. A point had been proved. Swirling of minds. I stayed in the city, emotionally shattered and needing to hide. The next morning my brain was walking on glass. Fragile entry to a newsagent's, no thought of a report. Gazing at a forlorn image of myself plastered all over the front page of the *Irish Times*. Disbelief. Turning to the *Irish Independent*, I saw more of the same: a banner headline, 'Lord Henry goes down fighting' an article stating I was the 'hero of the selection convention at Goff's at Kill, winning a standing ovation for a brilliant speech and will clearly be a force in the future'. Just as events were starting to slow down the momentum built up again. I retreated to Slane. The phone calls and letters started pouring in. They all had a common theme. Pressure was going to be brought to bear to add me to the Euro ticket. After all, Garret Fitzgerald had invited Joey Murrin, the Donegal fishermen's leader from Killybegs, to be third candidate in the Euro-constituency of Connacht–Ulster. My supporters in the Slane district arranged for a special meeting of the Meath constituency executive to pass a motion to have me added to the ticket. The following day it surfaced in the press. 'Party General Secretary, Finbarr Fitzpatrick, confirmed last night that there had been a number of overtures already

that Lord Henry should be added to the party ticket by the National Executive, but nothing along these lines is likely to occur at least until the Taoiseach, Dr FitzGerald, returns next weekend from the US.' I refused to comment. The Taoiseach and the National Executive would decide. This pressure was spontaneous, and if necessary I would state my case. On Friday 16th, I arranged to meet Miriam Kearney and Joe Kenny for lunch to discuss how to handle the situation. Then fate intervened. We were having lunch upstairs in Shrimps Wine Bar when the first wave of pain hit me. Kidney stone. Then so savage, sweat started to pour. No question, I couldn't cope. Joe took me to St Vincent's Hospital. They asked me to fill out a form requesting such information as religious denomination. 'Just get me a doctor. I need a shot.' That was it. I was out of circulation. The National Executive were due to meet the following Thursday. While I was in St Vincent's I was more or less out of it. The pain was particularly severe and I was heavily sedated. Joe and Miriam, Dick and Mary Burke and many other friends came to visit. Then Finbarr Fitzpatrick came to talk to me, and blew cigarette smoke all over my face. The party hierarchy was in a quandary. I was floating and really past caring. Garret FitzGerald returned, and the National Executive met. They decided not to add me. I was told afterwards that somebody at the meeting said, 'We are not ready for the likes of Henry Mount Charles.' At the end of the month there was a dinner at Slane for a group of Young Europeans. Garret FitzGerald arrived to play host. In conversation he made a most peculiar apology for the chain of events. It was not necessary, not dignified, and I was not very impressed. Joe Kenny is now personal assistant to the new leader of Fine Gael, Alan Dukes, TD for County Kildare.

The electric fire in my bedroom was vibrating. Larry Mullen was in occupation of my dressing room. Bono was pacing about the Castle in a creative fugue; Edge was manipulating his guitar with extraordinary dexterity; Larry was pulverizing his drums, Adam rhythmically coaxing his bass guitar. Warm sunshine on the lawn, long conversations with Adam. He could see before him, almost as a clairvoyant, the extraordinary explosion of attention that would soon burst upon U2. Cups of coffee, snatched conversations, standing in the corner of the Chinese lantern room, flashes of my parents when we were children transposed on to the birth of a record.

Concorde moves into the drawing room – a portable recording studio

from New York. Brian Eno arrives, soft smiles, and quiet introspective undulating voice. He is accompanied by Daniel Lanois, the Canadian engineer and colleague, with a grin as wide as the Grand Canyon and an engaging rasping chuckle. In time off, they walk up and down the river and go into Drogheda to play pool. Conversations about politics, music, pain, triumph, war, Ronald Reagan, love, sex, death, change, tradition, FitzGerald, Haughey, anything and everything. Visitors come and go. There are kids at the window. Sue Wade tries to keep track of who's in, who's out, how many for breakfast, lunch and dinner. Privacy is gone; it doesn't matter. Bono's conversations run deep and with feeling. Adam's wisdom is way beyond his years. We share views and perspectives, trade advice and share emotions. A growing friendship and trust. The house is full of music, life, work and laughter. These are but a few of the images of *The Unforgettable Fire*.

While the band were in the Castle, other events were on my mind, not the least of which was how we would celebrate the Orwellian year at Slane. If there was to be a show, who would it be, and how would it be put together? Following the Stones it had to be hot, or it had to be a legend. Preferably both. In December 1983 I had a meeting with Jim Aiken, more than anything just to touch base. I was still faced by a dilemma. The show in the Phoenix Park had been a co-promotion with Eamonn and Denis. This had created loyalties and bonds, but Jim had put together the deal with Bill Graham and done a fine job of promoting the Stones. Pressure. In early March there was a rumour that Michael Jackson was going on tour, and that it would be handled by the legendary Don King. The rumour had little substance. Then came the news that Bob Dylan was going on tour. That was it; the ultimate sixties figure. Good God, 'Blowin' In The Wind' was practically the anthem of a generation. It seemed the right act to follow the Stones. The tour was being handled by Bill Graham's organization. I decided to stand back and let the promoters fight it out. Eamonn and Denis, I think, felt I should have stood behind them, but I was exhausted by all the machinations, and had to protect the interest of Slane. In my heart, I suppose, I knew Jim had the edge. By the beginning of April Jim was moving towards a deal. By mid-April Jim had talked to Dylan's people in London. On 14 May we tied up the arrangements, but we made a mistake: the date selected was Sunday 8 July. We held a press conference in Dublin on 22 May at Dobbin's Bistro, one of Jim's favourite haunts. It was the day before my thirty-third birthday. The following

day we hit the front of the *Irish Independent* with a headline, 'Huge welcome for Dylan.' Everything seemed on course. Then things started to go wrong. Although Dylan's latest album had received critical acclaim, it didn't have the same impact as his earlier material. At Slane it is always critical to have a broad spread and appeal to several generations. News came from Europe of slow ticket sales. Long discussions with Jim. He was worried. He was carrying the can on this show. Dylan was touring with Santana. We added UB40 to the bill and pumped it. In the contract I had a strong influence on the selection of an Irish band. This has become part of the tradition of the Slane shows. We decided on In Tua Nua. As a result of these two moves, the ticket sales picked up, but not fast enough. Would we hit the break-even point? It was going to be damned hard to estimate the crowd. Costs, staffing levels – all so difficult. I was convinced we would get a big draw on the day. The fencers, the plumbers, the stage crew arrived; the buzz was on. There was excitement in the community. Everything seemed fine. Michael Ahern and Micky Brigden, who had both been at Slane for the Stones, returned for the event. It seemed like old times.

As the concert machinery cranked up there were other activities in the air. In the middle of April I was approached by a group of people in the Fine Gael organization in Laois-Offaly, to stand as a candidate in a forthcoming by-election caused by the death of one of the sitting Fianna Fail TDs, Bernard Cowen. It was very much outside my own territory in Meath, and in any event the by-election would almost certainly be won by Fianna Fail. My candidacy would be bound to be opposed, and I hadn't the stomach for another scrap at a convention. Almost simultaneously there was to be another selection process for the European elections, which went by the rather appropriate title, the 'B List'. This was designed to sort out a batting order for replacement candidates to the European Parliament. Miriam Kearney persuaded me to go through the mill. To be honest, I was rather depressed by the whole idea. Her judgement was right: I topped the poll by 67 votes. It was a sort of consolation prize. Some of my other activities did not prove so popular.

In 1984 Ireland was to be blessed by a major event: the visit by that most startlingly intellectual of American Presidents, Ronald Reagan. It was clearly a blatant attempt to copper-fasten the Irish-American vote in the forthcoming American presidential election. At the beginning of May, I made a speech to Young Fine Gael in Dun Laoghaire, the constituency in which the government Chief Whip, Sean Barrett, was

one of the sitting TDs. It was an outright attack on Reagan's visit. 'To be pro-Reagan is not to be pro-America, in fact quite the contrary. We are not extras on the Republican Party's great electoral motion picture. If we merely lie down like tame dogs, it will be seen by the political commentators and the voters of America as the endorsement of President Reagan's policies.' I also defended the right of those opposed to Reagan's foreign policies to demonstrate peacefully against his visit. I was not in total isolation in expressing this view. At the end of May in a meeting at the Shelbourne Hotel hosted by Young Fine Gael, I was joined by Monica Barnes, TD, and Senator Katherine Bulbulia. Just to hammer the point home I was also interviewed by ABC Television as part of a special on the President's visit. This stance was not popular within the ranks of Fine Gael. One senior party source was quoted as saying, 'He might be rolled out pronto himself if he doesn't shut up.' Since May 1984, I haven't been invited to the American Embassy.

The home fires were burning – literally. At the Castle we generate all our own electricity. My grandfather had installed a small turbine on the river just after the Second World War. When it is operating at maximum power it can produce about fifty kilowatts. It doesn't perform with great gusto in very low or high water. When overloaded, it trips out. I have fond memories during my childhood of my father clad in dinner jacket, pounding up the banks of the river at night to restart it, to bring light and some heat to a house full of guests. In the end, with enjoyment and normal living thwarted by a combination of nature and machinery, he decided to install a diesel generator to supplement the turbine. This produced an alternative source of power. Like all items of machinery at Slane, it received a christening. She is known affectionately as 'Bertha'. When we have high demands for energy, Bertha runs constantly. The turbine, by the nature of its design and distance from the Castle, takes a second or two to adjust to this demand. This can at times make the lights go up and down, and has produced its comic moments. A year or so ago, we were asked to host a banquet for the Electricity Supply Board, who were entertaining a number of their overseas customers for whom they were hoping to solicit further contracts. As the river was churning out plentiful supplies of electricity, we were operating on the turbine rather than Bertha. At one stage during dinner the lights did a dance. There was some consternation amongst officials from the Electricity Supply Board. I found an excuse to make a speech and explain to the assembled

company that they were having dinner in one of the few establishments in the country that had an independent source of power. All of this leads me back to U2, and the special relevance of the title of their new record to the trustworthy Bertha. It was all too much for her. Recording is a very exacting process and the variation of voltage produced by the river had to be eliminated. While Brian Eno and Daniel Lanois were taping the band, Bertha the generator was hard at work. After hour upon hour of labour the tension and excitement were too much, and she burst into flames. The Unforgettable Fire.

This was undoubtedly a very happy time at Slane. The presence of the band introduced a note of harmonious domesticity, a sort of extended family. Larry and Edge's humour, Bono's intensity and Adam's deeply sympathetic nature were in a very real way part of a process of healing and reassembly. To see them create a new musical plateau for themselves in surroundings which are so much part of my soul was something quite unique. In the eighteenth century, William Burton Conyngham had seen the arts flourish under his roof. Music was being born in Thomas Hopper's ballroom. The Chinese lantern from the Brighton Pavilion was seeing the creation of *The Unforgettable Fire*. This was twentieth-century life.

There was also time for entertainment. On 23 May, my thirty-third birthday, I decided to give a party in the night-club. The invitation invited guests 'to go over the top'. The day marked two very special pieces of generosity. While the band were staying, somebody had got into the Castle and stolen my stereo system. I was quite naturally upset. On the night of the party they presented me with a replacement. Nice one, lads. The same evening everybody who worked in the Castle produced an even more spectacular gift. They had commissioned Pierce Hingston, one of Ireland's leading chefs, to make a model of the Castle out of icing sugar. It was an exact replica, complete with electric lights. It was produced with a great flourish in the middle of the dance floor in the night-club.

June blazed by with the European elections, and the final dispersal sale of Oldbridge House, a few miles down river, which had belonged to the Coddington family since before the Battle of the Boyne. It was a poignant reminder of the continued disappearance of the old Anglo-Irish families. I went along to the auction and bought a small water-colour of the interior of a house called South Hill in County Westmeath,

where Lawrence of Arabia was born. I imagine the scene is what Lawrence saw when he was a child. The place is now a convent. The Coddingtons have emigrated to Canada. Oldbridge House is empty and forlorn.

July was Dylan. It was like a journey. Man of peace. Battle zone. Jim, his brother Michael and Micky Connolly arrived on site early in the week. The plumbers were already hard at work. The erection of the stage started. There was football on the lawn in the evenings. Everything was very relaxed, except that the ticket sales were still slow, and Jim had that slightly dishevelled look he develops when he is under pressure. Over the years things have acquired an almost rhythmic quality. When he's down I'm up, and vice versa. We were starting to work as a team. Towards the end of the week, Michael Ahern arrived. It was a pleasure to see an old friend, a professional and diplomat and the man who had kept the peace at the Rolling Stones concert. Sue was getting the Castle in shape for the onslaught of the big day. There was the usual last-minute panic to see all the insurances were in place, but all in all the atmosphere was relaxed, too relaxed. This sentiment had even permeated through to the authorities. The Rolling Stones had been such a peaceful event. I was still carrying some scar tissue from Phoenix Park. It was still difficult to predict the attendance. At a big show, it is always an advantage to have as many tickets as possible sold in advance. Apart from easing the financial strain, you have a clearer picture of what you are dealing with. For Dylan we had a high percentage of walk-ups — tickets sold on the day.

As Friday arrived, I started to feel a little uneasy. The weather was going to be reasonably good for the weekend, and there seemed to be a perceptible increase in the numbers of people moving into the area. Pressure. Saturday afternoon. Yes, definitely, more people, atmosphere still festive, but we had a long way to go before the gates opened the following day — a very long way before Sunday. The authorities were still relaxed. The publicans in the village had been granted extensions to serve drinks till 1 a.m. against the wishes of the Gardai authorities. They had orginally looked for the extensions to cover three nights. People were moving into the area heavily tanked up. 'The village of Ashbourne was totally sold out of flagons of cider yesterday afternoon, which forced fans to buy plastic bottles of minerals, pouring the contents into the gutter, and then asking the astonished barmen if they would fill them with cider.' (*Irish Times*) Drink was everywhere, sold illegally out of the

back of vans, sold across the counter in the pubs. Conviviality was turning into a collective binge, but it was still good-humoured.

Several friends had come to stay for the weekend. Thank God, because they helped me keep my head together. Saturday evening, all quiet on the site. Noise from the campsite. Noise from the village. Michael Ahern and I decided to make for Slane, and have a drink in one of the pubs to gauge the temperature. There were people everywhere, too few Guards on the streets, too many drunks. Mike and I looked at each other. If something went wrong, this was going to blow. We headed back for the Castle full of apprehension, and hoped the situation would hold. An hour or so later the phone calls came through. Rioters stoning the Barracks. Police cars on fire. Reports of murder. Minute by minute getting worse. Jim at the airport. Good God, what do we do? Impulse, have to get to the village. Head for the car. My security comes with me. We get into the village. Fires, broken glass, devastation. They had ripped stones from the Castle wall and hurled them at the Barracks. People were fleeing. We head for the Square. Guards armed with batons are containing the rioters up one street. Rumours are flying around that the Army is being sent in. In the middle of the square. Suddenly worried that somebody will recognize us. A guy comes charging over and bangs on the car. Window down. 'Do you want to keep your car? Do you want to keep your fucking car? 'Cos if you do, I'd get out of here now.' He had a strong Northern accent. We turned towards Slane Bridge. Road blocks, couldn't get back. Heading through the countryside trying to get back to the Castle, images burning in my brain, pounding the steering wheel. My God, what have I done. This is like the end. Gurriers, bastards, drunken louts. Holy Jesus. Hope nobody seriously hurt. Time moved like sludge. Near to tears. Eventually got back to the Castle via Stackallan Bridge. Things quieter. No murder. Impossible to sleep. The next morning rose early, and swallowed endless cups of coffee and tried to gather together jangled nerves. The sun was shining, it was going to be a beautiful day. At Gorhambury, just outside St Albans, Iona Grimston was drinking a glass of champagne.

We all felt like death. Somebody was dispatched to get the papers. After this the media were going to go to town. 'Savagery at Slane' (*Sunday Press*). On the radio, television and all over the papers. For me, this wasn't going to be a concert, but an endless press interview. 'What went wrong? Why? How do you feel? Will you ever do it again?' Over and over, speaking on automatic. Some idiot on the tour team said,

'Don't tell the man,' meaning Dylan. 'Fuck the man,' I could strangle him, but I still saw the point. Friends were arriving by helicopter; the usual high and buzz. The weather was beautiful, but I felt like a zombie. My friends tried to reassure me, and help me see things in perspective, but I was haunted by images, and hounded by the press. I went backstage to meet Dylan. I could hardly speak. We shook hands, and I mumbled. There was simply nothing to say. He looked almost hideous with his orange make-up, and life tracked on his face. Then still worse news came. A kid had drowned in the Boyne. This seemed like *Apocalypse Now*. No consolation. Kind words from Bono, and kind words from Dick Burke, shared pain with Jim Aiken. Then Dylan on stage 'With God On Our Side', there was no more to do. I discarded my walkie-talkie. Van Morrison, Bono and Leslie Dowdall from In Tua Nua joined the hero on stage. The day took off. Briefly for me the magic was back. Then the concert was over, the crowds headed for the hills. Eamonn McCann, the journalist from Derry, known affectionately in Slane as 'the other Eamonn' in deference to his namesake, the promoter, took me in hand. We headed for the bar. He stuck a bottle between us. I think we consumed most of it. I was carefully wound down in the company of friends, including Miriam Kearney, Joe Kenny, Bono and Senator Michael D. Higgins. Eventually some volunteers removed me to bed.

There was no reprieve the next morning. The media had a story and they weren't letting go of it. It was even carried in the *New York Times*. I got calls from friends in the States asking whether the Castle had been burnt to the ground. My head was pounding, my limbs were aching, my eyes hurt. The press were in the hall. I held an impromptu conference in the drawing room. 'Compensation?' 'Will there be another concert?' No talk of music, just of violence. It quickly became apparent that what had happened was giving those that were opposed to the concerts the maximum amount of ammunition to state their case. The public relations officer of the Slane Community Council, Mrs Pearl Baxter, never an ardent fan of my activities, announced, 'I don't blame the Gardai and I don't blame the publicans for what happened. No way. I blame Lord Mount Charles for it all.' Mr Carolan, a leading light in the group opposed to the concerts, announced, 'It may take a court order but I am now going to see that these rock concerts are stopped.' He also accused me of being primarily interested in making a fast buck. The media loved it. This was grist to the mill. I gave an interview outside

Slane Garda Barracks to RTE News, unshaven, unkempt, eyes sunk behind the darkest of shades. I didn't care about my appearance. The nightmare lived on.

Not everything was negative. Many letters of support came rolling in. From a journalist: 'I keep finding in my work that everything concerning news has to be sensationally negative and horrible in order to be given the go ahead by editors and sub-editors.' From somebody in Cork: 'But as you and I know, these were the mindless acts of mindless people. Media sensationalism makes this local issue a national one while simple preventive measures such as alcohol control or greater Garda presence could have avoided any problems. . . . My support will hopefully be one of thousands, but any decision about future concerts will of course be a personal one.' However, the media still had a field day fanning the flames of controversy. Several local people, depressed by the misrepresentation in the press, wrote to the *Meath Chronicle*, 'Whereas in general reports carried in the media were accurate, headlines such as "Slane Says Never Again" were, to put it bluntly, wrong . . . In conclusion, may we say that there are lessons to be learned by everybody over what happened. Violence of the type which happened in Slane is random and banning rock concerts in Slane will not solve the problem. Provided the lessons are learned by all involved, we feel that Slane should, and we believe that Slane will, rock on,' signed Gerry Hand, Brian Vaughey, Tommy Wogan, Robert Wogan, Slane.

Then it happened again, that same scraping and agonizing pain shooting through my body. If 1982 was the year of The Rolling Stones, 1984 was the year of the kidney stones. I was back in St Vincent's and out of circulation. To be honest, this time it was welcome, giving me an opportunity to reassemble my brain, and see things in the cool light of day. There was no doubt that Jim and I had made one miscalculation. The concert should not have been held on a Sunday: this had allowed too much build-up time. There had been fewer people at the Dylan concert than at The Rolling Stones in 1982, but there were thousands more in the area the night before the show. The atmosphere was charged and it only required a hard core of gurriers for it to ignite. There was also no question that because The Rolling Stones had passed off peacefully, everybody, including the authorities, were far too relaxed, and this resulted in the policing being far too low key, which meant when the violence erupted there were just simply insufficient Guards there to contain the situation. Finally it was clear that for a while my

spirit was broken. It was, as Joe Breen, the rock critic in the *Irish Times*, said, 'the Lunatic Fringe's finest hour'. The only solution was quiet introspection and, with the help of my friends, to avoid saying 'never again'.

10

The River and Champagne

Dylan left wounds, and the wounds went deep. I felt responsible for dividing the community. Many others involved in the show lived elsewhere. I was rooted to the spot; Slane was my home, my ground, and I had to stand on it. Over the years so many things had been tried to bring the Castle into the community, and to make it all work in a manner that was relevant towards the end of the twentieth century. The Castle was now providing more employment than my great-grand-mother did in 1939, and yet at the same time I was struggling to hold on to its soul, to the very essence of the place that had brought me home in 1976. This was a black period. I felt unnerved and isolated. It seemed momentarily that all the effort put into the place had been discarded in one fell swoop by the mindless vandalism of a crowd of gurriers. Accompanying all this was the inescapable sensation that perhaps none of it would have happened had I not persisted in my ambition to see these shows staged in the great natural amphitheatre by the banks of the Boyne. My friends and in particular Jim Aiken, stood behind me. The following weekend he gave an interview in the *Sunday Independent*.

I am breaking all the rules I have adhered to for 25 years in giving this interview, but I feel that I shouldn't be seen as running away from the situation. It would be easier to have gone home to Belfast to hide away but we didn't do that. We faced up to our critics. The village has been completely split as a result of the riot with very definite political undertones. There is Fianna Fail on one side and Fine Gael on the other. The old tribal line-up. And, of course, there is a die-hard anti-Henry faction in the village who see this as a glorious opportunity to have a go at him because of the historical thing. He is in an awkward position, but he is trying to live in the village, keep the Castle going and contribute to the community.

Any money he makes on the concerts won't go on holidays in Monte Carlo or Marbella; it will go to maintaining the Castle and there are not many such castles left intact in the country.

The day this article appeared I hauled myself from St Vincent's, as we were having an Open Day at the Castle to raise funds for the Slane Community Council and Tidy Towns Committee. Despite the fact that the anti-concert faction threatened to picket the Castle gates, the event proved to be a great success and raised nearly £3,000. It helped to rebuild bridges and I started to realize that those so violently opposed to the concerts were not necessarily in the majority. Prior to the show, both my father and I had pledged £1,000 as a contribution to the Slane Tidy Towns. Following the Dylan concert I added a further £2,500 as a gesture of goodwill. It generated, in retrospect, the inevitable jibes of 'he's trying to buy us off'. However, when I read such blatant nonsense as 'If this is what education has done for the young people of Ireland, well then it would be better if they remained ignorant', and that the village had been 'raped by organized vandalism, egged on by barbaric music', a clearer picture started to emerge. What had happened was without doubt deeply disturbing, but what was surfacing now was something else altogether – prejudice. It is something I have been confronted with throughout my life. It usually has the opposite effect on me to that intended by those who project it. It hardened my resolve to heed the voices of my friends: 'Never say never again.' That summer I took many long walks by the river, listening to the sweet music of nature rustling through the trees. It was part of a healing process. A decision whether to go again would emerge, but not yet; it would take time. I retreated into the other areas of my life.

If Slane was my spiritual home, the one solid thread in my life, it was also a place that had exacted a price. Few understood the conflict between bond and cost better than my father. We have been united in our purpose to preserve Slane as the family home; for both of us in different ways it has entailed sacrifices, and to both of us in different ways it has brought pleasure. As soon as I could, I went to stay with him in the Isle of Man. My father had in the intervening years remarried, having divorced my first stepmother, Elizabeth. She was a woman who cut a great shape, but also had an extraordinary capacity to introduce havoc into family relationships. In truth, I had little time for her theatrical tantrums, and the real crunch was that she made my father

[132]

unhappy. I was greatly relieved to see her move out of our lives. To the delight of us all, my second stepmother was a totally different kettle of fish. Warm, lively and, perhaps if at all at fault, almost overwhelmingly enthusiastic. She could also in her own way be very determined, even stubborn. In age she was closer to me than to my father, and she developed a very deep understanding of the bond between us. She also had another invaluable quality: she understood Slane, and loved it, and those involved in Slane loved her. She was even, on occasions, known to take to waiting at tables in the restaurant. Her humour, her laughter and fortitude are sorely missed. Staying with my father and Daphne for those few short days was a soothing experience. The Isle of Man is a peculiar place, best known as a haven for motorbikes and tax exiles, but contained within its few short miles is an extraordinary variety of topography, giving it the brush stroke of Scotland and Ireland, with the mountains and the sea. It has a population of only 65,000 and intimacy lacking in so many other places. I have always found visits there very therapeutic, and in this instance it presented an opportunity to unload the events of the last few weeks. From the Isle of Man I went to London to meet Alexander, and take him down to Southampton for the weekend. We stayed at Exbury with Marcus and Kate Agius, just a stone's throw from the famous gardens owned by Kate's family, the de Rothschilds. There was a respite of tennis, walking in the gardens and conversations with old friends, away from the hassle in quiet private space, in the company of Alexander, the next generation. Will he live at Slane? Returning to Ireland, I kept my head low and went north the following weekend for the wedding of Eamonn McCann, the promoter. A good opportunity to let the hair down. Then a week in New York on business. The children came home for their summer holidays. We went to the circus. I was starting to feel human once more.

Life started in earnest again in September. On the 9th, I was invited to address the annual Michael Collins Seminar in Mulranny, County Mayo. It gave me an opportunity to revive my political interests, and I chose a suitably provocative title, 'Revolution of Thought'. It reflected my growing frustration with the existing political system and was quoted extensively in the *Irish Times*.

There are many reasons for the quagmire, but I do feel at the heart of it all, the problem is political. There is no thrust or drive to the philosophical development of the two main political parties. We

[133]

have a coalition government, and Fianna Fail bays about its internal conflict, but Fianna Fail is a coalition. Politics is not dominated by specific party philosophy, but by personalities. Many public representatives find it impossible to escape the parish pump for fear of being removed from the political landscape. The public perception of Leinster House sinks lower each year, and wild rumours of splits, realignments and new parties fill the air.

Little did I realize at the time that this was the beginning of a long walk into the political cold. From the beginning my allegiance to Fine Gael rested upon the conviction that Garret FitzGerald would pursue his Constitutional crusade, and that the new government would introduce some imaginative thinking into the management of the economy. Instead Garret had faltered over the Abortion Referendum, and unemployment had soared above 216,000. Public expenditure was clearly out of control, and taxation was being widely conceived as a form of fiscal rape. This growing disillusionment was compounded by the attitude of the party hierarchy. I had been led to believe that Fine Gael was a party intent on pursuing an open-door policy, where new ideas would not only be encouraged but embraced. While I readily accepted that some of the views that I held differed radically in some instances from those of some long-standing members of the party, I felt that a new form of political energy was required. Together with others I attempted to set up a ginger group, the formulation of which was designed to introduce some fresh thinking into policy-making. Instead of being greeted with enthusiasm, it ran into open hostility, which came to a head at the Ard Fheis (Party Conference) at the beginning of October. It was made unequivocally clear at the time that such activities were considered 'subversive'. So much for the open-door policy of Garret FitzGerald's Fine Gael: dissidents were to be neutralized and silenced.

With the arrival of autumn, a totally new dimension appeared in my life, and its emergence revolved around of all things the consumption of champagne. In its inception it was very much a family affair. My two cousins, Peter and Harry McCalmont, sons of Major Victor McCalmont, from Mount Juliet in County Kilkenny, had been invited to bring a group of guests to Château Saran in France, at the invitation of Baron de Montesquieu, a Director of Moët et Chandon. They had asked me to join the crew. It was a motley bunch. Peter and his wife Annabelle, Harry, Jonathan and Mikaela Irwin, Kip McCreery, Ralph Fitzjohn, Guy

Sangster and a collection of other hard-hitters. My initial reluctance to take the time out was soon swayed by Peter and Harry's insistence that this was going to be an unforgettable experience. They were right in more ways than one. Quite frankly, it altered my life.

The trip to Château Saran was done in style, reflected not in our mode of transport (we travelled by bus), but by our conspicuous consumption. After an extremely good lunch, we wove through the French country-side, downing bottles of champagne. The French bus-driver thought us all quite mad. When we arrived at the Château, he leapt from the bus and started expounding to a rather astounded young lady that she had a collection of lunatics on her hands, and that he had no intention of coming to pick us up. We descended from the bus to be greeted by a tall, elegant, good-looking English girl called Iona, very obviously in com-mand. She showed us to our rooms. She did not join us for dinner. By the time she returned to the Château after entertaining a New Zealand wine critic and his wife, I was on my way to bed. We did not exchange a word. The next day we went to Moët's cellars in Épernay to learn all about champagne. Iona was there, a presence, something about her. That evening a stylish dinner at the Trianon, a building designed especially for Napoleon's visit to Épernay. Buckets of champagne and collective exuberance. We returned to Château Saran hitting the place like a wave. Jonathan Irwin performed a cabaret. Iona was there looking intriguing. We started to talk. We talked for hours. The next morning Château Saran was shrouded in mist. We were supposed to leave early, our departure was delayed. It gave me an opportunity to talk to Iona, and I discovered that she would soon be returning to London. We left Saran for lunch at a famous French restaurant called the Pré Catalan. My relations kept telling me my eyes were glazed and it wasn't champagne. We returned to Dublin on 29 October. By 6 November, I had traced Iona to London. I drove to the airport and got on a plane. Ever since I have always had a liking for champagne and a special affection for my cousins.

As winter approached, the trauma of the concert started to recede, and a more balanced perspective on the events began to emerge. Jim and I held a series of tentative discussions. We knew Bruce Springsteen was going on tour and contacts with his management had been made before Dylan. I was still feeling fragile, but Jim helped put steel in my back. It was difficult to measure our local support because the opposition was so

vociferous, but the more they agitated the more they unwittingly assisted our cause and hardened my resolve. By the beginning of November I decided to test the temperature of the water. 'Lord Mount Charles stressed that he had not yet made any decision on holding another concert, but said he had become involved in "active discussions" to see if it was feasible and what steps might be taken to avoid potential problems. There has been increasing speculation that a likely bill-topper at Slane next year could be American rock star Bruce Springsteen. And it is understood that the Gardai have no objection, in principle, to another concert taking place.' (*Evening Herald*) The headline said it all: 'Slane will rock on.' We let the hare sit and Iona and I went to the States for Christmas. By early January, the speculation was mounting and it was becoming increasingly difficult to keep the lid on events as they unfolded. In mid-January I returned to the States and had a meeting with Barry Bell of Premier Talent, Springsteen's agent in New York. Jim was also hot on the trail. While I was in Barry's office he telephoned, and to his obvious astonishment, I took the call. Everything was beginning to fall into place, with one notable exception: there was trouble at home. At a stormy meeting of the Slane Community Council in early January, Mr Gerald Breen, the local chemist, announced that 'you would have to have a fondness for public urination and public fornication to support this concert'. There were other more rational voices, including a member of the local Gardai, Sergeant Clarke, whose family had borne the brunt of the violence, but the battle lines were drawn.

By the end of March, things were really hotting up. Springsteen's advance team had visited Slane twice, and Jim Aiken had confirmed to the press, perhaps a little prematurely, that the Slane concert was on. The following day I issued statements about 'the high probability' and started talking about security. I knew we were heading for a storm. At the end of March, both Jim and I went to New York. It gave us an opportunity to tie up the arrangements for Springsteen and attend the U2 concert at Madison Square Gardens. Jim was promoting the band at Croke Park in Dublin later in the year. We flew out with a collection of journalists to review the show. It was an eventful journey. Saturday 30 March was the date of the English Grand National. A horse bred by my mother called 'Last Suspect' was entered in the race. Jim, an inveterate gambler, ran a sweep, and I drew my mother's old horse. If I hadn't, Jim had promised starting price, which as it turned out was fifty to one. Last

Suspect won. I won the sweep, and Jim was off the hook. Lucky for all. It was a good omen. Jim went to see Barry Bell. We were near to a deal. U2 were inspiring. It was an emotional evening culminating in a celebration with Adam Clayton and the rest of the band. From New York I flew to Geneva for a short skiing holiday with Iona and Alexander, while at home the controversy about the concert raged on. On 3 April, while I was in transit from New York to Geneva, the Slane Community Council met and voted against a motion 'condemning the events surrounding the holding of the previous concerts in Slane but accepting that the proposed concert should be held this year provided that adequate security precautions were taken'. The vote was close, 13 to 8 with three abstentions, and could hardly be interpreted as outright opposition. In addition, I was conscious that the Council was not exactly representative of the local community. It was reported that only 25 per cent of the local population had bothered to vote in its elections. If the Community Council presented a problem, a breakaway group called the Slane Village Householders Association were in a different league altogether. They had voted 49 to 3 to oppose future concerts and were threatening to take legal action, and their public relations officer, Gerald Breen, summarized his feelings on the events of the previous year with a further gem: 'youthful intoxication, public fornication and massive urination'. The media loved it. This was going to run and run, and generated banner headlines: 'Slane votes No to Springsteen.' My skiing holiday in Courcheval is fixed in my memory by a series of frantic telephone calls with Jim and our legal adviser, Vincent O'Reilly. We were both trying to keep our nerve. Then to add fuel to the fire a handbill was circulated in the locality:

> To the people of Slane Parish. There will be a meeting held in Slane House next Monday night, 9 April at 7 p.m. in connection with the forthcoming Rock Concert. We have heard from the media that it's thumbs down to Springsteen from the newly formed residents' Association. We feel that the previous plebiscite taken by the Community Council should be upheld. We invite anyone interested in the Rock Concert to attend the above meeting; your support is needed.

It was signed with a suitably theatrical flourish by 'The Unheard Voices of Slane'. The meeting was packed. Over 250 people turned up. They voted unanimously to support the concert, set up an organization called

[137]

'The Silent Majority' and claimed 91 per cent support in the locality. Jim arrived late to address the meeting and was given a rapturous welcome. There was now a new banner in Slane hanging in the local hamburger joint, The Yankee Express. It read, 'Who said Slane won't rock?'

This was decision time. Springsteen's management, based in New York, were starting to ask whether we could guarantee the site. The Irish media were making such a merciless meal of the whole issue that it had been picked up by the American press, and a story was carried in the *New York Daily News* on 8 April entitled, 'Fearing riots, Irish may cancel Bruce.' I thought long and hard. Clearly we had majority support in Slane, and the remarks made in public by leading members of the anti-concert faction bordered on the offensive. There was also another factor: much of the opposition to the show seemed to be directed against me personally. It even surfaced in the *Irish Times*. 'Mr Gerry Hand (25), who chaired the meeting, on Monday night, of the "Silent Majority", the main factor in favour of the Concert, said: "A lot of the anti-feeling is anti-Mount Charles. If he was Fianna Fail it would be a different story." ' We had already met with the Gardai authorities, and the security operation had been put in the hands of Chief Superintendent Michael Bohan, head of the Louth/Meath Division, one of the most critical areas in the country. Jim and I were impressed by his sheer professionalism, and grasp of the problems involved. Although he diligently expressed his neutrality on the issue of whether the concert should be staged, reading between the lines it was clear that the authorities were not ill-disposed to having an opportunity to demonstrate to the general public that an event like Slane could be run smoothly. Jim and I were not the only ones at the receiving end following the Dylan débâcle. If I bowed to this pressure, there would be no more concerts at Slane, and as I viewed it, the campaign to stop these events was partially driven by less charitable motives than protecting the local community. There was also another wider issue, of which I was deeply conscious. If there were to be no concerts at Slane, they might also be stopped elsewhere. There were many voices saying, 'Stand your ground.' Underlying all this was a determination and confidence that after the appalling events of the previous year all involved had learnt a critical lesson. This show could be run, and run well. We decided to go for it, and move on to the offensive.

The next question was tactics. It was clear that the Slane village Householders Association were contemplating a High Court injunction.

We got our solicitor to write a letter to the Association, making it clear we would resist all attempts to stop the show. 'We would point out that to date our clients have incurred great expense in making arrangements for this Concert, and have entered into very large and very serious financial commitments in connection with same. We wish to put you on notice at this stage that any such proceedings which you institute will be strenuously defended on the basis that there are no grounds for same.' It was also pointed out that we had engaged in 'discussions with the Gardai and the Eastern Health Board to ensure that the Concert is run in a smooth and trouble-free fashion', and that we would meet 'all of the requirements of these authorities'. I then went public: 'I'll move heaven and earth to bring over Springsteen.' (*Sunday Press*, 14 April) I made a final attempt to defuse the situation by having a meeting with Gerald Breen, and offered him assurances that the concert would be run in a responsible manner. This was an extraordinary situation. I had known Gerald Breen all my life, and in every sense had substantial respect for his judgement. It was an exasperating, even embarrassing, predicament. People suggested that I should cease doing business with him, and I immediately rejected such a proposition. I was determined to remain rational. He undertook simply to repeat my remarks to his group. It was to no avail. On the 17th they decided to proceed with a High Court injunction. Jim was now clearly rattled and felt all the hard work and effort put into the complex negotiations were disintegrating in front of his very eyes. He was also quite naturally concerned over his mounting costs and, equally crucial, the damage this might inflict on his credibility as a promoter, the most vital component in his business. At this juncture, it seemed as if there was hardly anybody in the country who hadn't heard about Springsteen coming to Slane, and the attempts to stop him. If we managed to stay the course, we would not need to generate publicity. The Slane Householders Association were doing all our work for us. As a deliberate tactic, we adopted a separate stance. I was determined to keep at some distance from the immediate fray. Along the bush telegraph I let it be known that I would fight any legal moves to the highest court in the land, and in public made it quite clear that I anticipated that the concert would go ahead, and that there were no grounds for a legal injunction. In the meantime rumours started circulating that I would sue the Householders Association for loss of earnings. I refused to comment on this angle and let circumstances create their own momentum, keeping my cards close to my chest. In the

meantime, Jim was making strong conciliatory moves. Together with Vincent O'Reilly, our solicitor, we drew up a detailed series of proposals to put to the Householders Association. Most of the measures were already in place following a detailed review of the Dylan concert the year before. We also offered to donate a sum of £10,000 to specified local charities. Jim and Vincent attended a heated and frankly somewhat hysterical meeting on the evening of 24 April. It ended at 2 o'clock in the morning. I had deliberately retreated into the background. At this stage Jim was seriously exposed with a significant deposit paid and the tickets printed and ready to go on sale. Under severe duress, and clearly with his back to the wall, he signed an undertaking not to be involved in any future concerts. The meeting demanded to know whether a similar undertaking would be forthcoming from me. Vincent O'Reilly stated he had no instructions whatsoever to accede to such a request. Indeed, Jim's action in signing such a document was against Vincent's strong advice. While I was extremely sympathetic to the huge pressure that Jim was under, quite frankly the whole melodramatic atmosphere at the meeting must have been a nightmare. I was both upset and deeply depressed that he had felt it necessary to give in on this point. It was to have extensive ramifications. However, at least the show was on the road, and I vowed to concentrate on the present, and leave the future to another day, while making it abundantly clear that under no circumstances would I agree to a similar undertaking. The tickets went on sale the next day. The end to the threat of court proceedings generated more press. The buzz was on. This was the big one – the 'Boss' was coming to Slane. The ticket sales started to soar, and with no need to pump up the hype, we could all concentrate on the real issue at hand to make the show an outstanding success.

The concert was fixed for Saturday 1 June, the opening of Springsteen's European tour. The tickets were sold out by mid-May. From then on my secretary, Emer, was under siege, and I developed an elaborate defence mechanism. There were people wanting tickets, people wanting to meet Bruce, people wanting autographs, people wanting catering concessions and even people wanting to perform at the show. 'Dear Lord Mount Charles . . . Two of my friends, John Ruane and Robert Naughton and my good self, have over the past few years gained much praise and recognition with the singing of our "party piece" at many formal and informal occasions, including parties, sporting events, public house sing songs and even a few wakes. Our reper-

toire is unfortunately extremely limited, only consisting of the song "The Oul' Triangle" . . . Our performance would not set the world alight, but would be that little act which would make a perfect day for, at a minimum, three people, and at a maximum, sixty thousand plus. Can you pass over this opportunity?' What more can you say to that?

All the hassle related to dealing with both mundane and outlandish requests paled in comparison with what is termed 'ligger pressure'. This was exerted by those who felt that they had an absolute undeniable right to gain access to the Castle compound or VIP area. Since the first show in 1981, we retained the Castle and the lawn immediately in front of the house under our exclusive control. It was carefully specified in the contracts, and we had separate security to monitor the area. Those who were given guest passes gained access to the interior of the Castle and to the bar and catering facilities provided. There were always a number of private receptions. By tradition, I always gave a lunch before the show for family and close friends. On the day of the Springsteen concert, we had our reception in the drawing room overlooking the concert site. CBS, Springsteen's recording company, retained the ballroom for both lunch and dinner. On the day of the show, there were well over 850 people in this area, and to put it bluntly some of them produced more aggravation than the most exuberant of regular concert-goers. On the day of a concert, there were really three categories of people one wanted to see in the compound: those genuinely involved in the show; the working media, as distinct from the apparent cast of thousands who claimed to fall into this category; and one's real friends, as distinct from the kind of friendships that seem to blossom regularly every June or July. Over the years, we have developed a reasonably comprehensive list of the Slane liggers. Those that we want to be there, those that should be there, those that we can't avoid having there, and last but not least, those who won't be there next year. Such was the excitement generated by the 'Boss's' impending arrival at Slane that, close to Saturday 1 June, Emer's office felt a little like a battle headquarters. Iona took control of the guest list, and Joe Kenny, who had been closely involved with my political activities, came down to stay and help Emer to deal with the more truculent movers and shakers.

Jim, his brother Michael, son Peter, and Micky Connolly moved into the area, determined that every detail would be closely examined. Following the heated debate surrounding the staging of the concert, it was crucial that the show went without a hitch. Our reputations were

on the line, and if there were any serious incidents, I might as well head for the hills. There were further meetings with the Gardai authorities, the health authorities and the ambulance services. Gussie arranged for the estate wall opposite the Garda Barracks to be repaired, so that any potential trouble-makers would be deprived of stones to hurl at the police. The grass in the lawn-field was topped and rolled in preparation for the big day, and the old front drive, which had been opened for the Rolling Stones concert in 1982, was cleared of the debris of the previous winter's storms. There were helicopter schedules to be worked out, endless interviews with the press, lengthy meetings with Iona and Emer over the latest hassle with the VIP list; and the catering arrangements to be worked out with Sue Wade and our head chef, Colman Smith.

Springsteen's team arrived. They were a pleasure to work with, a shining example of a group of people who could extract the maximum co-operation from the home team with the minimum amount of aggravation. George Travers, the tour manager, a consummate professional, knew the meaning of the word 'Please', not always paramount in the vocabulary of people in the rock and roll business. The trucks arrived, the stage was built, and you could feel the excitement in the air. Huge screens were erected each side of the stage to give the audience a larger-than-life vision of the 'Boss'. A system of delayed sound was installed to give those at the back of the amphitheatre the same clear rendition of that raw energetic sound as those in front of the stage. Every aspect of the show was examined in meticulous detail. The media interest intensified. I did an interview with TV-am and ABC from the States. The American crew asked me to encapsulate my feelings about the event in one sentence. Exposure on prime time is at a premium. 'St Patrick converted Ireland to Christianity from the Hill of Slane, and now Bruce Springsteen is here to convert it to rock and roll.' It glided off the tip of my tongue. I thought it sounded a bit banal, but they loved it.

Dylan was murder. There was no question about it. The Phoenix Park gig had been laced with drama and tension. Putting the whole Springsteen show together was hardly a picnic, but if we were going to go through all the hoops to get the show on the road, we were damn well going to enjoy it. We decided to fill the house with good people. In country house parlance, we decided to have a house party, with Bruce as a backdrop. Why not? You only live once. I got on the phone to my father. He had avoided all the previous shows, largely because they

[142]

smacked too much of future shock. The tranquil setting in front of the house, where lambs used to frisk in the spring, was to be transformed into a seething and enthusiastic mass of humanity. However, over the last few years, his curiosity had got the better of him, and this was an opportunity to see the quintessential all-American rock and roll star. Daphne, always an enthusiast for new experiences, was eager to sample the flavour of it all, and her daughter, my stepsister, Serena, was positively in orbit at the thought of being present for 'the hassle in the Castle'. There was another factor. Daddy was irritated that his previous absence from the festivities had been interpreted as disapproval of my activities. They came and thoroughly enjoyed the whole experience, although my father did get a little indignant the day before the show when the security at the Castle gates refused to let him pass. I don't think he anticipated seeing the day when he would be refused admission to the ancestral pile. Iona asked her brother and sister-in-law, Johnny and Dione Verulam, to come over for the weekend. To be frank, Johnny and Dione's kick is opera, and classical music. The idea of rock and roll featuring at their stately home just outside St Albans is not something that leaps immediately to the forefront of one's imagination. However, they accepted enthusiastically and took a crash course in Springsteen's music so they could appreciate the finer points of the day. Matthew and Lizzie Evans also flew over to join the fray, as did Pete and Karen Townshend, together with their daughters Emma and Aminta. I had first met Pete in New York a year or so before, on a mission for Matthew. My first impression of him was his intensity and disposition to sink endless cups of coffee. He laughs at me now and swears that when talking to him about business, I said, 'Pete, the thing is, cash is king.' He really is the archetypal rock and roll survivor. He has seen it all, been through it all, consumed it all, and kept body and soul together. Of the three great survivors that I know – Bowie, Jagger and Townshend – Pete strikes me as by far the most intellectual, but then in fairness to the other two, I know Pete a great deal better. Since our first meeting I have seen Pete in an entirely different light, as a compelling individual with a penetrating mind, incisive sense of humour, and generous spirit. Somehow the vision of Pete is incomplete without a picture of Karen. Funny, laid-back and stylish, with a sort of soft Rossetti-type face. The pair of them are great. To complete the party we had Dina Schmidt, an old friend and New York restaurateur. She was accompanied by her daughter. Most important of all, the children came. They slept on the

floor of our bedroom, and provided a running cabaret throughout the weekend. The last player in the pack was Richard Compton-Miller, social diarist of the *Daily Express*.

As the day approached, the sense of expectation mounted. Everybody was keyed up and conscious that any slips under the glare of publicity would be magnified ten-fold. The appalling events at Heysel Stadium the previous Wednesday, and the shadow of Dylan, helped to concentrate all attention on crowd control. Other European police forces sent observers to watch events unfold. A massive security operation was put in place. Severe traffic restrictions were introduced with no vehicles through Slane from 6 p.m. on Friday evening. Hundreds of Guards were on duty throughout the Slane area, and a sophisticated communications system was set up to avoid any repetition of the previous year's problems. On Friday Springsteen and his entourage flew into Ireland, accompanied by his stunning wife of only a few weeks, a model and aspiring actress, Julianne Philips. That evening they came down to Slane with the E. Street Band, and having inspected the site requested rehearsal facilities in the Castle. They moved into the Chinese lantern room, and beneath the portraits of the first Marchioness and my Great-Uncle Victor, they blasted their way through the set to be performed in the amphitheatre the following day. It was an inspiring occasion marred only by the frantic efforts of Iona and myself to curtail the activities of Richard Compton-Miller, who was intent on getting a juicy story for the *Daily Express*. We succeeded in keeping him more or less out of the way. Springsteen seemed rather taut, in stark contrast to the relaxed approach of the gigantic black saxophone-player Clarence Clemons. Bruce pounded his way up the slope to the Castle, displaying the characteristics of an athlete in preparation for a big event. I think we all underestimated the tension he was feeling at having to perform in front of such an enormous crowd in such an awe-inspiring setting. In addition to this, what he really wasn't prepared for was the unbridled enthusiasm of an Irish audience, very different from the more intimate settings with which he was familiar. His European tour was going to kick off with a bang. After rehearsal the band had drinks in the hall, and by this time we had all finished dinner. Joe Kenny and I, accompanied by Johnny Woodlock and his pals – a team who did special security in the Castle over the weekend – headed for the village to test the water. All was quiet on the western front. We headed back to the Castle. There were people sleeping everywhere. There was a guy from the Special Branch in the

hall cradling an Uzi machine pistol. There was going to be no hassle in the Castle that night. We retired to bed happy in the knowledge that we had received the best news of all: the weather forecast was good through to Monday.

We rose early to the friendly chug of the site generators. The children were still asleep on the floor, exhausted by the excitement of the previous day's activities. Colman Smith and his cohorts were preparing breakfast for our guests in the restaurant kitchen. Iona and I rushed downstairs. Cars were already drawing up in front of the house. The area had to be kept clear. Iona charged round barefoot acting as traffic warden. She was immovable, even asking Gay Byrne, Ireland's leading broadcaster, to shift his car, which he had somehow bamboozled through security. I raised Johnny Woodlock and his team from their slumbers and started on my rounds. We circled the area. Everybody seemed remarkably calm and good-humoured, and we were going to be blessed with sunshine. Jimmy Clarke, Jim's right-hand man in charge of security, was getting ready to check and position the hundreds of men required to secure the twenty-two-acre site. Our own men arrived, to be given instructions and to be told emphatically that nobody was to get into the Castle compound without a pass, 'even if she says she's the bloody Queen of Sheba'. Sue Wade and her deputy, Barbara Cassidy, started checking the staff rosters and distributed walkie-talkies so we could all keep in constant contact. Our guests were up and beginning to drink in the atmosphere.

By 12 o'clock, the helicopters started moving in and out, ferrying guests and VIPs. There were two main companies involved, Irish Helicopters and Celtic Helicopters, which is operated by Ciaran Haughey, one of Charles J. Haughey's sons. Ciaran seems to develop the edge at these events. He has the best contacts. I arranged a deal with both companies so that they would give me the use of a machine during the day. It proved invaluable, enabling me to take chosen photographers up in the air to get a good aerial shot of the site and also giving me an opportunity to see what was happening outside the perimeter fence. There was the added cachet of taking two of Springsteen's other European promoters up for a whirl, including the fast-talking, cigar-smoking Harvey Goldsmith. At around noon, I disappeared for a short bath, and a moment's quiet contemplation. Our guests started arriving for lunch. Nick and Sue Koumarianos, two close friends, arrived on their motorbike, with what they anticipated would be a stylish flourish.

[145]

They skidded on the gravel in front of the house and collapsed in a heap, much to the amusement of the assembled company. To my acute embarrassment I discovered Ben Dunne, the Irish supermarket supremo, in the Castle compound. He had been invited as a guest by CBS Records. In May I had issued a statement in support of eleven Dunne Stores workers who had been on strike for the previous ten months over their refusal to handle South African goods. I had also given them complimentary tickets to the show. Try explaining that muddle to a load of cynical hacks. More guests arrived, to give added flavour to the occasion: Elvis Costello, Paul McGuinness, manager of U2, and Spandau Ballet, who were recording in Dublin. Tony Hadley, the lead singer, distinguished himself by roaring around the compound on a motorbike with my stepsister Serena, much to the annoyance of myself and my security, who had other things on their minds than having to deal with errant relations and flamboyant pop stars. The political contingent arrived, represented by Fine Gael TDs, Monica Barnes, Liam Skelly and Michael Keating and friends. Monica still waves the flag of social democracy in Fine Gael. Liam Skelly was drummed out of the party and lost his seat, and Michael Keating is now deputy leader of the Progressive Democrats. P. J. Mara, then Fianna Fail press secretary, was there, representing the facsimile 'Boss', Charles J. Haughey, whose flag was also kept flying by his other most enthusiastic supporter, daughter Eimear. My cousins, the McCalmonts, arrived with a large entourage, including several people who had been on the trip to Saran, where I had met Iona. They kept happily blathering about Iona's new nickname to all and sundry. It was eventually picked up by the media, and she is still known in certain quarters as 'Iona Castle'.

There were endless media. Over 80 passes were issued to RTE. It seemed totally extravagant but hard to say No. There was aggravation as photographers tried for the best shots. For some inexplicable reason, the *Irish Times* was excluded from the list of those allowed near the stage. I had to embark on a diplomatic mission to sort out the confusion. Dave Marsh, the author of the book on Springsteen called *Glory Days*, was wandering about collecting anecdotes. His grasp of accuracy was a bit suspect as he described me as British in his tome. Up in the helicopter, down to the Castle gate, back into the Castle, quick talk with guests, pacifying photographers, interview, interview, retire to the drawing room, quick plate of food and a glass of wine and gossip with our guests. Endless grind until right on the dot of 5 o'clock, show time. Springsteen

roared on stage, and broke into the title track of his best-selling album *Born In The USA*. It was the beginning of three hours of what I can only describe as a vintage concert. The high point of the entire set was his delivery of his haunting song 'The River'. As the sound carried across the Boyne Valley, huge images of the weir below the Castle were transmitted from the giant video screens. (When Iona and I went to see the show at Wembley the same images appeared. The river Boyne flowed in London that day; we felt quite emotional.) It was in every sense a magic moment. Springsteen's performance was impeccable, only marred slightly by his reaction to the vigorous enthusiasm of the Irish crowd. I think he was a little freaked by the collective exuberance of the seething mass of humanity spread out in front of him, and wondered if it was to be like this throughout his European tour. However, watching him, you would never have noticed it; it was a stellar performance. Headlines: 'Slane resounds to the Real Thing' (*Irish Times*); 'That's the Boss – Born in the USA and made for Slane' (*Sunday Independent*); 'Springsteen at Slane: The man, the music, the magic' (*Sunday Tribune*). The last word goes to Joe Breen the rock critic of the *Irish Times*: 'It was clear that this was a band that loves to play, that loves to perform. Anybody who still believes that Bruce Springsteen and the E. Street Band are a rock'n' roll hype should think again. They are the real thing.'

The show was over. Springsteen headed for the choppers and Dublin to recuperate from what had been for him a mind-blowing experience. We headed for the Castle, smuggling in some of the band, John Landau, Bruce's manager Barry Bell, Barbara Carr, who handled the publicity, and the ever-gentlemanly George Travers, so that they could enjoy CBS hospitality. Inside the Castle the liggers and shapers were jockeying for position. Johnny Woodlock headed for the bar and we all started to relax. Spandau Ballet's minder started hurling abuse at Sue Wade because they weren't being allowed into the CBS reception. (Several weeks later the band came down to the Castle to join us for dinner. There were embarrassed looks when they saw Sue sitting at the table as a guest.) Downstairs in the restaurant, champagne and wine corks were flying. The McCalmonts, Eimear Haughey, and our house guests were celebrating and winding down from the buzz. All the struggle, all the hassle, all the tension and anxiety had been worth it for one statement made on the day of the concert by Gerald Breen. He believed that the way the concert had turned out would 'have a significant effect on our approach to future concerts'. In my heart I knew that Slane would rock

on, but there was still the written undertaking that had been extracted from Jim. He had poured all his energies into making the concert work. It seemed crazy to break up the team. We had travelled through so many hoops together. I said to him: 'Jim, where there is a will there is a way.' That was Springsteen.

11

Journey to Inner Space

Many have passed through the portals of the Castle since 1976. Jack Lemmon arrived one afternoon for tea with an old friend of my parents, Charlie Bird, who had once been joint Master of the Meath Hounds with my mother. Julius Nyrere came to gaze at my ancestors on his state visit to Ireland. He was almost disarmingly relaxed. President Hillery has been to the Castle on several occasions to shoot. Garret FitzGerald came to dine with Young Europeans and Charlie Haughey to see Sue and Ivan married. Sue is an old family friend of the Haugheys. He likes to refer to me as 'Mr Conyngham', casting a jocular swipe at my title and Anglo-Irish background. The Crown Prince and Princess of Japan came to lunch, and as a result we received a small grant from Bord Failte towards the costs of redecorating the ladies' cloakroom. His Royal Highness, like all normal human beings, received a call of nature and I was quickly summoned to escort him to the gents, being deemed the only person of sufficient rank. We have launched motor cars, washing machines, pharmaceutical products and even sweets. We have held dances, conferences, auctions, fashion shows and exhibitions. However, one type of event in particular dominates them all. We have catered for literally hundreds of weddings. They have had their comic moments, from abandoned guests to abandoned cars, intoxicated relatives to tearful brides, even to the bridegroom who showed an embarrassing preference for one of the bridesmaids. There have been joyful celebrations and family rows. There was a classic example of a fight between two women. When they were separated by a member of staff, the explanation offered was, 'If I can't bloody hit me sister, who can I bloody hit?' We have seen dancing, prancing, entrancing and intransigence, drunkenness, tomfoolery and long and serious conversations. At times it has been a

circus and a sanctuary. Throughout 1985 I was heading unknowingly towards inner space.

In politics one of the most valued commodities is pragmatism, but on occasions in recent Irish political history, even pragmatism has been swamped by that mortal enemy of progress, inertia. The very nature of my political involvement has always centred upon one purpose: the best possible method of articulating my views and perspective on current issues. This need has at times been on a collision course with the accepted norms of existing party politics. With the possible exception of the left in domestic Irish politics, that is the Irish Labour Party and the Workers' Party, the remaining parties – Fianna Fail, Fine Gael and now the Progressive Democrats – bear a marked similarity in their approach to many issues. Whether this consensus has provoked action or indecision depends very much on electoral mathematics. As I write, a minority Fianna Fail government holds power pursuing a cocktail of Fine Gael policies and Fianna Fail pragmatism. Fine Gael is trying to adopt a responsible approach to our tarnished economy, but is terrified of precipitating an election for fear of annihilation at the polls, and the Progressive Democrats are struggling to establish a separate identity. In late 1984 and early 1985, the Progressive Democrats did not exist, and much of the party politics had been relegated to the level of tribal football. There was an obsession for goal-scoring with a scant regard for the national interest.

I had been drawn into Fine Gael by Garret FitzGerald's Constitutional crusade, and the expectation of reform. If anything has provided a motivation for my involvement in political life, it is the conviction that it is nothing other than a form of base and atavistic arrogance to aspire to national unity without simultaneously striking out for a new Constitution that embraces the entire nation North and South. It boils down to one simple rule: you cannot and will not unite the island unless you unite its people, and any structure or manoeuvre designed to mask this truth is mere camouflage designed to hide the inadequacies of the positions adopted by many of our politicians. The blame for what has happened and is continuing to happen in the North of our island cannot be exclusively laid at the doors of the British government, the Unionists or even Sinn Fein, but rests equally on the shoulders of every politician in the Republic. It should be the duty of every public figure in this country to strive to find a way of ending the violence, the carnage and the wanton waste of resources that is the Northern Ireland of today.

Charles Haughey may argue that the North has failed as a political entity and thus far I agree with him, but is he prepared to examine the price that we must pay for its termination? I am a Protestant. I live in the Republic of Ireland. I have in my veins a mixture of blood, and in my mind a mixture of traditions, but most crucial of all in my heart I am an Irishman. The future lies in seeing the reconciliation of what may on the surface pass for contradictions. The mortal enemy of peace and prosperity is ambivalence and double-think. 'It need hardly be said that the subtlest practitioners of double-think are those who invented double-think and know that it is a vast system of mental cheating. In our society, those who have the best knowledge of what is happening are also those who are further from seeing the world as it is. In general the greater the understanding, the greater the delusion, the more intelligent, the less sane.' The words of George Orwell, in *Nineteen Eighty-Four*, written in 1949. Every move I have made politically has this as its core, and in 1985 it was to take me out into the political wilderness.

My first party political sin was not wanting to be a county councillor. When asked whether I would run in the local elections I said No, and stated that this was not an arena in which I wanted to make a contribution. I was accused of having 'a nerve as big as Slane Castle', and being 'a man who wants to walk before he can crawl'. The truth as I saw it was that by embroiling me in local issues, the constituency organization could tie me down and I had no intention of falling into any traps designed to silence my self-expression, whether laid for me locally or by party headquarters. If attempts to form a ginger group were frustrated by hostility and intimidation, another way would have to be found.

In April 1985 I was given the opportunity of doing something constructive. Ted Nealon, Minister for the Arts, appointed me to a committee set up to examine whether any steps could be taken to stem the flow of works of art out of the country. The committee was chaired by Liam Hamilton, President of the High Court, and I threw myself eagerly into the task. However, other matters were on my mind. Dessie O'Malley, a distinguished former Fianna Fail Cabinet Minister, who had lost the Fianna Fail whip in May of the previous year, made a dramatic speech in the Dail on a Contraception Bill introduced by the Coalition government. In one section of his speech he articulated views very close to my heart: 'You are supposed to be ashamed of wanting to see a pluralist society in this country. You are supposed not to want that, but to want one which is dominated by one form of thinking only. There are

[151]

Unionists in the North who want the same. While both of us are that way, we can assure ourselves that never the twain shall meet.' He concluded by saying, 'the politics would be, to be one of the lads, the safest way in Ireland. But I do not believe that the interests of this State or our Constitution of this Republic, would be served by putting politics before conscience in regard to this. There is a choice of a kind that can only be answered by saying that I stand by the Republic and accordingly I will not oppose this Bill.' His speech led to his expulsion from Fianna Fail, and talk commenced of a new political party being formed to break the mould in Irish politics. If this happened, and it was firmly founded on the twin principles of creating a more just society and reforming the Constitution, it would be a breath of fresh air in a political landscape littered with the detritus of mediocrity.

In March I had gone to New York to listen to U2 and tie up the arrangements for Springsteen. Jim and I had travelled out with a collection of journalists; the topics under discussion varied extensively. It was not confined to rock and roll. Niall Stokes, the editor of a magazine called *Hot Press*, was on the trip. O'Malley's speech had provoked much soul-searching and I felt compelled to put my thoughts on paper. I showed what I had written to Niall Stokes and he asked me whether he could publish it. I knew that the consequences of the article appearing in print would make my position in Fine Gael uncomfortable, but the gauntlet had to be thrown down. I threw it.

There is a sense of hopelessness around at the moment, as if we are powerless to arrest this decline. It is felt at all levels of society from the unemployed to the self-employed, from the old to the young. Politicians argue about how many people are leaving the country, but nobody seems to dispute that they are leaving. Confidence has collapsed, incentives have been destroyed, the tax rate rises and the government still squanders money. This is not to suggest that we must fall completely to the ship of the monetarists, for the requirement is for discipline and imagination. Above all else we need imaginative thinking if we are to haul ourselves out of this morass. It is perhaps on the very building blocks of imagination and courage that the future of a new political party will depend. In the present political climate, such a combination would be like the fresh air of spring after a very hard winter. Mr O'Malley, I shall watch your

movements with interest. The question is, will you have the courage to take up the mantle?

April and May were totally absorbed by the Springsteen concert. But four days after the gig was over I made deliberate and public attempt to display my wish to remain within the Fine Gael framework by campaigning in the local elections in Dublin Central for Fine Gael TD Michael Keating. (He was later to leave the party to join the Progressive Democrats.) At this stage I still very much wished to remain within the ranks of Fine Gael, because there were so many in the party who were equally disillusioned by the leadership's failure to grasp the nettle, and it seemed that the only course left open was to try and force the pace and attempt to flush Dessie O'Malley out into the open. In early August I wrote a long article for the *Irish Independent* which they headlined as 'Why our Politicians have failed us'. I did not mince my words.

Never since the founding of the State has there been such an urgent need for a New Departure in Irish politics, and never before have the existing parties appeared so moribund. I joined Fine Gael in 1982 because I firmly believed it was the only logical step to achieving reform in our political system. I freely admit that the reason I chose Fine Gael was because I felt strongly at the time that Garret FitzGerald had every intention of pursuing a programme of constitutional, social and economic reform, and that he would have the competence to be able to produce some really tangible progress on the Northern issue. I do not doubt the sincerity of the man, but I seriously question whether our party remains the proper vehicle for progress in the State.

The publication of the article provoked a substantial response. It had struck a chord. Ideally what I wished to see was a reinvigoration of Garret FitzGerald's sense of purpose, or alternatively O'Malley striking out in a radical fashion and forcing the other parties to respond. In truth, Garret seemed to have lost momentum, and O'Malley, with whom as yet there had been no discussions, seemed to be in too brooding and introspective a condition to act as a catalyst for change. I decided to push the boat out a little further. I was taking one hell of a risk, because whichever way you examined it, I still had a major credibility problem, and was in serious danger of burning my boats with Fine Gael. I discussed my feelings with Stephen O'Byrnes, then a political

[153]

correspondent with the *Irish Independent*, and now Press Secretary to the Progressive Democrats. Our conversation was on the record. He wrote an article with the headline 'Lord Henry proposes new party – with Des O'Malley'. Stephen O'Byrnes asked the right question, 'But even if the ideas he was articulating were correct, was he – a lord in a Castle – the man for the role of pied piper?' The answer, of course, was No, but I could hardly admit to it. O'Malley was the only person with sufficient susbstance and credibility to force the pace. In effect, I was running up a flagpole and hoping to hell to provoke a reaction. That evening there was a predictable response. An article appeared in the *Evening Herald* in which 'a prominent member of the Fine Gael National Executive, who asked not to be named, said that the recent political statements from Lord Mount Charles were certainly in conflict with his position as a member of Fine Gael. If he has not resigned, I would not be surprised if he was kicked out'. I was boxing myself into a corner. Several of my close friends pleaded with me not to indulge in an act of self-immolation. I tried, unsuccessfully, to discover what O'Malley was thinking. It was impossible to fathom. Clearly he hadn't made up his mind, but there was no doubt whatsoever that there would be widespread support for an attempt to break the mould. I dithered, not knowing what move to make next. Associates in Fine Gael asssured me that there was still room for self-expression within the ranks of the party. Maybe they were right, but I could not see it. It felt as if I was at the hatch of an aeroplane, waiting to jump, and not knowing whether my parachute would open. The open space had an almost seductive appeal, and increasingly I was convinced that I had manoeuvred myself into a position where it was becoming impossible to turn back. O'Malley appeared to be both taciturn and almost tortured by indecision, and I was feeling increasingly isolated in a Fine Gael party which seemed to have deserted the earlier reformist zeal of Garret FitzGerald. Towards the end of August I was convinced that there was a need for a new party, or movement, based on the building blocks of Constitutional reform, and a radical restructuring of the economy. I stood on the political landscape just left of centre, much akin to the SDP in Britain. I decided to take the plunge. It was a lonely decision, and many of my friends in Fine Gael, while sympathizing with my views, felt I was taking an appalling risk – in short, of burning out before I had even lit the fire. Inside, despite the risk of political suicide, there was a conviction that I had to stand by my marker. I took the plunge, resigned from Fine Gael, and declared an

[154]

intention to set up a new political party, which would be launched in November. I chose the name New Departure, which could equally well be applied to a political movement. Language is important in politics. The country abounded in talk of 'breaking the mould', the words New Departure had strong implications, and by delaying the formal launch until November it would still give me time to see if Dessie O'Malley would come out of his political closet. My move excited a good deal of interest, but also a substantial amount of hostility and derision. In the corridors of Dail Eireann it was described as 'the political non-event of the year'. Others argued that I was on a publicity trip, and the Fianna Fail director of elections in my own constituency, Mr Healy, described me as 'quite naive about the whole political scene'. However, I was not without support: 'A public debate such as that started by Lord Mount Charles and Mr Healy must be good and could give some indication of the amount of support there would be for a "New Departure" party. It could become a force similar to the SDP in Britain and might do better in this country because of the PR system. It deserves to be taken seriously and given a chance to succeed – it could hardly do much worse than what exists already.' (*Meath Chronicle*)

My stance also generated substantial mail, and many people made contact with me expressing interest in becoming involved. This was all very heartening, but I knew in my heart that for such an endeavour to succeed, I needed to attract some serious political muscle. I travelled the country, wrote endless letters, talked to a lot of people and accepted every speaking engagement I was offered. In the middle of October I went to University College, Cork, to address a debate on Church–State relations. Dessie O'Malley was one of the other speakers. I failed to extract an indication of whether he would make a move, but there was a just perceptible change in the temperature. At the end of October Iona and I got married, and we went to the United States and Jamaica for our honeymoon. On the far side of the world in totally relaxed circumstances, I contemplated my predicament, and came to the conclusion that I must delay the formation of a political party until Dessie O'Malley strode out into the limelight. If he did make his move, my own efforts would be swamped in the momentum. Coming home, I felt refreshed and invigorated, and although underneath I knew I was out to sea without a sail, I masked my apprehension and continued talking and making speeches. As the year moved towards a conclusion, I got a whisper that a move was on. Somebody close to Dessie indicated they

[155]

felt my activities were queering the pitch. From then on it was only a matter of time, but he still seemed to be hesitating. Then just before Christmas he showed his colours and the Progressive Democrats were born, and generated an almost disconcerting level of support, such was the disaffection with the established political structure. The initial groundswell seemed almost detached from any bedrock of ideology. The party's main thrust was provided by the persona of its leader Dessie O'Malley. The two of us met at his house in Dublin on Christmas Eve 1985.

While it was clear at the meeting that Dessie O'Malley was refreshingly conscious of the enormous problems facing the country, and gave every impression of being sympathetic to the need for Constitutional reform to embrace all the traditions on this island, there was an aspect of his approach which I found somewhat at variance with the sentiments he expressed in public. Frankly, he told me that in the early stages of the development of his party, somebody from my Anglo-Irish background would be in danger of alienating some of his support in his Munster base. This may have been *realpolitik*, but it cast a somewhat jaundiced light on the fine aspirations expressed in his much-vaunted 'I stand by the Republic' speech in Dail Eireann earlier in the year. This, coupled with the easily perceived intensity of the rivalry between himself and Charles J. Haughey, did little to inspire confidence that there was any future for me within this fold. We parted company on friendly terms on the understanding that I would cease all political activity, and wait to see how matters developed. Deep down I knew I had walked out into the political wilderness. On and off during the following year my feelings blew hot and cold about the Progressive Democrats because what they represented was so hard to interpret. I wavered when Michael Keating, TD, from Dublin Central, a friend and politician for whom I have considerable admiration, joined them and was appointed deputy leader of the party. Almost exactly a year after my meeting with Dessie O'Malley, with a general election looming, I gave an unequivocal answer to the General Secretary, Pat Cox, and the Director of Policy and Press Relations, Stephen O'Byrnes, that for the foreseeable future I was going to remain neutral.

12

Inner Space

As 1985 drew to a close, a dark shadow was cast over my life. We received some ominous news from the Isle of Man: my father had cancer. Quite suddenly I was confronted by the awful possibility that I could be deprived of not only a father and a friend, but also my closest adviser and confidant. Every other aspect of our lives was driven into the background. It was a harrowing and emotional period, dashing back and forth from the island. My stepmother, Daphne, was a Trojan in every possible respect, and the cruel irony of it all was that my father made a remarkable recovery, and later in 1986 Daphne fell victim to this pernicious disease and died in November of the same year. She is remembered with profound affection by all who knew her.

If the threat of death presented anguish, an actual death changed our lives. On 15 March 1986, my next-door neighbour and distant cousin, Sir Oliver Lambart, died. It was very sudden and totally unexpected. The following day, a Sunday, Bono and his wife Ali, together with Larry Mullen and his girlfriend Anne Acheson, were having lunch in the restaurant. We joined them for a bottle of wine. The house was open to the public and a message arrived that there were two gentlemen in the main hall insistent on seeing me. Iona went upstairs to establish both their identity and their purpose. They explained that they were Sir Oliver's legal representatives and wished to inform me that he had died. Iona responded by saying that we already knew but they insisted on seeing me. Iona returned to the restaurant, puzzled by their odd demeanour. When I went to talk to them, they solemnly informed me that Sir Oliver had died, and that shortly they would have some news of interest. It was a most bizarre episode. The following Wednesday Sir Oliver was buried in the family vault at Beau Parc. As soon as he was lowered into the ground, I was informed that he had left me the

property and the contents of the house. It all seemed like a strange dream.

The Lambarts had originally been Cromwellian settlers, and established themselves at Beau Parc in the early 1600s. The house dates from 1753, and was designed by Nathaniel Clements, a close friend of Ireland's leading Palladian architect of the time, Richard Castle. The house is situated in what can only be described as a stunning and dramatic setting above the Boyne. It has a more intimate and more private feel than the more public drama of the Castle. The woods that border the river stretch below it, like a giant herbaceous border, and in the distance is the Hill of Slane. The two properties complement each other like brother and sister, straddling the Boyne, and protecting one of the most beautiful natural landscapes in the country. 'At Slane stands the magnificent seat of Earl Conyngham and Mr Lambart. The grounds belonging to these places have the appearance of one domain, being separated only by the river running in between romantic rocks, the summits and sides of which are adorned with wood. The view of this scenery combined with the dressed lawns of the two seats, renders the whole prospect highly interesting.' (Edward Wakefield, *Account of Ireland. Statistical and Political*, London, 1812.) It was to be 174 years before they were truly united.

In the middle of the last century, Lady Fanny Conyngham, daughter of the second Marquess Conyngham, married Sir Oliver's grandfather. As the story goes, the Lambarts were then in some financial difficulties and the second Marquess is supposed to have bought the property from them and given it back as a wedding present. Ever since, hanging in the Castle there has been a portrait of Lady Fanny dressed in a flowing romantic dress with Beau Parc in the background – no doubt designed to serve as a reminder to her father of where she had gone. At Beau Parc there was a matching portrait showing her in a somewhat severe-looking Victorian riding habit with the Castle in the background – no doubt serving as a statement to her husband about her origins. The house was also furnished with more than subtle reminders of their benefactor, Francis Nathaniel, the second Marquess Conyngham, and Lord Chamberlain to Queen Victoria. The links between the houses had been very strong, and it was only when examining these items after Oliver had died that I truly appreciated their significance. Lady Fanny was Oliver's grandmother, an important figure in anybody's back-

ground, especially for someone surrounded by her images. Lady Fanny was my great-great-aunt, hence a somewhat more remote figure in my thinking, save for one extraordinary coincidence. When I was christened in 1951, I was given a rather beautiful silver cup by my great-aunt Edina, Lady Holmpatrick. I was the first Viscount Slane for almost a hundred years. Apart from the inscription to me, it bears one other message: 'From his Godmother and Aunt, The Lady Fanny Lambart, to Henry, Francis, the Viscount Slane, born 1st October 1857'. How the world turns.

Sir Oliver was a bachelor. His father died when he was young. His mother was almost forty years younger than her husband and lived at Beau Parc until she was well into her nineties. The last occasion I recall her visiting the Castle was for Henrietta's christening. In her youth she was an enthusiastic balloonist. She ran a successful stud, and bred the Epsom Derby winner, Hard Ridden, at Beau Parc. Sir Oliver was a shy and retiring fellow. Passionate about racing, and certainly in his later years not very social. I had known him all my life. My father had once rescued him from the river Boyne. When I returned to Ireland in 1976, I would visit him occasionally at Beau Parc. We would sit in his study, and he would talk vividly of events that had taken place years ago. He also displayed what struck me as an unusual interest in the concerts at Slane, for I could not imagine him ever attending such an event. We talked about the future of Beau Parc on only two occasions. He knew it was something about which I cared. In the seventies he sold two wonderful eighteenth-century Irish landscapes of scenes along the river Boyne. In the finer of the two, Beau Parc features prominently. The other is a view of the Maiden's Rock, and the Castle before it was reconstructed. Eventually I managed to acquire them and they now hang in the drawing room at Slane. When they were cleaned and placed in their new positions I rang him up and invited him round for a drink. He had the other four to the set still at Beau Parc. I asked him, if he ever wished to sell the others, would he give me first refusal. He smiled. They were in the house when he died.

When I discovered Oliver had left me the property we were faced by a daunting prospect. It was in a state of almost total disrepair, riddled from top to bottom with dry rot and held together by sentiment. He had also made no residuary clause in his will and I was to lose a construction suit for the funds that would have assisted in its rehabilitation. However, the circumstances of his gift were so special, almost eerie, that we could not

let Beau Parc die. Over the last few years we have restored the house to its former glory and now, to echo Wakefield in 1812, Slane and Beau Parc have more than 'the appearance of one domain'.

Two days after learning the news of my bequest I had a car crash. It was to put me in a cervical collar for months, and keep my movements severely restricted. It gave me an opportunity to look back upon the events of the past five months. Iona and I had got married, my father had nearly died, I had received a totally unexpected and dramatic inheritance. I had walked out into the political wilderness. I was sedated and in pain. Out of circulation, I had moved to inner space.

Inner space or not, there was still rock and roll. 1986 was the year Queen came to Slane. They may have had a hit called 'A Kind of Magic', but, for me, it lacked that special sparkle associated with The Rolling Stones, Springsteen and David Bowie. Queen was something of a hassle, and I really wasn't in the best shape to deal with it. It all began with the undertaking that the Slane Village Householders had extracted from Jim prior to the Springsteen show not to be involved in any more concerts. We had both by now been round the tracks together. We trusted each other, and I knew that, although he didn't live in Slane, he had grown to love the area and understand the idiosyncrasies of its people. There was a bond of friendship between us that extended to his son Peter, now very much part of the team, and brother Michael. Jim had stood firmly behind me when I was subjected to a barrage of criticism during Dylan, and without any equivocation he had put his back into making Springsteen a success. Slane is part of my soul, I live there and love it, but by now it had become just a small part of Jim too. There was really no question about it. He had to be got off the hook. At the end of October 1985, I went to see my solicitor, Vincent O'Reilly, and instructed him to write to the Slane Village Householders Association's solicitors, stating I was putting together a show for 1986, and was in the process of appointing a promoter, and that my first choice was Jim. The die was cast. It did not take long to get the lie of the land. There was a small group implacably opposed to the concert, and, to put it politely, they were far from my most ardent fans. However, I was firmly convinced that by now we were facing a minority within a minority, so we went on the offensive. A petition was circulated in the locality to be signed by all those over eighteen years of age. It read: 'We, the undersigned, residents of Slane and the surrounding area, wish Mr Jim Aiken to promote the 1986 Concert at Slane Castle.' Over 700 signatures

were collected, and most encouraging of all, several were members of the Slane Village Householders Association. However, it was clear we were going to have to go to court to get Jim released. In the meantime my car crash had severely hampered my movements, and I was in considerable pain. My condition meant that unless we succeeded, there wouldn't be a show.

It was 21 April before we got to court. Our Senior Counsel, Ercus Stewart, had just returned from completing the London Marathon. I hoped that this didn't indicate we were in for a long haul. The pain was so severe in my neck that I had to lie prostrate on one of the benches in court to relieve the agony. Gerald Breen, the former public relations officer of the Slane Village Householders Association, was called into the court by the Judge. He stated that although he had no authority to release Jim from the undertaking, he felt on a purely personal basis that if there was going to be a concert, he would like to see Jim promote it. The Chief Superintendent of the Louth/Meath division of the Garda Siochana expressed a similar sentiment. After lengthy legal argument and a lot of nervous waiting, we won the day. Jim left the court and headed for his telex machine and the deal was done.

If the courtroom drama provided tension, there were also problems of a quite different nature. Gerry Stickles, who was running the tour for Queen, had visited the Castle, and was very impressed with the site. During our discussions, we touched upon the thorny issue that the band had played at Sun City, and were listed on the United Nations register of entertainers who had performed in South Africa. I was sensitive on this issue having been vigorously opposed to apartheid ever since I had worked in an Anglican Mission after leaving school. He assured me that the band were never going to play there again, and that steps were being taken for them to provide an undertaking to the United Nations Centre Against Apartheid that would ensure their removal from the register. It was clear I was not the only person who had raised the question. In early March I was contacted by Kadar Asmal, Chairman of the Irish Anti-Apartheid Movement. I immediately got back to Gerry Stickles, who said everything was under control. The day after the court case I got a letter from Kadar Asmal stating, 'We understand that Queen have refused to address a letter to the UN with the undertaking that they will not perform in South Africa in future. If this is so, then we have no alternative but to call for a boycott of the Concert.' I couldn't believe it. There must be crossed wires. To my intense relief, I discovered all was

well. The band had delivered their undertaking and been deleted from the register on 11 March.

If matters international presented problems, so did matters commercial. Queen were involved in a sponsorship deal with Harp Lager. Jim and I hadn't been consulted. Slane is a dry site, and it struck me we were into promoting alcohol. In any event, sponsorship is fraught with difficulties, particularly when it comes to rock and roll. It was crucial to protect the long-term interests of the site, and I didn't want to see it decked out like a football stadium. We were faced by a *fait accompli*, but we stuck our oar in to try and retain an element of control. Although this link helped make the concert a commercial success, it proved an uneasy relationship. It tipped the scales too heavily in the direction of brash commerce. Somehow it all seemed a bit cheap.

With the Queen show there seemed to be endless difficulties, not helped by my condition. Iona was trying to keep me tied down, and I couldn't drive or move about, which was enormously frustrating. Joe Kenny arrived to help and act as an extra pair of eyes and ears, and with Iona and Emer to hold the fort. There seemed to be endless storms in teacups fraying already painful nerves. Emer was yet again struggling with the distribution of free tickets to the teenagers in the locality – a serious nightmare and, to cap it all, she was accused of leaving out a retarded child. We also distributed endless free tickets to charities. There were numerous trivial and ridiculous rows as to how many each organization received. Just before the event, as I was hobbling around the site inspecting Harp's installations, I slipped and fell, further injuring my neck and back, and was confined to bed, restricted to yabbering in a frenzied fashion on both my walkie-talkie and the telephone.

By Saturday 5 July, the day of the show, I had recovered sufficiently. Braced with painkillers and a good deal of rest, I ventured forth. My father and Daphne arrived together with the children, and Matthew and Lizzie flew in from London. Peter and Barbara Lee Schmidt arrived from New York. (Peter was a colourful but unscrupulous American lawyer who has since disappeared without trace with large sums of his clients' money.) The show started with an Irish band called The Fountainhead, which I had been anxious to have included on the bill. They were followed by Chris Rea, who was good, but didn't really excite the crowd. Glamour was introduced by The Bangles, a female band from the United States, who were making their first major appearance in Europe. The weather was mixed and the crowds enormous. Jim's security was

having problems keeping a lid on things at the entrances. There was a mêlée near the front of the stage and our always delicate relations with the media were not enhanced by some bright security man lifting a photographer's film. Some cretin smashed the valves supplying water for the Castle. There were problems with the loos. Iona had an altercation with a record executive who reckoned he wasn't getting ace treatment. Queen went on stage. The crowd reacted enthusiastically but somehow I sensed Freddie Mercury wasn't pulling out all the stops. I retired to the drawing room, neck throbbing, to watch the show. It had its moments. When it was all over we were sitting relaxing talking about the day's events. Suddenly there were two faces we didn't recognize passing through the hall. Something was wrong. Peter Schmidt leapt to his feet and with assistance pinned them to the floor. They had various items of jewellery which they had lifted from our bedroom. To this day I don't know how they breached our security. The following morning a fire broke out in the stableyard. Somebody had been sleeping there and a mattress had been ignited by a smouldering cigarette. The fire brigade was called. In the afternoon we went to Beau Parc for a picnic. The seagulls were doing the same in the lawn-field in front of the Castle. The tranquillity was welcome. That was Queen.

Circle

In the summer of 1987 we were invited to a lunch at Knebworth House to mark the retirement of Patrick Forbes as Managing Director of Moët et Chandon in the UK. David and Chrissie Cobbold had also played host to Queen at Knebworth the previous summer, and Chrissie Cobbold had written a book about their experiences called *Board Meetings in the Bath*, which had prompted me to start contemplating recording the events at Slane over the last decade. At the lunch I met an old friend, Hilary Rubinstein, the literary agent and author of *The Good Hotel Guide*, who had offered me a job eleven years ago. We had animated conversation and I discussed the idea with him. I promptly received a copy of *An Inn Keeper's Diary* by John Fothergill, which had been first published by Chatto and Windus in 1931 and reprinted in 1987 as a paperback by Faber. It was intended to harden my resolve to put my experiences down on paper.

The events of 1986, starting with the extraordinary gift of Beau Parc from Sir Oliver Lambart, and the opportunity for reflection presented by long hours resting and reading following my car crash, enabled me to gather together the strands of the previous decade, and examine where it had taken me. By early 1988 I started writing, and when I delivered the first half of my manuscript to Faber it induced the strangest sensation. Had I travelled full circle, and was I trying to find a way of returning to the freedom I had enjoyed before coming home? By the time I had completed the manuscript, it seemed like a circle, but I had emerged a somewhat different person from how I had gone in.

Childhood at Slane had been protected, full of mystery and wonderment. An enclosed community, not really vulnerable to the outside world, dominated by my parents, Mary Browne, and all those that lived

in the enclave, it was very much a private space, but it built the foundations of a bond with Slane from which I judge it would be impossible ever to sever myself. The late sixties and seventies changed all that, and I met head-on an Ireland that was bedevilled by division and hypocrisy, and where frankly I had felt an outsider, a non-participant, belonging to a sort of limbo class, with no real role to play. It was, I suppose, a rather confused state which I could have avoided confronting had I not returned home. Events since 1976 have made me more sure of my identity and given me a sense of direction.

It has been the struggle of trying to lead a private life in a public space. Evolving a method of dealing with the personal future shock experienced by seeing, and indeed causing, such radical changes to a building that was once such a personal sanctuary. The concerts have brought exposure, and in turn hardened us all. I detest the idea of using the word 'cynicism': it is not that, but something else, deeper and less destructive. Politics has brought me into a world uncertain and precipitous, but it has also filled me with a burning conviction that many questions still need to be asked about the validity of the existing political and Constitutional structures of this island, and that it is the fundamental obligation of all involved in Irish public life to strive to see the termination of the endless slaughter in the North. It may seem strange to write a book like this at this stage in my life, but I have enjoyed the experience, and it has helped crystallize my thoughts, travel through the circle, find a sort of freedom. I hope the reader has enjoyed discovering the hold of a place called Slane by the banks of the river Boyne, a river that flows to the Irish Sea, 'A sea fed by many streams'.

Index